Languages of revolt

Inez Hedges

Languages of revolt

Dada and surrealist literature and film

Duke University Press Durham N.C. 1983

Library of Congress Cataloging in Publication Data

Hedges, Inez, 1947–
 Languages of revolt: Dada and surrealist literature and film.

 Includes bibliographical references and index.
 1. Dadaism. 2. Surrealism. 3. Arts, Modern—20th
century—Psychological aspects. I. Title.
 NX600.D3H35 1983 700'.9'04 82-14738
 ISBN 0-8223-0493-7

Contents

Illustrations

Acknowledgments

Grateful acknowledgment is due to a number of people who helped me in the preparation of this book. In the preparation of individual chapters, I was fortunate to have the advice of Anna Balakian (chapters one and four), Hans Robert Jauss (chapter two), Mieke Bal and Siegfried Schmidt (chapter three), and Benjamin Hrushovski (chapter four). My special thanks go to *Poetics Today* for permission to reprint the chapter on metaphor and to *Visible Language* for permission to reprint part of chapter five. Franz Mon and Maurice Roche read the sections in chapter five devoted to their work and offered helpful suggestions. In the rewriting phase of the book, I was helped by the comments of Albert Sonnenfeld, Paul Ricoeur, and others too numerous to mention but certainly not forgotten. I would particularly like to thank Mary Ann Caws and Wallace Fowlie for their encouragement. My thanks also go to the Ossabaw Foundation which made it possible for me to present part of my manuscript to an international group of scholars during the colloquium on "The Structure of Reality in Fiction" (organized by *Poetics Today*).

The computer research was done with the aid of Arthur Kunst and David A. Smith, II, and paid for with funds generously provided through the Chairman of my department, John M. Fein. The Duke University Research Council provided support through the years for the research and helped to defray publication costs. Thanks go also to many other colleagues at Duke who were supportive of my interest in Dada and Surrealism, especially Lee Phelps and Frank Borchardt. With Harold Jantz I spent several memorable hours perusing the alchemical treatises of the Jantz Collection. Rafael Osuna provided me with invaluable material on Luis Buñuel.

Provided with a National Endowment for the Humanities summer grant, I had the good fortune to profit from the advice of M. François Chapon, Conservator of the Bibliothèque Littéraire Jacques Doucet. Helmut Sorge, Paris Bureau Chief of *Der Spiegel*, and Yves Chevrier, Research Associate at the C.N.R.S. in Paris, were also instrumental in making my research trip to Paris a successful one.

My thanks go to those who helped me to obtain illustrations for the book: Mary-Jane Victor and Karen Dalton of the Ménil Foundation, Werner Spiess and Günter Metken assisted me in obtaining illustrations of Max Ernst's work. Patricia Howell of the Beinecke Rare Book and Manuscript Collection at Yale, Susan Halpert of the Houghton Library at Harvard, and Antoinette Rezé-Huré of the Musée National d'Art Moderne in Paris should also be mentioned. For film research and stills, I had the assistance of

Charles Silver and Mary Corless of the Museum of Modern Art, New York; Sybille Deleuze of the Cinémathèque Française; and the Cinémathèque Nationale de Belgique. My special thanks go to Dorothea Tanning for permission to use illustrations by Max Ernst.

My deepest gratitude goes to my editor, Reynolds Smith, for enhancing the readability of the book; and to Lisa Wilson for performance beyond the call of duty in the preparation of the manuscript. Finally, I should like to thank Dr. Irwin R. and Mrs. Janice N. Hedges for their continued support, and most especially John Amber, who kept the faith through all the crises.

Introduction

In the second and third decades of this century, many of the most fundamental conditions of human life had changed so rapidly that some artists and writers decided that literature and the arts should become a central mechanism for the adaptation of human attitudes, values, and perceptions to the actual situation. In the face of radical social, economic, political and ideological disruptions of the existing order—intensified by the trauma of world war—these artists and writers discovered that the existing traditions of their various arts were inadequate to express the new awareness they had found. Collectively, they turned their energies into transforming their instruments and techniques for producing meaning—the symbol systems or "languages" of their arts—into languages of revolt.[1]

At the outbreak of World War I, a number of young dissidents had taken refuge in Zürich, Switzerland, and in 1916 a small group of these constituted themselves as the Dada group. There were five principal members: Hans Arp, a painter and sculptor from Alsace-Lorraine; the poet Tristan Tzara and the painter Marcel Janco from Roumania; the poets Hugo Ball and Richard Huelsenbeck from Berlin. Arp set the tone for the group in his autobiography *Dadaland*:

> Revolted by the butchery of the 1914 World War, we in Zürich devoted ourselves to the arts. While the guns rumbled in the distance, we sang, painted, made collages and wrote poems with all our might. We were seeking an art based on fundamentals, to cure the madness of the age, and a new order to things that would restore the balance between heaven and hell. We had a dim premonition that power-mad gangsters would one day use art itself as a way of deadening men's minds.[2]

The spirit of Dadaland lived and flourished at the "Cabaret Voltaire," named after the rebellious eighteenth-century philosopher. At the opening of the cabaret, in the year of Dada's founding, announcements went out to the newspapers to gather in like-minded artists and sympathizers. Thus, in what might be seen as the juxtaposition of a cabaret with a battlefield, began one of the most important artistic movements of this century; important not only for its own achievements but for the enormous influence which it exercised on subsequent developments of the international literary and artistic scene. Fed by the continuous arrival of new expatriates from France, the United States, Spain, and Germany, the movement accepted any experiment and any act of violence done to art as the expression of a frustrated and exhausted Europe in the grips of an insane war. The result was a violent explosion of all artistic conventions.

If rationality and European high culture had led to such a result, the dadaists argued, then the only cure for man was irrationality. So they practiced "creative irrationalism," attempting to redress the balance of sense in the chaos that surrounded them.[3] In art and film they tended toward abstraction, setting themselves against the norms of representation; in poetry and theatre, toward circular word-games and comic nonsense that mirrored their frustrations with the nineteenth-century inheritance of scientism and materialism.

The scene at the Cabaret Voltaire was wild. From Tzara's and Ball's diaries a picture forms of the cabaret decorated with paintings from the modern schools of Cubism and Futurism, and later with Arp's abstract reliefs, Sophie Taueber-Arp's tapestries, and paintings by Janco. A typical evening might include a poem such as "L'amiral cherche une maison à louer," recited simultaneously in three languages by Huelsenbeck, Janco, and Tzara; a recital of "bruitist" poems based on "bruitist" or noise music, and consisting only of grunts and noises; of "gymnastic" poems accompanied by deep-knee bends and arm movements; and of all sorts of dances, some of them assisted by weird costumes and masks. The audience, which originally came as a spectator, became a participant, as the German painter Hans Richter reports: "Bells, drums, cow-bells, blows on the table or empty boxes, all enlivened the already wild accents of the new poetic language, and excited, by purely physical means, an audience which had begun by sitting impassively behind its beer-mugs. From this state of immobility it was roused into frenzied involvement with what was going on.[4]

The Cabaret closed after six months—no one ever bothered to collect admission fees so the enterprise went bankrupt. But the group went on to stage public dada performances and to found a dadaist gallery and periodical. After the war, as there was no need to remain in Zürich, Dada shifted to other cities: Berlin, Köln, New York, Paris.[5]

In *Man's Rage for Chaos*, Morse Peckham writes that art is a rehearsal for unpleasant surprises—it has a "disorientative function" which trains the individual's adaptive abilities.[6] The Dada movement that sprang into being in 1916 had many of the characteristics of such a rehearsal, except that it was taking place "on-stage" as an actual performance. In other words Dada sought to create the situation that would make the adaptation necessary. This it sought to do by questioning not only the content of what can be expressed in language, but the basis of language itself—its official status as the cultural standard for all human activity.[7] The dadaist enterprise attacked the form of language, breaking words down to their phonetic components, films into the abstract play of light and shadow, sculptures into mere objects, paintings into arbitrary combinations of color and line. It generated, at the same time, a series of "anti-forms"—anti-narratives in films and novels, anti-representation in art, anti-poems. These forms were especially useful in

carrying out the dadaist programme. They at once restated and attacked the expectations of the audience towards whom Dada practiced a politics of radical disorientation.

Once the old language was destroyed, the dadaists believed, a new consciousness would arise out of the tenacity of life itself. At the base of the destructiveness of Dada is a positive vision of man as a species capable of renewing itself through first-hand contact with life forces untrammeled by the distortions of decadent civilization. Much of the dada spirit was magico-religious in tone, and more than one dadaist compared his function to that of a priest.[8]

The proselytizing spirit of Dada found expression in numerous manifestoes. Many of these, in the recalcitrant spirit of Dada, actually present themselves as "anti-manifestoes." Tzara wrote in his landmark *Dada Manifesto of 1918*: "I am on principle against manifestoes, as I am also against principles."[9] For this reason it is incorrect to speak of dada*ism*. A large part of Dada was the rejection of "isms," or of the idea of creating a school of art. Yet certain salient features of Dada do emerge from the juxtaposition of Tzara's manifestoes and lectures and the other activities, art works and events that were the outgrowth of the movement:

Spontaneity: "Art is a private thing; the artist does it for himself."[10] In many of their works, the dadaists publicized the private act of creative perception: Max Ernst invented the method of *frottage*, by which the image emerges from the crayon-and-paper rubbing of an object (e.g., a piece of wood); later, Marcel Duchamp invented the "ready-made," an industrial object raised to the status of art by the artist's act of perception.[11]

Anti-rationalism: "We must have strong, upright works, precise, and forever unintelligible. Logic is a complication. Logic is always false. It draws the strings of ideas, words, along their formal exterior, toward illusory extremes and centers. Its chains kill, like an enormous centipede stifling independence."[12] The irrational in Dada is not an escape, but a guiding principle, manifested in the refusal to decide between opposites ("order = disorder; I = not-I; affirmation = negation") and in the richness of dadaist images which are not fixed to conventional norms. This holds true not only for verbal expression but for film and art as well: Hans Richter's late dadaist film *Ghosts Before Breakfast* (1927) overturns received notions of causality (a necklace takes on a life of its own, water flows into a hose, a door opens from both sides) and Duchamp's *To Be Looked at (from the Other Side of the Glass) with One Eye, Close to, for Almost an Hour* (1918) subverts the normal function of sculpture by inviting the viewer to look at a transparent work made principally of glass from a vantage point too close for observation.

The work of art as a product of the artist's inner necessity: "There is a literature which doesn't reach voracious masses. A work of creators, the

result of a real need of the author."[13] The dadaist experimentation with chance as a method of composition understands this chance as a kind of necessity; the point of making a poem from the cut-up words of a newspaper article is that the created work will resemble its author.[14]

Dada as a state of mind: "You may be gay, sad, afflicted, joyous, melancholy or Dada. Without being literary, you can be romantic, you can be dreamy, weary, eccentric, a businessman, skinny, transfigured, vain, amiable or Dada."[15] The dadaists themselves never agreed on one coherent explanation of the origin of the word "dada" because to do so would be against the spirit of Dada.[16]

An ideology of negation of social and cultural institutions: "Every product of disgust capable of becoming a negation of the family is *dada*; the whole being protesting in its destructive force with clenched fists: DADA"[17];

> The beginnings of Dada were not the beginnings of an art, but of a disgust. Disgust with the magnificence of philosophers who for 3,000 years have been explaining everything to us (what for?), disgust with the pretensions of these artists [*sic*] God's-representatives-on-earth, disgust with passion and with real pathological wickedness where it was not worth the bother; disgust with a false form of domination and restriction *en masse*, that accentuates rather than appeases man's instinct of domination, disgust with all the catalogued categories, with the false prophets who are nothing but a front for the interests of money, pride disease, disgust with the lieutenants of a mercantile art made to order to a few infantile laws, disgust with the divorce of good and evil, the beautiful and the ugly (for why is it more estimable to be red rather than green, to the left rather than the right, to be large or small?)[18]

Although this ideology was shared by all dadaists, it was the Berlin Dada group that put it into concrete political practice:[19] Johannes Baader, the self-appointed Oberdada (Head Dada) dropped leaflets directed against the heads of the new first German Republic assembled in the State Theater of Weimar in 1919[20] and interrupted a sermon in the Berlin Cathedral with shouting.[21]

The primacy of art: "We have proclaimed as the single basis for understanding: art."[22] In their radical attempt to disrupt the conventional perception of reality, the dadaists created works of art as a means of making their own perceptions concrete and of communicating them to others. Quite often the act of creation was more important than the end product, so that many dadaist works are oriented less toward the result obtained than toward the method employed to obtain that result: Duchamp's "ready-mades" testify to a moment of creative perception; Tzara's collage poems demonstrate the possibilities of the chance combination of words arranged in contrasting typographies; Kurt Schwitters' columns of junk collage, in which the

mementoes of friends were encased in layers rendered inaccessible to observation by successive additions, are no less memorable for having been destroyed.[23]

The cult of nothingness — nothingness as a state of existence; indifference as a form of commitment: "You will never be able to tell me why you exist but you will always be ready to maintain a serious attitude about life. You will never understand that life is a pun, for you will never be alone enough to reject hatred, judgment, all these things that require such an effort, in favor of a calm and level state of mind that makes everything equal and without importance."[24] "Dada means nothing."[25] The dadaists' refusal to constitute a school was a result of this studied indifference; indeed one of the problems in writing about Dada is that its cult of individualism makes sweeping generalizations impossible.[26] "DADA was born of a desire for independence, of a distrust of the community," Tzara writes. "Those who belong to us keep their freedom."[27]

The placing of man on an equal footing with objects as evidenced in the turning away from representation: "The new artist protests: he no longer paints (symbolic and illusionistic reproduction) but rather creates directly in stone, wood, iron, tin, rocks, and locomotive organisms that can be turned about on any side by the limpid wind of momentary sensation."[28] Dada artists "foreground" the materials of their art, whether canvas and paint, celluloid, or letters. In this way the materials of art, through the operation of the artist's chance encounter with them in the real world, become a part of the artist's necessity for expression — chance controlled and utilized for aesthetic ends.

Even though Dada stressed individualism, however, it should not be forgotten that it was, for the most part, a group effort — lone dadaists like Kurt Schwitters, who worked practically by himself in Hanover,[29] were the exception. The collective nature of Dada accounts for many of the distinguishing characteristics of dadaist art works:

Group compositions in mixed media: artists illustrate poems; poets experiment with typography or imitate films; films become animated paintings. Music is made from noises (the so-called "bruitist" music); poetry constitutes itself out of sound patterns.[30]

The role of performance: Dada was necessarily an urban phenomenon since the audience was essential to the dadaist performance. The concept of performance, so central to the Cabaret Voltaire, was equally important in other cities: in Paris, some of the most famous events were the simultaneous readings of manifestoes at the Grand Palais in February of 1920 to a disappointed public that had come to see Charlie Chaplin;[31] the "Dada Festival" at the Salle Gaveau in May of the same year during which the dadaists, who had promised to crop their hair on stage, were greeted with tomatoes, turnips, eggs and veal cutlets thrown by the audience;[32] and the

performance of *Le Coeur à Gaz* organized by Tzara in July 1923 in which dadaists came to blows with one another in a schismatic confrontation that presaged the end of Dada in Paris and the birth of Surrealism.[33]

The participatory role of the spectator: Dada sought not only to offend its audience but to convert it to Dada—to teach the spectator dadaist modes of the perception of reality. In the "Note on Art" Tzara wrote: "We want to make men realize afresh that the one unique fraternity exists in the moment of intensity when the beautiful and life itself are concentrated on the height of a wire rising toward a burst of light, a blue trembling linked to the earth by our magnetic gazes covering the peaks with snow. The miracle. I open my heart to creation."[34] The dadaists tried to reach the public through manifestoes, journals, performances, and exhibitions.

The rallying cry of the dadaists was freedom: freedom for the individual artist, freedom from externally imposed constraints, freedom from rationality and convention. The emergence of Surrealism from Dada after 1924 in Paris under the leadership of André Breton meant an abrogation of individual freedom in the interest of common goals.[35] For the surrealists, the work of Freud, who had published his *Interpretation of Dreams* in 1900, was decisive. To the dadaist ideal of freedom from rationality the surrealists added the search for the more profound logic of the unconscious. From 1924 (the date of the publication of the *First Manifesto of Surrealism* by Breton) onward, the surrealists were to orient themselves toward the research of unconscious phenomena, by which they hoped to discover the deeper truths of human nature.

From Freud, and from other psychologists such as Pierre Janet, the surrealists took the idea that language—captured in moments of semi-wakefulness or in dreams—is the key to uncovering man's unconscious thoughts and desires. Yet the surrealist emphasis was different: where the psychoanalyst attempts to reduce the conflict between the individual and his or her environment, the surrealists wanted to use the expression of unconscious wishes as a programme for the modification of society. Gerald Mead states the matter succinctly: "For Freud, the voice of the unconscious was simply a means, a tool to be used for his study of the structure and dynamics of the personality, and in the treatment of mental disorders. For the Surrealist it was a prophetic, revolutionary voice."[36] The modification of society had to be pursued, above all, as a modification of consciousness: surrealist works become "rehearsals" for attitudes which the viewer or reader is then to practice upon real-life phenomena. They are training-grounds for perception and conceptualization which are caught up in a double movement: they seek to disestablish the conventional expectations of the perceiver and, at the same time, to make him or her construct a new set of expectations based on the aesthetic experience conveyed by the works.

Unlike the dadaists who eschewed definitions, Breton defined Surrealism

in his *First Manifesto* of 1924: "A pure psychical automatism by which one attempts to express, either verbally, in writing, or in some other way, the real functioning of thought. Dictation of thought, in the absence of any control exercised by reason, without any consideration for aesthetics or morality."[37]

The surrealist emphasis on discovery and research into the unconscious lends a curious flavor to their principal organ, the journal *La Révolution surréaliste*, which was published from 1924 to 1930.[38] The book reviews, fiction, and poetry one would normally expect in a literary review appear side by side with sections devoted to the written accounts of dreams by surrealists Benjamin Péret, Paul Eluard, Robert Desnos, André Breton and Georges Ribemont-Dessaignes; a suicide column that reprints newspaper accounts of suicides appears alongside the announcement of a future opinion poll devoted to the question, "Is suicide a solution?"[39] In 1924 the surrealists announced the founding of the Bureau of Surrealist Research at 15, rue de Grenelle. Here members of the public were invited, from October 11, 1924, through January 30, 1925, to come and tell their dreams and surrealist experiences:

> The Bureau of Surrealist Research is collecting information by every suitable means about the diverse forms of unconscious mental activity. No limits are set *a priori* on this enterprise; Surrealism intends to collect the greatest possible number of experimental results. The conclusion of these researches is not yet certain. All persons who can contribute in any way to the creation of a veritable Surrealist Archive are earnestly requested to make themselves known: Let them come forward to explain an invention, to propose a hitherto unknown system of psychical investigation, to let us be the judges of remarkable coincidences, to explain their most instinctive ideas about fashion or politics, etc. . . . or else let them freely criticize morals, or simply recount their strangest dreams and what these dreams suggest to them.[40]

Breton gave a new name to chance occurrences in reality that appear mysteriously significant: *hasard objectif* or "objective chance." *Hasard objectif* is defined by Breton in "La Situation surréaliste de l'objet" ("Surrealist Situation of the Object," 1925) as: "That sort of chance that shows a man, in a way that is still very mysterious, a necessity that escapes him, even though he experiences it as a vital necessity."[41] By recognizing these privileged moments for what they were, he thought, surrealist practitioners could change their orientation toward reality, making the operations of chance the basis for day-to-day existence. *Humour objectif* or "objective humor" is an associated concept which Breton defines as "The contemplation of nature in its accidental forms coupled with the caprices of the observer's personality."[42] The surrealist who contemplates the accidents of the external world can decide that they are humorous by an act of imaginative perception. The

combination of "objective chance" with "objective humor" yields *humour noir* or "black humor"—a form of humor that is used by the surrealist as the expression of revolt against everyday reality.[43]

Yet the surrealist may create these accidents of nature as well as discover them. Collage, film montage, and "automatic writing" were operations of transformation effected upon the artistic, filmic, and literary media in the service of *humour noir*. Although surrealist works display many of the characteristics of dadaist art outlined above, Surrealism also proposed new forms: new genres, new ways of organizing literary and filmic discourses, linguistic combinations and visual juxtapositions which created new verbal and visual metaphors. Surrealist art is an art of "crisis" which attempts to create a learning situation in the perceiver's mind. Because of its orientation, it provides, along with Dada, an ideal ground on which to examine the relation between cognition and the arts.

This book addresses itself to the problem of defining a theory of dadaist and surrealist expression which takes into account new developments in the "human sciences"—theories of cognition, communication in society, meaning in context—as they are exemplified in recent work in semantics, linguistics, psychoanalysis, and psychological research into the structure of memory. In the United States, a large body of scientific work in the field of cognition has grown up almost unnoticed by humanists. Many scientists working in this field have addressed themselves to the problem of literary communication without, however, going on to make the novel literary interpretations which their findings suggest. As a result, these scientists often overlook the implications of their work for humanistic studies. The areas of scientific research I employ for the study of Dada and Surrealism are those of "frame theory" and natural-language processing.

"Frame theory," as it has been elaborated by Marvin Minsky, Terry Winograd, and others, offers a model of learning and memory which can be partially computer-simulated.[44] The aim is to discover not only how human beings recognize visual shapes, social situations, or linguistic contexts, but also how they learn new concepts when confronted with the unfamiliar. The literary and artistic relevance of this theory would base itself on the idea that new art forms are created in order to publicize and promulgate changes in the modalities of perception of an era. Great art and literature enable us to keep abreast of our ever changing conceptualization of reality. Much of the force of dadaist and surrealist literature and film lies in the breaking of the reader's or perceiver's conceptual frames. At the same time the outlines of the frames are respected since the breaks would not otherwise be noted. Dadaist and surrealist works are privileged areas of investigation in that they allow us to establish the minimal conditions for the recognition of frames while enabling us to observe at the same time the effects of frame transgressions.

The second focus of investigation in this book is on natural-language processing. This is a form of computer-assisted linguistics which in the last five years has made significant contributions to our understanding of how language functions.[45] One of the most exciting applications of this research is the computer-generation of texts, or "text-modelling." Through text-modelling methods, the descriptive accuracy of critical statements about literature can be controlled by seeing whether these statements can be used to make models of the texts they are attempting to explain. Since *disorder* plays a significant role in dadaist and surrealist works, text simulation offers an interesting alternative to descriptive criticism. Disorder can be simulated in text-modelling whereas descriptive systems tend to emphasize the order in texts.

The study deals principally with André Breton, Max Ernst, Antonin Artaud, and Luis Buñuel. The rationale for this selection was to provide clarity of focus while considering dadaist and surrealist productions in a variety of media.

André Breton (1896–1966), who became the leader of the surrealist movement, had been influenced by Freud and the new developments in psychiatry through his work as a medic during World War I. He explored a procedure which he called "automatic writing," according to which the writer attempted to transmit images from the unconscious onto paper without the inhibitions of rationality or censorship. In his *First Manifesto of Surrealism*, Breton defined this procedure as basic to Surrealism, and stated that it could be applied to all forms of artistic creation.[46] Breton and his friend Philippe Soupault produced a volume of "automatic writing" in 1919 which they published under the title *Les Champs magnétiques* ("The Magnetic Fields"), a work which has been described as a new genre of writing. Breton believed that anyone could learn to use "automatic writing" as a tool for self-discovery: "Language has been given to man so that he may make surrealist use of it."[47] In his novel *Nadja* (1928), Breton created a new genre which represented a new consciousness—a changed conception of the relation between self and world.

Max Ernst (1891–1976), primarily a painter and sculptor, also made "collage novels"—works which he created by modifying woodcut illustrations from adventure novels by the collage process. The images, changed into fantastic monsters and landscapes, were then arranged into a sequence and occasionally accompanied by a text. Like Breton, Ernst created an entirely new genre of artistic expression. The interpretation of the works demand considerable ingenuity on the part of the reader since the text and images are interdependent without being mutually explanatory. Ernst's novel *La Femme 100 têtes* ("The Hundred-Headless Woman," 1929)[48] exemplifies the surrealist theory of art and creativity in that it attempts to teach the reader a new way of seeing. As the art critic Germain Viatte wrote of a Max Ernst exposition at the Grand-Palais in Paris in 1975: "Max Ernst is

one of the *inventors* of the Twentieth Century. More profoundly than any-
one else, perhaps, he has, by a shift of emphasis, dislocated our perceptual
conventions and upset our visual syntax."[49]

Antonin Artaud (1896–1948), actor, director, playwright, and critic,
wanted to turn the theatre into a training-ground for the new surrealist
sensibility. Assaulted by non-verbal stimuli—sounds, gestures, colors, and
lights—the spectator was to rediscover the magical dimension of the
theatre. Like Breton, Artaud believed that art would foster the self-discovery
of the perceiver. Artaud's major production, *Les Cenci* (1935), was an
attempt to create a theatrical experience that would transform the spectator.
His only filmed scenario, *La Coquille et le clergyman* ("The Sea Shell and
the Clergyman," filmed by Germaine Dulac in 1927), is an example of his
efforts to find a non-verbal language through which the myth of personal
transformation could be expressed.

Luis Buñuel (1900–) made two surrealist films in collaboration with
Salvador Dali: *Un Chien andalou* ("Andalusian Dog," 1928) and *L'Age d'or*
("The Golden Age," 1930). *Un chien andalou* is one of the most successful
attempts in Surrealism to recreate the dream experience. *L'Age d'or*, on the
other hand, is closer to Ernst's collage novels in its principles of composi-
tion: the juxtaposition of incongruous elements creates a sense of disorien-
tation in the viewer who must expend considerable effort to interpret the
work. In a sense, cinema was the art form which lent itself most easily to
Surrealism, since it was a new medium uninhibited by convention. In
addition, as an art form requiring a sophisticated technology, it was
appropriate for a technological age.

Previous commentators on Dada and Surrealism have noted the preoccu-
pation of the movements' leaders with the "occult science" of alchemy—an
interest shared by Breton, Ernst, and Artaud.[50] Until now this preoccupation
has been explained as a fascination with the irrational. Viewed from the
perspective of cognition theory, however, it becomes clear that alchemy was
a metaphor for surrealist poetics because it offered an analogy to what I
have described as the creation of new frames—a qualitative jump of
perception similar to the alchemist's aspirations to create gold out of "base"
materials.

The first chapter examines alchemy as a structural and thematic presence
in Surrealism. The second chapter discusses the way in which the literary,
filmic, and artistic productions of Dada and Surrealism destroy the concep-
tual categories of their readers and perceivers. The third chapter shows how
some dadaist and surrealist works replace old categories with new ones and
examines this in light of cognitive psychology, linguistic theory, and psycho-
analysis. The fourth chapter is a study of surrealist metaphor that takes into
consideration new developments in linguistics. In this chapter, a computer
model for producing surrealist literary metaphors is proposed. The fifth and

final chapter addresses itself to the problem of artistic exchange. The discussion focuses first on the interaction between the members of the two movements, and concludes with an analysis of three contemporary writers whose work can be interpreted in part as readings of Surrealism and/or Dada: Franz Mon in Germany, Julio Cortázar in Argentina, and Maurice Roche in France.

Finally, I cannot bring this introduction to a close without a few warnings to the reader. This is neither a book of pure theory nor one of pure criticism, but rather a mixture of the two. I have chosen dadaist and surrealist texts because they offer the ideal testing-ground for the theory I am proposing; that this theory can be applied to other texts should be clear from the last chapter in which I take up more contemporary literary works.

My approach may cause some puzzling moments for the reader, who will find that some of the same texts are taken up from chapter to chapter, and examined in view of different elements which are highlighted by the nuances of the changing theoretical perspective. Nevertheless I believe the result to be cumulative, and that the final picture is clear. If the book appears to jump from subject to subject, this is unavoidable, given the expository mode in use. As a means of accomodating the reader, the chapters are arranged in order of theoretical difficulty. The first chapter offers a frankly thematic approach, whose implications for theory become evident in the second and third chapters. By the fourth chapter, the thematic element has become no more than a controlling metaphor—but one which, I believe, still lends cohesion to the overall view. If this strategy of argumentation appears innovative, it must at least be acknowledged that it is not without predecessors, in Mikhail Bakhtin's *Problems of Dostoevsky's Poetics*, which has long been valued both as a contribution to the study of Dostoevsky and as the formulation of a radically new theory of literature; and more recently, in Wolfgang Iser's *The Implied Reader* and *The Act of Reading*, which employ a limited number of texts that become paradigms for the demonstration of his influential theories.

If this book at once demonstrates my theory and makes an original contribution to the study of Dada and Surrealism then my greatest hopes will have been realized.

Languages of revolt

one

Surrealism and the alchemy of the word

From alchemy the surrealists drew some of their central ideas: some having to do with alchemical myths (the alchemists' view of the world as set forth in their sixteenth- and seventeenth-century treatises); some with alchemical motifs (the stages of the alchemical process, along with their representative symbols). Most important, alchemy provided the metaphor for the process of psychological transformation by which the "new man" was to come into being through a qualitative leap of perception, much as the alchemist aspires to create gold out of "base" matter. Art was to furnish a training ground for this experience. In his *Second Manifesto of Surrealism*, Breton stresses "the remarkable analogy, insofar as their goals are concerned, between the Surrealist efforts and those of the alchemists: the philosopher's stone is nothing more or less than that which was to enable man's imagination to take a stunning revenge on all things, which brings us once again, after centuries of the mind's domestication and insane resignation, to the attempt to liberate once and for all the imagination by the 'long, immense, reasoned derangement of the senses.'"[1]

Alchemical myths

Alchemical myths appropriated by the surrealists include the concept of mental transformation; the idea that all things in the world are but the metamorphoses of one, primary essence; and the attitude that the phonetic structure of words reveals the true state of things in the world.

Alchemy is often cited as the ancestor of modern chemistry; but quasi-scientific chemical experiments had little to do with the mythical strain of alchemical thought which interested the surrealists. According to them the quest for gold becomes synonymous with the quest for wisdom, the metamorphosis of matter analogous to the transformation of the spirit. In his essays, Breton often refers to the works of Fulcanelli, a twentieth century alchemist. The author of the two-volume *Les Demeures philosophales* and *Le Mystère des cathédrales*, Fulcanelli appears to have exerted a considerable influence on the other members of the surrealist movement as well. He warns aspiring followers not to confound the solar gold of the wise with vulgar gold;[2] in some schools of alchemy at least, the quest for gold was a "technique of illumination" aiming at spiritual perfection.[3]

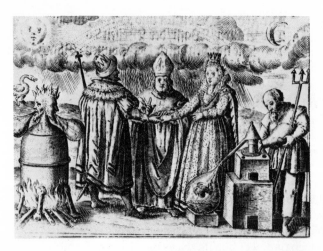

1. The alchemical wedding: royal alliance of sun and moon / Basilius Valentinus, *Les Douze clefs de la philosophie*

As the spokesman and leader of the surrealist movement, Breton argued that the world could be transformed through the languages of art which in Surrealism replace the alchemist's raw materials. Breton even found scientific justification for this transference of the field of experimentation, noting in 1948 that "recent discoveries in physics have shown that the opposition between idealism and materialism is one of pure form."[4]

Surrealist perception transforms the poet and artist; but the surrealist work was also intended as a catalyst that would transform the reader or perceiver, enabling him or her to accomplish the radical mental act—an inherent part of the surrealist aesthetic. Anna Balakian has commented on the quasi-religious nature of this involvement: "Art is not for esthetic pleasure, but a rebus holding many meanings; it is an undefined substance, containing the power of fire, serving for the viewer as a source of meditation and of psychic renewal. Art is an education in life, a cult that comes closest to replacing the religions in modern time."[5]

The philosophic alchemist was committed to the idea that all things in the world are one: *omnia ab uno et in unum omnia*.[6] The cosmic unity postulated by alchemy is symbolized in the *uroboros*, the serpent that eats its own tail. From this first principle, two others are derived: metamorphosis and the reconciliation of opposites. In alchemy the unification of opposites is effected by the union of contrasting elements. The unification of water and earth, and of fire and air generate the opposite pairs moist/dry, and hot/cold. On the other hand, the unification of earth and air is represented as the union of sulphur and mercury whose "coupling" is iconographically translated into the pairing of sun and moon, king and queen, male and female (plate 1). The surrealists made good use of this rich store of symbols, and applied the principle of unification to still more pairs: dream/reality, conscious/unconscious, chance/necessity, matter/spirit. Moreover, Breton in

2. Four stages of the alchemical process from *coniunctio* to *ablutio* / Mylius, *Philosophia reformata*

the *First Manifesto of Surrealism* (1924) translates this principle to the operations of language itself in his famous definition of the surrealist image: "It is, as it were, from the fortuitous juxtaposition of the two terms that a particular light has sprung, *the light of the image,* to which we are infinitely sensitive. The value of the image depends upon the beauty of the spark obtained; it is, consequently, a function of the difference of potential between the two conductors."[7]

In alchemical iconography, the androgyne is the most striking symbol of this unification; often she/he is presented as having two heads (plate 2). For Breton, who sought to reconcile the "female" with the "male" view of the world, the androgyne was the personification of an ideal: in an essay titled "Of Surrealism in its Living Works" he speaks of the "necessity of reconstituting the *primordial androgyne* of whom all the traditions speak, and of incarnating him/her in the most desirable and *tangible* way, in ourselves."[8] Implicit in this statement is the concept of metamorphosis: seeking to unify conscious life with the unconscious, the surrealists posited the radical transformation of the self.

The insistence of Breton that this transformation was to be carried out through language is another inheritance from alchemical thinking, which posited a relation between truth and the phonetic system of language. The cabalistic "language of the birds" (gai sçavoir) postulates that there is a relation between word sounds and sense; a buried treasure of wisdom which the alchemist can uncover. Alchemical texts, particularly those of Fulcanelli, are rife with phonetic speculation. Indeed, Fulcanelli's *Le Mystère des cathédrales,* which attempts to show that Gothic cathedrals are secret

textbooks of alchemical knowledge, lays the groundwork for this argument by interpreting the word "gothic" cabalistically:

> For me gothic art *(art gotique)* is simply a corruption of the word *argotique* (cant) which sounds exactly the same. This is in conformity with the phonetic law, which governs the traditional cabala in every language and does not pay any attention to spelling. The cathedral is a work of *art goth* (gothic art) or of *argot,* i.e., cant or slang. Moreover, dictionaries define *argot* as "a language peculiar to all individuals who wish to communicate their thoughts without being understood by outsiders." Thus it certainly is a *spoken cabala.*[9]

From Breton to Michel Leiris and Robert Desnos, the surrealist relationship to language betrays the influence of cabalistic concerns. Breton makes this position explicitly clear:

> For Surrealism, everything depended on the conviction that we had put our hand on the "primary matter" (in the alchemical sense) of language. ... One can't insist enough on the meaning and significance of the operation which attempted to restore to language its real life, and which consisted, rather than in backtracking from the signified to the sign which outlives it (which would be impossible anyway), in springing back in a single leap to the birth of the signifier.[10]

In many surrealist texts, the signifier is "reborn" through intuitive moments of perception. For Michel Leiris, definition was a preferred mode of phonetic experimentation: "révolution: solution de tout rêve" ("revolution: the solution of every dream"). Robert Desnos explored cabalistic language in the following poem in which all the lines are variations on the well-known phrase "c'est la vie":[11]

Rose Sélavy

Rose aisselle a vit.
Rr'ose, essaie là, vit.
Rôts et sel à vie.
Rose S, L, have I.
Rosée, c'est la vie.
Rrose scella vît.
Rrose sella vît.
Rrose sait la vie.
Rose, est-ce, hélas, vie?
Rrose aise héla vît.
Rrose est-ce aile, est-ce elle?
Est celle
AVIS

Alchemical motifs

The alchemist's purpose in performing his chemical operations was to gain self-knowledge: *nosce te ipsum*. The work was represented by stages which, once completed, had to be started all over again. The process of illumination was therefore at once linear and cyclical, a series of progressive steps infinitely repeated. The type of operation, also, was distinguished by its degree of difficulty: the "oeuvre au blanc," appropriate for the creation of "silver," had fewer cycles than the "oeuvre au rouge," which culminated in the production of "gold."

The stages of the process were symbolized by colors, the sequence being black, white, red and optionally yellow. The color symbolism is complemented by an elaborate iconography, tracing the process as an allegory of dismemberment, sexual union, death, and resurrection (plate 2).

In the first stage, matter must be reduced to a state of blackness (*nigredo*). This is achieved by separating the two elements, sulphur and mercury, from elemental matter (*separatio*). The elements are then unified; alchemical iconography represents this as the union of a king and queen (Venus and Saturn) whose companion symbols are the sun and moon. Their conjunction (*coniunctio*) is represented as a sexual union.

The union is followed by the death of the couple (*mortificatio, putrefactio*). The next stage of washing off (*ablutio*) ends with resurrection, as the hermaphrodite is reborn from the remains of the dead couple. In the color scheme of alchemy the *ablutio* corresponds to the color white (*albedo*).

In the next stage the matter reddens (*rubedo*), producing the elixir. This stage is represented iconographically by Mercury, the sun-moon hermaphrodite, enclosed within the philosophical egg (plate 3). Projected onto metals, the elixir turns them into gold (*citrinitas*, or yellowing) in the stage of multiplication (*multiplicatio*).

Alchemical texts vary as to the exact division of the stages, as any recipe for wisdom must vary. In addition, each of the major stages is divided into many sub-stages. What the surrealists kept in many of their works was the concept of progression, and the differentiation of the stages of illumination accompanied by alchemical symbols of various sorts.[12]

As a cyclical quest, the alchemical search was allegorized by the alchemists themselves in terms of a great number of myths: the labors of Heracles, especially his theft of the golden apples of the Hesperides; Jason's voyage in search of the golden fleece; Danae's shower of gold; creation myths which begin with the separation of elements. The quest theme finds iconographic expression in the representation of labyrinthine cities to be entered, mountains to be climbed, and sea voyages.

8

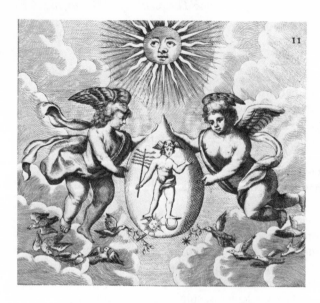

3. Mercury in the philosopher's
egg / Altus, *Mutus liber*

By successive stages, the alchemical process unifies opposites: sulphur and mercury, king and queen, fire and water, earth and air, sun and moon, male and female, life and death—to produce a synthesis. Alchemy could be used as a metaphor for almost any activity which pursues an ultimate goal by successive, dialectical stages—with the proviso that the final step must be a qualitative transformation. The surrealists were not the first to explore these metaphorical possibilities: one finds analogous patterns in Hellenistic and Christian gnosticism as well as in the writings of Carl Gustav Jung, who discovered in alchemy the medieval exemplar of his theory of "individuation."

In 1935, Jung addressed himself to the subject of alchemy in a series of lectures; these were afterwards published under the title *The Integration of the Personality*. Although Jung's analyses were published later than many of the major surrealist texts, they help to explain why the surrealists, with their concern for uniting the conscious self with the unconscious, chose alchemy as a privileged metaphor for their activities.

Jung's curiosity about alchemy stemmed from his observation of the abundance of treatises, written in obscure language, which purported to describe methods of changing common metals into gold. The seriousness and carefulness with which a few of these were written led him to suspect some mystery behind their avowed purpose. He discovered that the experience of the alchemist was one of projection: what the experimenter observed as a particular behavior of the chemical process was actually the psychic experience of his own unconscious.[13]

The material and spiritual are united into a common symbol in the

"philosopher's stone." Again, Jung explains this in terms of the alchemist's own psychic experience: "The alchemist does not practice his art because he believes on theoretical grounds for correspondence; rather, he has a theory of correspondence because he experiences the presence of the idea in the physical order."[14]

Jung's own theory of "individuation" posited that people, in their development from childhood to adulthood, undergo a "psychological process that makes of a human being an 'individual'—a unique, indivisible unit or 'whole man.'"[15] Individuation, he argues, can only come about through the unification of the conscious and the unconscious; and it was this goal that the alchemists, with felicitous intuition, were pursuing.

Although the surrealists were not directly influenced by Jung, his analysis of alchemy in terms of the life of the individual points out the fundamental humanism of the surrealists' alchemical preoccupation. Like Paracelsus, they were of the school that held "there is nothing on heaven and earth that is not in man."[16]

Alchemy as initiation

In their predilection for the occult, the surrealists were also drawn toward the Tarot, whose carefully worked-out progression of trumps had been appropriated by alchemical mythographers. For Fulcanelli, the first trump (usually referred to as "the Fool") represents the alchemist, while the remaining twenty-one trumps are a coded narrative describing the stages of the alchemical process: "The Tarot, a complete hieroglyph of the great work, contains the twenty-one operations or phases the philosophic mercury must pass through before attaining the final perfection of the elixir."[17]

Like the stages of alchemy, the system of Tarot trumps has been interpreted as a symbolic representation of man's progression through the trials of life toward wisdom.[18] Though the surrealists were surely unaware of the possibility of a "Jungian" reading of the Tarot, they anticipated it in their surrealist exhibition in 1947, where the visitors were initiated into surrealist art by climbing a twenty-one step staircase modelled after book spines whose titles corresponded in meaning to the twenty-one divisions of the Tarot.

The concept of initiation in this exhibition is one proper to alchemy, and helps to explain one of the differences between the earlier, dada movement and Surrealism. Alchemy is an "occult" science (from Latin *occultus*: hidden, secret) and in its occultation the dadaists found a useful purpose: *obscurity*. Fulcanelli's pupil Eugene Canseliet admonished:[19]

> *Cum solo*
> *sale et*
> *sole sile*

The alchemist is often represented in iconography with his eyes bound, so that he can better turn his attention to true science which is not evident through the superficial observation of the senses. In Dada, obscurity was used as a means of separating the group from the rest of the world. The dadaists' refusal to make sense arose from their attitude toward a society in which reason had had cataclysmic consequences. Breton's defense of hermeticism during his Dada period is interesting in light of the different attitude he developed later: "The obscurity of our works is constant . . . to read a book in order to gain knowledge denotes a certain naiveté. . . . Those poets who have realized this flee the intelligible . . . they know that their works have nothing to lose."[20]

Yet on the following page, Breton says that hermeticism is not the *purpose* of dadaist texts. Citing Lautréamont, he concludes: "Nothing is incomprehensible." This ambiguous attitude foreshadows the development of his concept of language as "revelation," according to which anyone can attain surrealist insight through the experience of language. "Language has been given to man so that he may make surrealist use of it," he states in the *First Manifesto of Surrealism*.[21] In his later writings he is even more ecumenical:

> The contribution of Surrealism has been to proclaim the total equality of all normal human beings before the subliminal message, to have always maintained that this message constitutes a common inheritance which can be claimed by everyone and which must at all costs cease to be viewed as the property of a select few. It is in the interest of all men and women to convince themselves of the absolute possibility for themselves to have recourse at will to this language which has nothing supernatural about it and which, for each and every person, is the vehicle of revelation.[22]

At the same time, Breton was capable of defining Surrealism quite narrowly, to the extent of "excommunicating" those whom he accused of no longer serving the movement. In the *Second Manifesto of Surrealism* he consecrated entire pages to the examination of the surrealist credentials of former friends — Desnos, Georges Ribemont-Dessaignes, Francis Picabia — resulting in expulsion of some, admonishment to others, and a reconciliation with the estranged Tzara. Sarane Alexandrian, a first-hand observer of Breton and his circle, comments on the initiatory nature of these breaks and reconciliations: "There was in his relations with his friends an almost ritual phenomenon . . . the break with Breton had the character of an initiation; it was like proof that one had assimilated his teaching."[23] Other, less sympathetic observers have compared the relations between the members of the surrealist group to those of the German *Bund*, noting that "certain activities held the value of initiatory rites . . . the game of the 'cadavre exquis,' promenades in certain places, expressions of hatred against family, nation, religion."[24]

The 1947 surrealist exhibition, which was to initiate visitors into a "new myth," attempted to integrate proto-surrealists of past epochs (what Breton called "surrealists in spite of themselves") with present ones, in a cosmic reinterpretation of Western cultural history. Each of the twenty-one steps modelled on the Tarot trumps had a person associated with it, many of whom were writers appearing in Breton's *Anthologie de l'humour noir* (1939). The choosing of a particular trump for an author gave Breton the opportunity to create some interesting juxtapositions:[25]

1. The Magician	Charles Maturin: *Melmoth the Wanderer*
2. The High Priestess	The Life and Works of the Mailman Cheval
3. The Empress	Jean-Jacques Rousseau: *Rêveries d'un promeneur solitaire*
4. The Emperor	James Frazer: *The Golden Bough*
5. The High Priest	Charles Baudelaire: *Fleurs du mal*
6. The Lover	Friedrich Hölderlin: *Poems of Madness*
7. The Chariot	D. A. F. de Sade: *Justine*
8. Justice	Master Eckhardt: *Sermons*
9. The Hermit	Valentin Andreae: *Les Noces chimiques de Simon Rosenkreuz*
10. The Wheel of Fortune	Franz Kafka: *The Trial*
11. Fortitude	Commandant Lefebvre des Noëttes: *L'Attelage et le cheval à travers les âges*
12. The Hanged Man	Jean-Paul Brisset: *La Science de Dieu*
13. Death	Guillaume Apollinaire: *L'Enchanteur pourrissant*
14. Temperance	Emmanuel Swedenborg: *Memorabilia*
15. The Devil	Alfred Jarry: *Ubu Roi*
16. The Tower	Johann Wolfgang von Goethe: *Faust II*
17. The Star	Charles Fourier: *Théorie des quatre mouvements*
18. The Moon	Xavier Forneret: *Et la lune donnait et la rosée tombait*
19. The Sun	Hervey Saint-Denys: *Les Rêves et les moyens de les diriger*
20. The Judgment	Saint John: *The Apocalypse*
21. The World	Isidore Ducasse: *Complete Works*

According to interpretations of the Tarot, which view the progression of the trumps as an allegory for psychic maturation, the key positions are number 10, which makes the transition from the subject's confrontation with the outside world to his or her confrontation of self, and 21, which

denotes the point of reintegration of the androgynous self with the world.[26]

It is significant, in this respect, that the moment of greatest dis-equilibrium is filled by Kafka's *The Trial*, and the moment of greatest integration by Lautréamont's (Isidore Ducasse's) complete works. The surrealists were unabashed admirers of Lautréamont; Breton had copied, by hand, the *Chants de Maldoror* from the only extant copy in the Bibliothèque Nationale and republished it in his journal *Littérature*. In his *Anthologie de l'humour noir* ("Anthology of Black Humor") he writes:

> All the most audacious thoughts and actions of the next several centuries have been formulated here in advance by the magical law of this work. The word, not just the style, undergoes a profound crisis with Lautréamont, makes a new beginning. The limitations according to which words could be combined with words, things with things, have been removed. A principle of perpetual mutation has taken over objects and ideas, straining toward a total liberation which implies that of man as well.[27]

Kafka is also mentioned in Breton's anthology. In its pivotal position, *The Trial* represents here the breakdown of authority—language, society, and law. For Breton, Kafka's world had overtones of dream logic and cabalistic inspiration.[28]

In some cases, Breton took advantage of the fact that the Tarot trumps are traditionally organized in pairs. For arcanum 17 the corresponding text is Charles Fourier's *Theory of the Four Movements*, a work which fascinated the surrealists because of its elaborate system of analogies.[29] The pair to arcanum 17 (fifth from last) is 5, The High Priest. Here Breton chose Baudelaire, whose preoccupation with correspondences (as evidenced in his famous poem, "Correspondances") makes him a fitting match to Fourier. Emmanuel Swedenborg, who developed yet another system of correspondence in his *Memorabilia*,[30] is assigned to arcanum 14, Temperance. For the surrealists, the systems of correspondences and analogies developed by these writers were paradigms for the metamorphosis of matter and spirit which they advocated.

Another pair is that of arcana 3 and 19, the Empress and the Sun. These are assigned to two works having to do with introspection: Jean-Jacques Rousseau's *Reveries of a Solitary Wanderer* and Hervey Saint-Denys' *Dreams and How to Direct Them*. Saint-Denys had discovered that he could influence his dreams by having auditory, sensory, or olfactory stimuli administered to him while sleeping. He would then dream of the person or event which, in his waking hours, was associated with the administered sound, touch or smell.[31] The placement of this work in the position of the Sun arcanum makes it a symbol of mental powers and emphasizes the importance the surrealists accorded to dreams. Correspondingly, The Empress

represents the natural gifts belonging to the individual at birth which he or she must develop. Rousseau's *Reveries*, particularly the "Ninth Promenade" in which he describes the difference between happiness and contentment, are in the spirit of this idea of self-fulfillment through the development of one's own innate qualities.[32] The Empress also forms a pair with The Emperor; in this position Frazer's *The Golden Bough* could serve to complement individual inheritance wtih cultural inheritance.

Arcana 7 and 15 pair the Marquis de Sade's *Justine* with Alfred Jarry's *Ubu roi*. Both writers were enshrined in the surrealist pantheon because of the freedom from convention expressed in their works. Of Sade, Breton wrote in his *Anthology*: "The immense importance of Sade's *oeuvre* is unquestioned in our day: psychologically, it stands as the most authentic precursor of Freud and all of modern psychopathology."[33] Commenting on Jarry, he wrote: "From Jarry on, the division between art and life, so long considered a necessary one, is contested, in order to be finally destroyed in principle."[34] In terms of the Tarot, their placement is significant. Alfred Douglas, in his psychological interpretation of the cards, writes that the Chariot (Sade) symbolizes the "construction of a safe 'vehicle,' or persona in which to proceed through the world,"[35] while the Devil (Jarry) represents the danger of yielding totally to unconscious drives. Sequentially, the placement of Goethe's *Faust II* in the following arcanum presents a kind of narrative logic, since Faust "sold" his soul to the devil.

The other assignments appear to have been suggested by thematic associations with the arcana themselves from the writers who were Breton's favorite "surrealists in spite of themselves." Thus the Gothic novel *Melmoth the Wanderer* fills the position of Magician, symbolizing the first stage of the soul's journey. A work by the minor French romantic Xavier Forneret is assigned to the Moon arcanum: "And the Moon Gave and the Dew Fell."[36] Fortitude is given over, somewhat mysteriously, to *Harnessing and the Horse Through the Centuries*, a work that discusses the means of increasing animal power (and thus liberating man from the enslavement of manual labor) through the use of different types of harnesses.[37] Assigned to Death is Guillaume Apollinaire's fairy tale of a magician who is visited by various mythological figures while trapped in a tomb by his cruel mistress.[38] In the Tarot, Death is also a symbol of resurrection; thus Appollinaire's magician cannot die any more than the immortal figures of mythology. The Hermit, an arcanum symbolizing the individual's turning inward to reflect on himself, is represented by a fifteenth century German alchemical fairy tale, *The Chemical Wedding of Simon Rosy-Cross*. The tale relates the trials of a hermit who is pulled from his forest meditations to become a Knight of the Golden Stone.[39]

Friedrich Hölderlin's *Poems of Madness* are placed in the position of The Lover. In part this choice may have been motivated by the resemblance of

some poems from Hölderlin's late period to "automatic writing."[40] But the choice of Hölderlin for The Lover surely stems from his idealization of women, particularly in *Hyperion,* a work which comes very close to Breton's concept of woman as a redemptive force.

Thematic considerations, as well, seem to have gone into the choice of *The Apocalypse According to Saint John* for The Judgment, and Master Eckhart's *Sermons* for Justice. This leaves two of the most curious works in this series: Jean-Paul Brisset's *The Science of God* and "Mailman Cheval."

Maurice Cheval was a postal carrier who built a small castle in his backyard out of the stones and pebbles he collected on his rounds. His little castle, which he used as a tool shed, is often cited as an example of fantastic architecture. The surrealists idolized him because he showed that imagination could triumph over reality.[41]

Jean-Paul Brisset was adept at using logic for illogical ends. One of his works, *La Grammaire logique,* constructs a "logical grammar" that defies the rules of usage.[42] His talent at inverting logic makes him a perfect choice for The Hanged Man, who, Douglas informs us, represents a "reversal of values and aims."[43] Brisset's *The Science of God* is in the same spirit as *La Grammaire logique,* for if the latter affirms the superiority of imagination over the conventions of language, the former presents a theory of human self-determination in all things: "The real God is the spirit of man."[44] Brisset's arguments are abundantly defended by cabalistic language games that prove his point through invented etymologies and phonetic resemblances. Implicitly, Brisset asserts that man's place in the world can be determined by linguistically inspired associations of thought.

After traversing the Hall of Existing Superstitions at the top of the twenty-one steps, the visitor was to discard these and adopt, instead, twelve new myths proposed by the twelve altars the organizers had set up. These included Jules Ferry's "urbane tiger" (from a short story about a tiger who was trained to dress up in evening clothes and fondle babies); Lautréamont's "hair of Falmer" (a hair of God which complains bitterly, in the *Chants de Maldoror,* about being abandoned in a brothel); Max Ernst's feathered alter-ego "Loplop, the bird-secretary;" Duchamp's "keeper of gravity" (an incomplete part of his major work, *The Bride Stripped Bare by Her Bachelors, Even*); and the mystical "starred mole" whose subterranean efforts to attain daylight made it the perfect mascot of Surrealism.[45]

The 1947 surrealist exhibition was a reading of past and present works that became the generative force for new works. The procedure was one which Anna Balakian has described as characteristic of Breton:

> Breton's critical activity consists in effect of selecting from the great body of literature the visionary writers; his definition of "visionary" as it emerges from his critical writings is that quality of a writer that, without necessarily driving the reader to action, creates an almost chemical

change in his mind, makes him aware of the dynamic character of the universe and thus unsettles his established mental classification of art and institutions.[46]

Breton's idea of "black humor," the title he chose for his anthology of favorite predecessors, was linked to that of rebellion and ultimately to the idea that "beauty must be convulsive or not at all" (the last line of his novel *Nadja*). "Convulsive beauty" is good epithet for the stages of the alchemical process, and for the radical transformation that is its culminating moment.

Surrealism could ally itself with the hermetic tradition because, like the alchemists, the surrealists sought to create a bridge between the material and the ideal. Seeking to unify conscious life with the unconscious, the surrealists posited a reality that would be permeated with mind: hence the concept *surreality*. In view of the global ambitions of its founders, it is difficult to view Surrealism as just another art movement. Its encompassing vision of the world has more of the flavor of a religion, though the object of "worship" was man himself. It is no wonder the surrealists gravitated toward the alchemical myth that made each alchemist a minor god rehearsing the creation of the world in his laboratory, with results that were entirely dependent upon his own imaginative powers (or, as Jung would say, upon the projections of his own unconscious). The central surrealist myth is the creation of a new world through the use of language: languages of prose and poetry, film, and art. If alchemy provided the model for poetic creation, it also provided, in many cases, the philosophy underlying the artists' modes of composition and the thematic and structural organization of the works. A close reading of surrealist literature, art, and film reveals the presence of alchemical references on both verbal and iconographic levels; alchemy even supplies the poetics of the reading, since many of the works were intended to facilitate the radical transformation of the reader's consciousness according to the alchemical model.

Max Ernst and the germination of language

One of the preferred techniques of surrealist visual artists was collage, a procedure whereby the representations of persons, objects, and landscapes are combined so as to liberate them from their original contexts, artistic or otherwise. For Max Ernst, collage was the "alchemy" of the visual image; it allowed the radical disorientation of perception by "the coupling of two realities, irreconcilable in appearance, upon a plane which apparently does not suit them."[47] Ernst employed the collage method for his picture novel *La Femme 100 têtes*.[48] The work can be interpreted as an extended alchemical allegory.

The title of the novel bears a double reading: *La Femme 100 têtes* may be translated either as "the hundred-headed woman" or "the woman without a

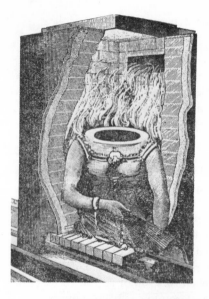

4. Cover illustration / Max Ernst, *La Femme 100 têtes*

5. "Where you can see a charming little insect with metallic hair" / Max Ernst, *La Femme 100 têtes*

head." The alchemist Eugène Canseliet, who is often quoted by Breton, devotes a whole chapter in his *Alchimie* to the woman without a head whose decapitation symbolizes the moment of separation of whiteness from blackness; elsewhere Canseliet's teacher Fulcanelli writes that the whitening in the stage of *albedo* can only be accomplished by burning water with fire—hence the expression "to cut the water's head off."[49] The cover illustration of *La Femme 100 têtes* shows a furnace in the shape of a headless woman, affirming the plausibility of the alchemical interpretation (plate 4). The other possible reading of the title, "the hundred-headed woman," could refer to the hundred-headed dragon Ladon that guards the

6. "Open your bag, my good man" / Max Ernst, *La Femme 100 têtes*

7. *Separatio*, the separation of matter in alchemy / Salomon Trismosin, *La Toyson d'or ou la fleur des trésors*

golden apples of the Hesperides, a myth that has resonance in alchemical symbology.

In its overall organization, Ernst's novel interweaves Christian motifs with the alchemical myth of the complete individual. The latter is announced in the first illustration, an aerial nude held to the ground by guide ropes: "Crime or miracle: a complete man." The circularity of the alchemical process is mimicked by the circularity of the book, which ends with the same picture and the comment: "End and continuation."

8. "Unlimited meetings and robust effervescences in the wheel known as Poison" / Max Ernst, *La Femme 100 têtes*

The first chapter introduces the Christian myth in three illustrations of failed attempts at the immaculate conception. In a fourth, successful attempt, a nude woman is posed suggestively beneath a pipe organ.

The second chapter shows scenes from childhood: the Christian myth is kept alive in the "extreme unction" administered to a child's bottom, while the alchemical motif finds expression in the illustration of a small girl in a metal incubator. The raw materials of alchemy are in a state of "childhood" before undergoing the processes of maturation and change (plate 5).

From chapters three through six the alchemy theme dominates; each chapter is centered around one phase of the process (*separatio, coniunctio, putrefactio, ablutio*).

Chapter three portrays the separation of matter (*separatio*); the truncated limbs found here have parallels in alchemical iconography (plates 6 and 7). Representing the Christian theme, God the Father, "his beard laced with continuous lightning," appears in a subway accident.

The stage of unification (*coniunctio*) is reached in chapter four in several dramatic illustrations of couples caught within a wheel (plate 8). The parallel for this in alchemical iconography is found in the ninth key of the seventeenth century work by Basilius Valentinus, translated by Eugène Canseliet as *Les Douze clefs de la philosophie* ("The Twelve Keys of Philosophy"). There the union of the male and female principles is represented in terms of the "wheel of the world" (plate 9). Continuing the Christian theme, Ernst's alter-ego Loplop assumes the dimensions of the Christ figure ("Loplop, Bird-Superior has transformed himself into flesh without flesh and will dwell among us"), while Perturbation (his sister) is identified with the Virgin Mary ("Each bloody riot will help her live in grace and truth").

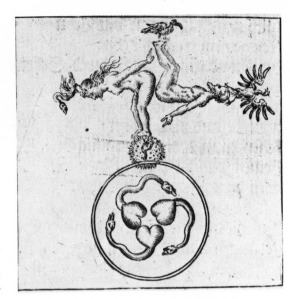

9. The revolution of Venus and Saturn and the symbolic colors of alchemy (represented by birds) / Basilius Valentinus, *Les Douze clefs de la philosophie*

Chapter five corresponds to the stage of *putrefactio* in the alchemical myth, as the conjoined elements are punished and tortured. Assassinations and violence appear side by side with collages showing ironsmiths at work at their anvils. The serpent and the lion beside them can be found in another of Valentinus' keys showing the lion devouring the serpent, before the flowering of the philosophic stone bestowed by Mercury (plates 10-12).

Water predominates in the sixth chapter, devoted to the stage of *ablutio*. The announced "departure for the miraculous catch" can be interpreted as an alchemical as well as a Christian symbol; alchemical engravings show the alchemist and his "mystic sister" (the alchemist's female assistant) fishing for Mélusina, the mermaid goddess who embodies the aquatic element in alchemy (plate 13).

The overt parallel to the alchemical process is interrupted in chapter seven, which deals with the emergence of the double, or phantom, and explores the idea that alchemical operations upon matter are regarded as the "double" of psychic operations. The bird Loplop doubles himself and "remains motionless for twelve days on both sides of the door." This section calls to mind Breton's description of Ernst in his introduction to this work as "the most magnificently haunted brain of our day"—a statement that echoes Breton's own question in the opening lines of *Nadja*: "Who am I? If this once I were to rely upon a proverb, then perhaps everything would amount to knowing whom I 'haunt.'"[50] The phantom in Surrealism is the unconscious, the haunting double of the self.

Chapter eight treats the themes of death and resurrection, bringing the

10, 11. "Gray, black or volcanic smiths will whirl in the air over their forges and will forge crowns so large that they will rise higher" / Max Ernst, *La Femme 100 têtes*

12. The lion consuming the snake precedes the thousandfold flowering bestowed by Mercury / Basilius Valentinus, *Les Douze clefs de la philosophie*

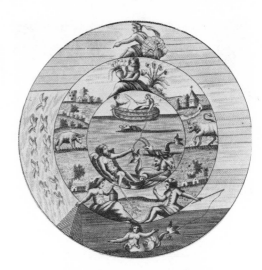

13. The chemical *artifex* and his *soror mystica* fishing for Melusina / Altus, *Mutus liber*

alchemical operation to a successful close. Skulls and skeletons proliferate among butterflies that symbolize resurrection. The monkey makes an appearance alongside God, as the alchemist was thought to be a monkey imitating God's creation. Yet in Ernst's irreverent portrayal God comes as a suppliant to the alchemist (plate 14). In this chapter, also, Ernst presents some "surrealists in spite of themselves": Fantomas, the hero of serialized novels and films in pre-war France who appeared in innumerable disguises; Dante, transformed by his long itinerary and through the agency of a woman; Mata Hari, presumably chosen for the double life she led; St. Lazarus, ambassador of Resurrection; and Jules Verne, who transformed reality through his powers of imagination.

The final chapter begins with an expression of gratitude to Satan, recalling that alchemy was said to be the devil's work. In this chapter the enigmatic "femme 100 têtes" keeps her secret by plucking out people's eyes (plate 15). This chapter also shows God trying in vain to separate light from darkness, represented as a black and a white woman (plate 16). Does this cast doubts on the Creation as well as the alchemist's mimicry? Perhaps the message is that the rational cannot separate itself from the irrational; knowledge can only be purchased at the price of certainty. This would seem to be the meaning of Ernst's answer to the question, "What is the most noble conquest of collage?" "The irrational . . . the magisterial eruption of the irrational in all domains of art, of poetry, of science, in the private life of individuals, in the public life of peoples."[51]

La Femme 100 têtes reveals the influence of alchemy both in the collage procedures used in its composition and in the themes it develops. The visual appearance of many of its images resembles alchemical engravings, in which the alchemist's quest is narrated in the landscape of symbols. Michael

22

14. God comes as a suppliant to the alchemist, his imitator: "All doors look alike" / Max Ernst, *La Femme 100 têtes*

15. "The eye without eyes, the hundred headless woman keeps her secret" / Max Ernst, *La Femme 100 têtes*

Maier's seventeenth-century *Atalanta fugiens* offers a wealth of engravings which would not seem out of place in Ernst's work even though they are not the products of collage. "The royal bath" (plate 17) is not far from Ernst's "Quietude" (plate 18). Maier's "The Alchemist and his Guide" (plate 19) gives, perhaps, a clue to the identity of the "hundred headless woman"; she appears to be Loplop's *soror mystica*. Ernst's names for his heroine are "Perturbation" and "Germinal," names easily assimilated into the alchemical processes of violent disruption and resurrection, represented in Valentinus

16. "The Eternal Father tries vainly to separate the light from the shadows" / Max Ernst, *La Femme 100 têtes*

as the germination of wheat out of a grave (plate 20). The term "germination" may also be applied to language, as Breton said: "The word must *germinate*, so to speak, or else it is false."[52]

André Breton and the open book

Alchemical symbols permeate Breton's writings. In part, the presence of the alchemical theme can be accounted for by its presence in the writers whom Breton read and admired, as he himself stated: "Those poets who have influenced us the most are those who themselves were the most influenced by esoteric philosophy, such as, in France, Hugo, Nerval, Baudelaire, Rimbaud, Lautréamont, Jarry, Appollinaire."[53] But the influence was also direct. When charged by the businessman Jacques Doucet to recommend books for a private library, Breton recommended the purchase of the alchemical text *Ars Magna* by Raymond Lulle.[54] In his essays, he often quotes the alchemists Canseliet and Fulcanelli. The influence of alchemy in his works is so pervasive that Anna Balakian states flatly: "There is no work of Breton's, in verse or prose, which does not make an allusion to some aspect of hermeticism or to its multiple ramifications."[55]

In Breton's novel *Nadja*, alchemical symbols become indices for the psychic rejuvenation that comes about when an individual gains access to his or her unconscious. In *Nadja*, the alchemical symbols are not built into a complete system but remain on the level of allusion. *Nadja* is the fragmentary story of the narrator and his "muse"—an enigmatic woman whom he meets by chance in the streets of Paris. As he gets to know her he begins to see in her the spiritual embodiment of Surrealism; quite unconsciously (and

17. The royal bath / Michael Maier, *Atalanta fugiens*

18. "Quietude" / Max Ernst, *La Femme 100 têtes*

this is no small part of her fascination for him), Nadja appears to live according to surrealist ideas. The narrator writes that she is a "free genius, something like one of those spirits of the air which certain magical practices momentarily permit us to entertain but which we can never dominate (111)." Nadja's elements are not only the air, but water: she is allegorized as the water-nymph Mélusina (129) whose husband was not allowed to see her on Saturdays (when she wore a fish-tail) lest she turn permanently back into a mermaid. For Breton, the aquatic spirit of Mélusina was assimilated into

19. The alchemist and his guide /
Michael Maier, *Atalanta fugiens*

20. The *putrefactio,* major key of
the resurrection and of the Great
Work / Basilius Valentinus, *Les
Douze clefs de la philosophie*

his model of the ideal feminine mode of thought: "Only through her can
these savage times be redeemed," he later wrote in *Arcane* 17. Like so many
other myths, Mélusina became a part of alchemical philosophy and iconog-
raphy (plate 13).

Nadja, in turn, sees the narrator as "black and cold . . . like a man struck
by lightning, lying at the feet of the Sphinx" (111), and also as the sun. For
her, his element is fire. These symbols reinforce the idea that for the narrator
Nadja is a catalyst that enables him to transform his consciousness from an
unrefined state into one of philosophic wisdom. The narrator also relates
that in a game consisting of finding the resemblance between a person and

an animal, he is generally compared to a dolphin (89). This, again, is an alchemical symbol frequently mentioned by Fulcanelli.[56]

A recurrent motif in *Nadja* is the mystical voyage. The narrator even meets Nadja by chance; for him, the labyrinth of city streets is polarized into select places that are especially conducive to surrealist experiences. Marie-Claire Bancquart has named this surrealist preoccupation with places "le génie du lieu" and comments: "Breton makes Paris the receptacle of the Grail, which is self-knowledge."[57] In some of his other works, Breton writes of his attraction to places historically associated with alchemy, such as the Tour St. Jacques mentioned in his commentary on his poem "Tournesol."[58] In *Nadja*, the "génie du lieu" is carried over into color symbolism (the red window on the Place Dauphine, [83]; the blue wind, [84]) and into the feeling that propitious places exist:

> You can be sure of meeting me in Paris, of not spending more than three days without seeing me pass, toward the end of the afternoon, along the Boulevard Bonne-Nouvelle between the *Matin* printing office and the Boulevard de Strasbourg. I don't know why it should be precisely here that I almost invariably go without specific purpose, without anything to induce me but this obscure clue: namely that it [?] will happen here. (32)

In another passage the narrator mentions that the statue of Etienne Dolet at the Place Maubert induces "unbearable discomfort" in him. Recalling Fulcanelli's play on the word "gothique," it seems clear that the narrator is being cabalistic here, reading "dolet" to yield the Latin meaning, "it hurts." As Bancquart states: "Word play, in the relations between the poet and the city, takes on the value of a revelation."[59]

In his pursuit of the elusive Nadja, the narrator very much resembles the alchemist who seeks to unify the male with the female principle. Breton's other works repeat this figure of pursuit, culminating in *Arcane 17*. There the heroine is said to embody the vital forces of the 17th arcanum, the Star, which symbolizes the powers of the imagination. *Nadja* in addition is an "open book": the narrator, whom it is difficult not to see as the persona of Breton, insists on being interested only in "books left ajar, like doors" (18). The motif of the "open book" is also alchemical, designating not only matter transformed ("opened" to its philosophic potential) but also cabalistic language deciphered by the key of the initiate.[60] *Nadja* itself becomes the locus of alchemical operations upon language that is transformed to reveal its secrets. A number of phrases and sentences in *Nadja* resemble "automatic writing." The transformation of language effected in the images produced is equivalent to the transformation of matter in alchemy: language begins to "germinate" in its multiplication of images, just as the "germination" or resurrection of matter makes possible the *multiplicatio* in the final stage of the alchemical process. Some of Nadja's phrases—"the heart of a

heartless flower" (71); "the lion's claw embraces the vine's breast" (116)—are examples of language transformed into an "open book."

Antonin Artaud and the theatre of alchemy

In his preface to *The Theatre and Its Double*, Antonin Artaud wrote: "If the sign of the times is confusion, I see at the base of this confusion a disruption between things and the words, ideas, and signs that are their representation."[61]

The problem of language is crucially posed in Artaud's writings. Artaud felt his very existence threatened by the corruption of language. Of himself, he writes: "I am quite aware of the stops and jerks of my poems, jerks which touch the very essence of inspiration and come from my ineradicable inability to concentrate on an object. And this from a physiological weakness, a weakness which touches the very substance of what one is accustomed to call the soul and which is the emanation of our nervous energy, coagulated around objects. But from this weakness the whole era suffers."[62]

As his co-sufferers, Artaud named Tzara, Breton, and Pierre Reverdy. For them, he says, the problem remains on an intellectual plane; as for himself, he feels his whole being caught in the paralysis of language. By necessity, he actively seeks a "cure" for this "illness which takes away my words, my memories, which uproots my thoughts."[63]

Artaud set himself the task of discovering a non-verbal language that would permit the reintegration of the psyche. He developed a theory for a new theatre of psychic integration—a theatre designed to transform the spectator and to cure him or her of the illness of the time. He called this theatre, among other things, a "theatre of alchemy."

In alchemy, Artaud argues, the material operation was the double of a spiritual one: spiritual redemption (the obtaining of "gold") was the purpose of the more sophisticated practitioners of alchemical operations. He finds significance in the fact that one speaks of the "theatrum chemicum" in alchemy—alchemy is naturally theatrical.[64] In his new theatre, Artaud sought to produce the "spiritual gold" of alchemy by mixing the elements of color, sound, gesture, movement, incantatory words; out of this apparent chaos would come the new order, since "true theatre is born out of an anarchy which organizes itself."[65]

Thus in Artaud's writings alchemy becomes a metaphor for the healing of man's divided and impotent consciousness: "If the primitive idea of theatre is not to allow us to attempt, in the hollow and dug-out excavation of the scene, a psychological action analogous to that attempted by alchemy, that is to say to liberate in a small way forces which are then obliged to contract themselves—then theatre has no reason for being."[66]

In his only filmed work, *The Sea Shell and the Clergyman* (filmed by

Germaine Dulac in 1927), Artaud created an allegory supported by alchemical symbolism. Film, he maintained, offers more direct access to the unconscious than any other medium; thus it was well suited to his goal of creating a non-verbal language of the unconscious that would permit man to overcome the impotence of thought entailed in verbal forms of expression.[67]

The Sea Shell and the Clergyman allegorizes sexual union in terms of alchemical motifs and symbols that become the structuring principle of the film. Interpreting the film as an alchemical allegory clears up much of the confusion engendered by its otherwise mysterious narrative progression.

In the beginning of the film, the camera-narrator slowly traverses a corridor lit by a circular patch of light. At the end of the corridor the camera cuts to closeup shots of a clergyman in an adjoining room. A medium shot identifies him as an alchemist who is pouring a black liquid from a scallop shell into some test tubes. As each test tube is filled, he drops it onto a large cone-shaped pile of broken glass. He is recognizable as an alchemist, both because of his activity and the fact that the shell he is using is a "Coquille St. Jacques." Fulcanelli notes that the alchemist's search for wisdom was sometimes symbolized as a pilgrimage to Saint James of Compostella, whose emblem is the scallop shell. The scallop shell, he says, is "the consecrated receptacle of the alchemical liquid."[68]

The camera passes over the pile of glass and earthen floor of the room, then cuts to a long shot of a man in military dress entering through a door in slow motion. The officer is Mars, who in alchemical mythology is associated with the stage of *rubedo*, or reddening.[69] Here Mars is associated with the elements of air and fire—once in the room he levitates to the ceiling, then descends to wrest the sea shell from the clergyman. After carrying it around in a ritual circle, he splits it with his flashing sword. This is the stage of *separatio*, or separation of the elements.

The shots immediately following this violent act portray the subjective state of the clergyman, and consist of a montage in which everything in the room appears to be distorted. The clergyman's quest now begins in earnest, and he follows the officer out of the door on all fours to crawl through his first labyrinth—the city. In his progress through the streets he sees the officer riding with a beautiful woman in a horse-drawn carriage. The woman is Venus, whose adulterous union with Mars was often used to symbolize the *coniunctio*.[70] The couple gets out of the carriage to enter a church and the clergyman springs up and runs through the streets in their pursuit.

From this point on, the clergyman's efforts are directed toward breaking this couple apart and taking the place of Mars beside Venus. As he enters the church, he sees the officer in the confessional, listening to the woman. He runs toward the officer in slow motion and starts to throttle him. The officer's clothes change into those of a priest, and his head cracks and splits

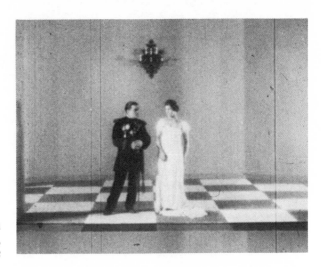

21. The royal alliance / Antonin
Artaud and Germaine Dulac,
La Coquille et le clergyman

down the middle. The heads of all three protagonists are then seen turning
slowly in closeup shots, underscoring the ritual aura of the plot.

The quest theme continues as the clergyman traverses a labyrinth of
corridors, swinging a large key with which he unlocks door after door. The
key is, of course, another symbol for the alchemist's search. As he enters a
large room, he finds the officer and the woman united as a couple (plate 21).
They run out and he pursues them through the corridors and out onto a
country road. This episode ends with a closeup shot of several fists pound-
ing on a flat surface. Assuming that the union between Mars and Venus has
taken place despite the clergyman's efforts, this could be the *mortificatio.*

In the next stage, the *ablutio*, the scene shifts to water images. The three
characters are now on board a ship. The clergyman is lying in a hammock
next to another circular patch of light. He rises to go on deck where the
officer lies enchained. The woman leans over a balustrade and kisses the
officer, thereby driving the clergyman into a fury. He makes a motion as
though to strangle her, and a transparent image of her neck appears between
a closeup shot of his hands. This image fades and is replaced by a small
island that rotates and grows into a city (plate 22). A split-screen effect then
shows a closeup of the clergyman's head at the bottom left of the screen
while the island appears alongside him in a watery grotto. The structuring of
matter thus appears to be the result of the alchemist's mental activity. A
small ship is seen making its way toward the island, a restatement of the
quest as a voyage. The episode concludes with another closeup of the small
island, surrounded by water and smoke—the first cycle has culminated in
the *rubedo.*

In the next episode, the clergyman makes a renewed effort to tear the
woman away from the officer by attempting to marry her himself. The

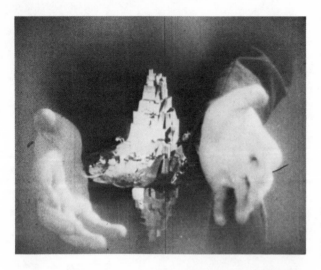

22. The coagulation of matter during the alchemical process / Antonin Artaud and Germaine Dulac, *La Coquille et le clergyman*

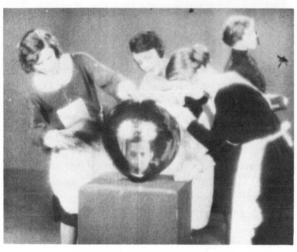

23. Mercury in the philosopher's egg / Antonin Artaud and Germaine Dulac, *La Coquille et le clergyman*

setting is a room in the middle of which rests a large glass sphere. Eight maids enter to clean the room and dust the bowl. When the head of the clergyman appears inside of the bowl (plate 23) it becomes clear that he is associated with Mercury, traditionally portrayed inside the philosophic egg (plate 3).[71] The woman begins to assume several identities—she enters the room as a governess; the camera cuts to an outside shot where she is dressed in a tennis outfit and talking to a young man as the clergyman walks by. The camera then cuts back to the room to show the clergyman and the woman coming through the door to be married by the officer, now dressed in a cassock. Eight houseboys enter to assist the maids, emphasizing the union of

male and female elements in this scene. As the "alchemical wedding" takes place, a split-screen effect shows the clergyman imagining himself back in the grotto with the island and the ship. The water symbolism here foreshadows the *ablutio* that will follow this second *coniunctio*.

The camera then cuts to the headless clergyman descending a ladder, carrying the glass sphere in a wrapper. He appears among the maids and houseboys assembled in the room and lifts off the cover. The camera pans across the amazed faces of the servants before they dissolve. Alone in the room, the clergyman drops the sphere and his own face is revealed among its broken pieces. Scooping with the scallop shell that materializes in his hands, he drinks black liquid in which floats the image of his face.

This act appears to give him sudden strength—transported in a flash to a cliff, he lifts the officer, dressed as a priest, and throws him off the precipice. The officer-priest appears next to the clergyman again, and is once more thrown down.

The camera cuts back to the earlier confessional scene, but now the clergyman has replaced the officer. Beckoning suggestively to the woman, he leaves the confessional box and rips off the front of her dress to expose her breasts. Almost immediately, the naked breasts are covered by a brassiere in the shape of scallop shells (the viewer will perhaps think of Botticelli's *Birth of Venus* in which Venus rides on this type of shell). The clergyman rips this off too and brandishes the brassiere in the air.

The next scene takes place in a ballroom where guests are dancing in circles below a swaying circular chandelier. Mars and a rather more corpulent Venus, now a royal couple, cross the ballroom in order to sit upon throne-like chairs above the dance floor. The clergyman materializes in a door holding the scallop shell, then fades into thin air. The camera cuts to several dancers kissing. Then the Clergyman intrudes once again, brandishing the bra-sea shell during which the king and queen fade and disappear, and the dancing stops. In a door opposite the clergyman the woman appears dressed in white. The transfixed clergyman drops the brassiere and it bursts into flames. From a low-angle shot the clergyman is shown trying to recompose his clothes. His coat tails grow into a long train, and he strides out of the room majestically.

The clergyman has still not obtained the woman—again she runs along a country road, the clergyman in hot pursuit. Distorted closeup shots of her face show her teasing him with stuck-out tongue—the tongue turns into a rope that he tries to climb up. The woman vanishes, finally, against a backdrop of clouds.

Back in the room containing the glass sphere, the clergyman beckons to an imaginary person. He makes motions of grabbing the person whom he places inside the sphere. The final shot of the film is that of the woman's head trapped inside the sphere.

Dulac's filmed version underscores the male/female conflict between the clergyman and the woman and ends with his imprisoning her in the glass sphere. This ending is very different from the one Artaud proposed original-ly.[72] According to that scenario, the two scenes in the confessional are consecutive, followed immediately by the ballroom episode. Thus the cler-gyman successfully prevents the *coniunctio* between Mars and Venus, and captures the woman's head in the glass sphere.

Artaud's scenario then continues at the stage when the clergyman is traversing the labyrinth with his key. This is followed by the shipboard episode, then the wedding between the woman and the clergyman. After the successful "alchemical wedding," the scenario ends when the clergyman imbibes the image of his own face from the sea shell. It would appear that Artaud's original ending emphasizes the allegorization of the clergyman's self-discovery through a symbolic sexual union in which alchemy becomes the vehicle for the metaphorization of the unconscious.[73] Dulac's version, on the other hand, emphasizes her characteristically feminist viewpoint that man imprisons woman against her will.[74]

Artaud publically repudiated Dulac's film, but recently Alain Virmaux has produced new evidence that Artaud's feelings on the subject were ambiguous; in later years, when Cocteau's *The Blood of a Poet* and Buñuel's *L'Age d'or* were produced, Artaud upheld his own work as the first and only authentic surrealist film.[75]

From the perspective of the alchemical symbolism, Dulac's major mistake was in shifting the order of the scenes, so that the logic of the first part is lost. The alchemical metaphor is somewhat diluted by the director's use of irises, slow motion, and other impressionistic devices typical of her style. The more effective elements in the film were her uses of lighting and the introduction of circular movements of the camera, persons, and objects in ways that suggest the ritualization and circularity of the alchemical process.

Was Artaud's alchemical theatre successful? According to one account, Artaud himself broke up the premiere of *The Sea Shell and the Clergyman* by hurling obscenities against Germaine Dulac.[76] As for his only produced play, *The Cenci*, it was a magnificent flop and Artaud was ruined by it. Rather than abandon his ideas, however, he redoubled his efforts and continued to work for the transformation of artistic language which, he believed, would offer a cure not only for his own ailments but for the *mal du siècle* experienced by his surrealist friends. Like Breton and Ernst, Artaud's preoccupations with alchemy went far deeper than mere allusion. As Florence de Meredieu maintained:

> The relation between Artaud and alchemy cannot be reduced to that of simple reference, or even metaphor—unless one means a lived metaphor, assimilated, transmuted until it becomes an organic and living culture which penetrates into the very nerves. Body, universe, structures, geologi-

cal (and genealogical) strata of the earth: these are just so many scenes in which man reflects himself in his doubles, a world as stratified as the trumps of the Tarot. The text appears in the guise of a temple, "like a vast theatre, a theatre where everything would be true."[77]

Conclusion

In 1918 the French poet Guillaume Apollinaire gave a talk at the Theatre du Vieux Colombier in Paris. His subject was "The New Spirit and the Poets."

What distinguishes the new spirit in modern poetry from all previous epochs? Apollinaire asks, and answers that it is the element of surprise. Scientific invention and discovery are forms of progress, he says, but surprise is a form of truth. Poets, too, are inventors and creators, and they are the discoverers of truth, which is always new. Apollinaire compares poetic creation to alchemy: "By lyrical teleologies and archlyrical alchemies, poets will be given the task of purifying the idea of the divine."[78]

By juxtaposing scientific discovery and invention with poetic creation and by describing the poet as a lyrical alchemist, Apollinaire prophetically grasped the essence of what was to develop into a surrealist poetics. Following on the heels of the dadaist *tabula rasa*, the surrealists were to find themselves confronted with the problem of dealing with radically new modern conditions in their art. These conditions, which can be briefly enumerated as the emergence of the theory of the unconscious in psychoanalysis (a new vision of man); the increasing role played by the machine in society (a new mode of interaction between man and his environment); and new developments in science such as the theory of mathematical probability,[79] suddenly demanded not just an adaptation, but a mental transformation—what the critic Michel Carrouges called a "coup d'état of consciousness."[80] In alchemy, which aims at an abrupt transformation on either a material or a spiritual plane, the surrealists found a metaphor for the difficulties they had to grapple with and a model for their poetics.

For the critic, the alchemical metaphor is useful as well, for it permits him or her to see Dada as the necessary stage of dissolution preliminary to the recombination, in Surrealism, of elements into a new vision.

The surrealist enterprise defined itself as the search for a new language that would be in direct communication with the unconscious. It was, in a sense, natural that surrealist artists, writers, and filmmakers would have gravitated toward the myths of rejuvenation of matter and spirit that are associated with the *theatrum chemicum* of alchemy. In doing so, they were merely reaffirming a time-worn truth: no disruption of the existing order is ever total: in breaking with the present, the surrealists allied themselves with the ancient myths of the past.

two

The revolt: breaking the frames

In terms of the alchemical metaphor, the dadaist proclamation and dramatization of the destruction of old values in art and literature can be said to correspond to the stage of *separatio*, when primary matter is first prepared for the stages of the alchemical operation. Surrealism defined itself quite differently; again in terms of the alchemical metaphor, Surrealism can be seen as a search for the recombination of elements culminating in the discovery of truth or what alchemy calls the "philosopher's stone." In alchemy, "base" metals are turned into gold through contact with the philosopher's stone. But alchemy is itself metaphoric: the final transformation is a metaphor for the qualitative leap of insight that is achieved at the end of the arduous and repetitive stages of the alchemist's researches. Fulcanelli is careful to warn the aspiring alchemist not to confuse the alchemist's gold with "l'or vulgaire." Alchemy is a way to self-knowledge, as Jung was later to point out.

This double movement of dissolution and reintegration describes the relation of dadaist and surrealist works to their audiences as well. As phenomena whose relationship to the audience was largely polemical, Dada and Surrealism can be subsumed under two complementary activities: the dislocation of aesthetic norms by the failure to fulfill expectations; and the reintegration of the audience's fractured sensibility into a new aesthetic norm. The first is especially characteristic of Dada, whereas surrealist works are learning devices that provide dislocations and reintegration within the same aesthetic experience.

From the beginning, however, the aesthetic experience of the audience was said to be a rehearsal for real life; the abolition of aesthetic norms stood for the abolition of the constraints of all social norms. Tzara's *1918 Dada Manifesto* states this explicitly:

Abolition of logic, which is the dance of those impotent to create: Dada; of every social hierarchy and equation set up for the sake of values by our valets: Dada . . . abolition of memory: Dada; abolition of archeology: Dada; abolition of prophets: Dada; abolition of the future: Dada; absolute and unquestionable faith in every god that is the immedi-

ate product of spontaneity: Dada . . . Freedom; Dada Dada Dada Dada, a roaring of tense colors, and interlacing of opposites and of all contradictions, grotesques, inconsistencies: LIFE[1]

Breton, on the other hand, proclaimed in his *First Manifesto of Surrealism* of 1924 that "Language has been given to man so that he may make surrealist use of it."[2] In the "surrealist use" of language, "automatic writing" occupied pride of place. This exercise, *de rigueur* for every practicing surrealist, consisted of trying to write with all the constraints of logic removed (some managed to put themselves into a trancelike state to facilitate this goal). The purpose was not to create permanent works of literature, but to reach another cognitive dimension that, once attained, could become the basis for the subject's subsequent perception of reality. Dada as a state of mind, Surrealism as a mode of thought: this was the import of the movements' polemics.

In proposing the aesthetic experience as a rehearsal, the dadaists and surrealists were not radically redefining the function of art; art has traditionally had a didactic and social dimension. Moreover, while the didactic import of works of art is more commonly seen in terms of content, some have studied the way in which form produces learning experiences. Morse Peckham, in *Man's Rage for Chaos*, writes that art is a rehearsal for unpleasant surprises in life—it has a "disorientative function" that trains the individual's adaptive abilities.[3] The Russian formalist Viktor Shklovskij and the Prague structuralist Jan Mukařovský offer full-fledged theories on the way art disorients conventional aesthetic perception: Mukařovský in particular suggests rather tantalizingly that aesthetic cognition provides "a certain direction to our view of reality in general."[4] What was new in Dada and Surrealism was the emphasis: the role of art in actuating the perceiver's cognitive adaptation to reality is seen as its central function.

The literary or art critic is disarmed by this pragmatic function of dadaist and surrealist works, since any attempt to view them as evolutionary developments in a particular tradition is a recuperative gesture the works themselves disallow. For instance, although many of the literary works can be construed to represent "new genres," they are at the same time works that demonstrate the irrelevance of genre classification; their message points outside of literature, whereas genre distinctions are literary. The concept of genre itself must therefore be subsumed under a much larger class of concepts that deals with the organization of experience (including aesthetic experience) in general.

The relationship of genre to the larger question of overall cognitive experience can best be approached by considering a specific moment in the history of Dada, recounted in the diary entry for June 23, 1916, of the poet Hugo Ball:

I have invented a new genre of poems: poems without words or sound poems in which the balance of the vowels is weighted and distributed solely according to the values of the beginning sequence. I gave a reading of the first of these poems this evening. I had made myself a special costume for it. My legs were in a cylinder of shiny blue cardboard, which came up to my hips so that I looked like an obelisk. Over it I wore a huge coat collar cut out of cardboard, scarlet inside and gold outside. It was fastened at the neck in such a way that I could give the impression of winglike movement by raising and lowering my elbows. I also wore a high blue-and-white striped witchdoctor's hat. I could not walk inside the cylinder so I was carried onto the stage in the dark and began slowly and solemnly:

> gadji beri bimba
> glandridi lauli Ionni cadori
> gadjama bim beri glassala
> glandridi glassala tuffm i zimbrabim
> blassa galassasa tuffm i zimbrabim[5]

What Ball has described is an event that took place within the "frame" of a poetry reading. Several of the elements probably did not "match" the audience's concept of such a reading: the non-referential nature of the morphemes; the immobility, indeed invisibility of the poet. Yet in another sense the audience's expectations of a dadaist soirée frame the event; the audience at the Cabaret Voltaire would be entitled to expect "breaks" in the traditional frame. The poem has meaning insofar as we can ascribe an ideological content to its disruptive gesture. From a theoretical standpoint, it is most interesting that despite the breaks in frame the event is still recognizable as a poetry reading. This is assured both by formal elements of the "poem" (repetition of sounds, "weighted" vowels, rhythm), and by pragmatic aspects of the performance (intonation, mise-en-scène). If this were not so, the event would be meaningless.

The concept of "frames" has been explored recently in the fields of sociology and psychology, and provides a model both of the way we store our knowledge and of the way this knowledge is activated when we are confronted with new experiences. The sociologist Erving Goffman defines social frames as "schemata of interpretation" within which experience becomes meaningful.[6] In psychology, the major contributor to frame theory is Marvin Minsky, who is careful to point out the tentative nature of the theory he proposes. Nevertheless, the possibility of using frame theory as a model of aesthetic communication is very attractive indeed.

According to Minsky's view, human beings store in memory organized structures of associated concepts representing stereotyped situations. Working in the field of "artificial intelligence" where problems are habitually

represented in a logical sequence of steps so that they can be computer-tested, Minsky defines a frame as a network of nodes and relations: "The 'top levels' of a frame are fixed, and represent things that are always true of the supposed situation. The lower levels have many *terminals*—'slots' that must be filled by specific instances or data. Each terminal can specify conditions its assignments must meet. . . . Once a frame is proposed to represent a situation, a matching process tries to assign values to the terminals of each frame that are consistent with the markers at each place."[7]

Minsky's theory allows, in addition, the definition of minimal require-ments for the identification of a frame. Once a frame has been proposed, many assumptions can be made about the object or situation based on previous experience. Minsky calls these assumptions "default assignments." It is only when these expectations are violated that a new frame must be sought:

> Much of the phenomenological power of the theory hinges on the inclusion of expectations and other kinds of presumptions. A frame's terminals are normally already filled with "default" assignments. Thus, a frame may contain a great many details whose supposition is not specifically warranted by the situation. . . . The frame systems are linked, in turn, by an information retrieval network. When a proposed frame cannot be made to fit reality—when we cannot find terminal assignments that suitably match its terminal marker conditions—this network provides a replacement frame.[8]

An example of how frames work can be provided very simply by using one of Minsky's favorite examples, a child's birthday party. When a child is invited to a birthday party, he or she is asked to perform a specific cognitive task, within a "birthday party frame." At the top level of the frame are things that are always true: the child can reasonably expect that the party will celebrate the birthday of another child, the child's mother will be present, there will be a birthday cake with candles, and various party games. Beyond that, the child will also have filled in other terminals or "slots" with expectations based on what he or she has been told will happen or on experience from previous birthday parties. Thus, the child might expect the terminal assignments for "food" and "games" to be filled, respectively, by "hot dogs" and "pin-the-tail-on-the-donkey." The failure of the party to live up to these default assignments does not disqualify the birthday party frame but may modify the child's default assignments for a subsequent birthday party. However, if the child arrives at the door only to be told: "April fool, it is not my birthday and mommy is not here," then the frame for "birthday party" will be replaced by 'April fool joke.''

From the above, it should be clear that a frame is not a concept in itself but refers, instead, to the way concepts are organized by convention. Teun

A. van Dijk, who has explored some of the applications of frame theory to discourse analysis, states that "frames define units or chunks of concepts that are not essentially, but *typically,* related."[9] Since conventions play as large a role as the cognitive organization of the human senses in the determination of frames, Minsky's formulation of a frame as "a collection of questions to be asked about a hypothetical situation" is useful.[10] It clarifies, in addition, the relation of frames to large-scale cognitive models, such as scientific world models. As Thomas Kuhn points out in *The Structure of Scientific Revolutions,* a world model functions as a working hypothesis within which scientists attempt to answer questions.[11] To formulate questions that fall outside of the model is to call for the creation of a new frame.

The concept of frames can be extended to literature, where a reader's perception of such frames as theme, genre, and mode will lead to different strategies for understanding the text.[12] In Minsky's terms, "reading" can be defined as an understanding process in which the reader tries to "match" perceived conceptual structures with conceptual frames stored in memory. If no frame to which the conceptual structures can be matched exists in the reader's memory, then he or she will attempt to learn a new frame whose characteristics will be hypothetically deduced from the context of the material being evaluated. Another alternative, of course, is to reject the work altogether, to "close one's mind to it."

Literary and linguistic conventions, when seen as frames, produce "default assignments" that correspond to the conventional expectations of readers once the particular frame has been identified. Works in which these default assignments are consistently violated demand considerable cognitive activity on the part of their perceivers, who will be kept on edge wondering whether to discard the frame initially selected or to make modifications on the old frame.

Consider, for instance, the "story-frame" or narrative. Walter Kintsch has conducted psychological experiments supporting the thesis that story comprehension does indeed conform to the frame hypothesis advanced by Minsky. A person who understands a story does so by filling in the slots in a "story-frame" acquired from reading other stories.[13] Discourse analysis of stories suggests that these "slots" are likely to have to do with continuity of place, time, major characters, and anaphoric reference.[14] Now suppose the educated reader of stories is confronted with a surrealist narrative in which *most* of the slots are filled in ways that are contrary to the reader's expectations, but enough are filled according to expectation that the reader cannot immediately discard the story-frame and search for a new one. With each new sentence, the reader will have to confront the question: does this sentence strengthen the story-frame hypothesis or weaken it? The reader's experience will be an experience of limits, since readers will normally go to

almost any length to make sense. The redoubled cognitive activity of the reader is caused by the fact that the surrealist text pushes against the limits of sense and challenges the reader's store of organized knowledge with a new experience that he or she can only partially account for by his or her existing set of frames. To read a surrealist text is a learning experience, possibly rewarded for those who perservere, with insights that constitute entirely new frames of knowledge. These new frames, in turn, may become ways of organizing lived experience: such is the surrealist practice as envisioned by Breton.

Cognitive theory thus makes it possible to grasp the relation between art and life that lies at the base of dadaist and surrealist practice. Literary theory, although it has dealt with organized structures of conventions, cannot provide this essential link. Among writers, Bertold Brecht comes the closest, perhaps, with his theory of the epic versus the dramatic theatre;[15] among critics, E. D. Hirsch, who argues in *Validity and Interpretation* that the notion of genre points to something more fundamental in the structure of human understanding. Hirsch concludes that the "identity of genre, pre-understanding, and hypothesis suggests that the much advertised cleavage between thinking in the sciences and the humanities does not exist. The hypothetic/deductive process is fundamental to both of them, as it is to all thinking that aspires to knowledge."[16]

The cognitive approach outlined by Minsky has the advantage, however, of providing a model for two distinct dadaist and surrealist activities: frame-*breaking* and frame-*making*. It is important to separate them even if the distinction becomes artificial when both activities are elicited by the same work.

Frame-*breaking* simultaneously calls up associations with the "inter-text" from which the frames were constructed, and makes it possible to evaluate the work against the conventions it violates. This aspect of the work is in dialogue with other works, and the aesthetic experience of the perceiver is enriched by reference to them. In simple terms, frame-breaking refers to the social aspect of frame conventions. On the other hand, frame-*making* is a more specifically cognitive activity, relying upon strategies of understanding that the perceiver has learned through experience. Minsky supposes that the simplest way to construct new frames is to combine two old ones. It seems more plausible to suggest that strategies such as contextualization, ways of dealing with new information, and knowledge of syntactic and semantic patterns—in other words, cognitive strategies which are of a general nature—are activated in the construction of new frames. If this is true it would support the idea that the mental exercise dadaist and surrealist works require of their perceivers is a kind of training.

Literary and artistic works that break conventional frames define themselves against the horizon of expectations entertained by their real or

presumed audiences; the examination of this intended pragmatic interaction between the work and its audience—whether successfully carried out or not—is of prime importance in the consideration of dadaist and surrealist works, whose intent was audience or reader provocation. In his article "Literary History as Provocation of Literary Theory" Hans Robert Jauss sets out seven points which can be expanded to include the media of art and film in addition to literature, in order to provide a guide for the discussion of the frame-breaking nature of dadaist and surrealist works:

1. Literary history should be constructed out of the historical reception of works by the reader, the critic, and the artist.
2. The experience of the reader or audience should be evaluated with reference to the then prevailing "horizon of expectations" which may be established either by evaluating signals in the work itself or by knowledge of the society of the time.
3. By comparing a work with its associated horizon of expectations, one can analyze its aesthetic properties in terms of their effect on a presupposed reader.
4. The reconstruction of the horizon of expectations makes it possible to reconstruct the works' initial effect on their first readers.
5. This last reconstruction allows the works to be integrated into a literary series.
6. The diachronic view of literary history is thus complemented by a synchronic view which makes a transverse "slice" of the historical situation at a given period.
7. The horizon of expectations includes knowledge of the world in addition to knowledge of convention; the reader's experience of new horizons in his aesthetic reception conditions his subsequent way of relating to experience in the world. Literature should thus be viewed as a problem-solving activity.[17]

The first two points are especially interesting, since they establish several levels at which an aesthetic of reception must proceed. According to the first point, "frame-breaking" can be analyzed in terms of the expectations of the reader (the "public"), the critic (the representative of the public who responds by writing), and the artist (a reader who responds by creating works of his or her own). It is easy to see that the cognitive act is different in each case, and that the "frames" would not be quite the same for an artist who considered himself or herself a part of Dada, a critic standing outside of the group, and a member of the public attending his or her first dadaist event.

The second point is complicated by the fact that expectations established by the work itself may come through overt statements in the work, or covert strategies of reception that are induced in the reader by the structure of the

work ("gelenkte Wahrnehmung"). Expectations established through knowledge of society include known norms (such as genres), implicit relations to other works of the literary environment, and knowledge of the world, including knowledge of the relation between fiction and reality.[18]

The latter point is also of considerable importance in the theory of the reception of dadaist and surrealist works. Jauss' vision of a link between work and world is in agreement with cognitive "frame theory." His emphasis on the way literature changes the reader's perception of reality through formal devices rather than influencing his or her behavior through a message conveyed in the content is also significant. For, although artistic works have historically influenced behavior by offering moral lessons, the injunction implicit in dadaist and surrealist works is addressed to the audience's structure of thought (including the perceived relation between language and reality) rather than to the modelling of behavior.

Formally, the challenge to structures of thought was posed by dadaist and surrealist works as breaks in the frame defining the pragmatic function of art: its relation to the world. Art, as Tristan Tzara claimed so succinctly, was to break the boundaries traditionally assigned to it and spill over into "life." This challenge to the context within which art works were to be apprehended by the public was expressed at once in terms of overt statements in the works themselves, in the way that these works distinguished themselves structurally and linguistically from other works in the same artistic environment, and in the newly postulated relation between the work and reality. Each of these methods brought about different types of frame-breaking.

Frame-breaking as structural dislocation

One type of frame-breaking is "structural dislocation." Here the work undermines the genre within which it simultaneously inscribes itself, so that the perceiver is kept in an unrelenting state of tension—unable to reject the frame of the genre appearing to govern the rules for reading the work, while continually tempted to do so. By pushing against the limits of their genres, these works also push against the limits of sense. The simplest illustration is the anti-narrative, of which there are examples in Dada and Surrealism in both literature and film.

A dadaist example is Melchior Vischer's *Sekunde durch Hirn* (loosely translated "The Brain-Splitting Second"), subtitled: "an uncannily quick rotating novel."[19] The opening is almost ordinary:

> Jorg Shoe straddled the scaffolding, laughed together with the shrill tone of the burin, chewed his bread and knew that he stucco-worker. The wind was bitter in this bird-perspective. With one eye ornamenting toward the ledge and the other on the pavement blinding down forty stories on

sun-spotted asphalt which screamed up glaringly. Even though street-scurrying plebes pullulated very tiny underneath, he still saw the big bust of Hanne the maid in skyscraper number 69 next door.

The bust, the big bust is splendidly sculptured as though formed by a stucco-worker: ecstatic sentence tore itself out of Jorg's admiring throat surmounted by lewd goggle-eyes which somersaulted, plank see-sawed, head, feet interwove waveringly, *wind whistled.*(34)

What frame is the reader likely to call up in order to deal with this piece of writing? So far it seems to be a narrative. The reader has been provided with a setting in time and place, a principal character, an event. But the careful reader will already be alert to the fact that this conventional frame is likely to be broken. The signals for this alert come in the story itself, in the multiple semantic and syntactic violations occurring in this short passage: nouns used in predicate positions ("he stucco-worker"); verbs matched to the wrong nouns ("eyes ornamenting"; "asphalt screamed"). The reader has already been prepared for this, however, by the "Pro- and Epilogue" which calls the novel an "epic," a "lung-bleeding dream," a "mardi gras play," an "ash Wednesday with sunflowers," a "bible," and an "astronomical connect-the-dots book." This introduction suggests another frame for the reading, placing the work in the context of dadaist revolt where breaks in conventional frames are expected.

After he loses his balance on the scaffolding the hero goes through a series of picaresque-like adventures beginning with the witnessing of his own conception in a bordello scene. In narrative time, his adventures only last the one second they flash through his brain before he hits the pavement and cracks his head open. But in that second he visits over a dozen countries, travels in time as well as in outer space, and rivals Casanova in sexual accomplishments. The following is an excerpt from his trip to the moon:

When he ran in the form of a rat through dirty street of Peking, despite which everyone acclaimed him as a god, he stank himself out, vanished, sneaked out through ether into outer space, breathed in relief in the free air current, then no more, murmuring Jorg! Jorg! was suddenly flying faster, skidded onto barren land which glimmered magically like Castan's panopticon: the Moon.

He was just feeling around with his hands when a man sailed out of a crater bowing profusely and presented himself in a Greek accent as Pythagoras. Jorg hardly recognized him, for this charming pile of cells, once so famous in mathematics in his mother planet down there, now looked incredibly mixed up. His nose was at the back of his head, his mouth protruded in the angle of his leg like a female pudendum.(59)

Pythagoras' logic is similarly twisted: "A question dear Pythagoras: do you think that one might succeed in establishing here on the moonscape a

factory for support hose?"—"That would be very impractical from the point of view of nonexistent beings and especially for moon-bacteria. Because of their mutual attraction"(60).

Sekunde durch Hirn is a narrative posed near the limits of narration. The absence of the kind of reassuring redundancy one finds in a realist novel makes this a purer form of narrative, one where we are more likely to discover the minimal conditions for the establishment of the narrative frame in the reader's mind. In *Sekunde durch Hirn*, the narrative is established by conventional elements. There is consistency of character: Jorg is the main character throughout. He displays qualities of selfishness, lust, and a tendency to flee when faced with a difficult situation. The narrative time is linear, developing along the sequence of his birth, growth, travels and death (which links up to the opening section of the novel when he falls off the scaffolding). Semantic consistency is observed, to some extent, in the descriptions: in the moon passage one predictably finds craters, in Alaska igloos and Eskimoes. Finally, there is a fairly consistent narrator who speaks in the same tone and register.

These consistencies, however, are minimal. Jorg changes form, becomes a rat, flies through the air; he goes from place to place instantaneously; and each semantic universe contains some surprises (the presence of Pythagoras on the moon; the existence of moon-bacteria in the passage just quoted). Although most of these elements might be accomodated under the frame of fantastic narrative, there are other aspects of the work which contradict this hypothesis. The narrator punctuates the story with references to Dada ("Melchior Vischer's dada-games are the cheapest around today;" "here I am, Da Da;" "Haha, dada, allelujah") and to other members of the Dada movement such as Tzara and Kurt Schwitters. Semantic violations continue to interrupt the narrative ("an airplane, mated by a French victory officer, raped air" (75); "The rapidities of electricities are not beechwood either" (65). And there is no attempt at logical consistency: Pythagoras objects to Jorg's plan for a support-hose factory because it would clash with "nonexistent beings."

The breaks in frame constitute the essential message of *Sekunde durch Hirn*. Linguistic trangressions and trangressions of literary conventions and expectations are evidence of a dadaist ideology of protest and socio-cultural critique. Vischer's ideological message becomes clear as Jorg's brain splits open to reveal the collective prejudices of his time and ours: racism, anti-semitism, anti-feminism, to name a few. In one sense, Jorg's death symbolizes the death of conventionalized thought. But Jorg is also a dadaist hero whose death is an apotheosis of liberation. As the atoms of his brain are freed to the cosmos, all the languages he knows are reduced to primeval language: "We break, break, and dada from the ground up, first smoothly lacquered language, so that nothing remains other than one great DADA'

(76). The endless sexual quest with which Jorg's fall is dramatized is a symbol of his transformation.

Sekunde durch Hirn stands as an exemplary work of Dada, for in it formal experimentation serves an ideological function: the structural dislocations of the narrative frame are calculated to make the reader question his or her own structures of thought. Making fun of readers who expect a narrative, Vischer provides a mock-conclusion for "sentimental people with sighing deeply-moved cinema souls who want endings" (79). A comparison is even made between Jorg's death and the death of Büchner's Woyzeck, supplying a mock-intertextual dimension; the careful reader will also have been aware of the egg motif that supplies a thematic connection between several of the episodes and the final cracking open of Jorg's brain. These elements do much to strengthen the narrative frame; but the reader who remains sensitive to the frame-breaking aspects of the text will ultimately find them outweighed by the anti-narrative.

Luis Buñuel's and Salvador Dali's surrealist film *Un chien andalou* offers another good example of structural dislocations that break the audience's perceptual and cognitive frames. Like Vischer, Buñuel defined his aesthetic against a prevailing norm, in this case the avant-garde film. Historically, this film represents a violent reaction against what was at that time called "avant-garde ciné," directed exclusively to the artistic sensibility and to the reason of the spectator with its play of light and shadow, its photographic effects, and its preoccupations with rhythmic montage and technical research.[20]

The avant-garde film that Buñuel criticized was characterized by a belabored visual style that took much of its inspiration from the art movements of Futurism, Expressionism, Impressionism, and Dada. The futurists had been the first to explore the relation between film and art, since film combined two of the elements they prized most highly; motion and machinery. The futurist cinema manifesto of 1916 denounces the written word and proposes in its place a kind of "pure cinema" liberated from all the constraints of traditional literary norms, and from reality. The free cinema of futurists was to be "painting, architecture, sculpture, words-in-freedom, music of colors, lines and forms, a jumble of objects and reality thrown together at random."[21] The futurist cinematic projects were for the most part never carried out, but some of the effects they recommended became staples of the French avant-garde film and of dadaist films:

Cinematic analogies that use reality directly as one of the two elements of the analogy: Germaine Dulac's *La Souriante Madame Beudet* (1922) juxtaposes shots of her heroine with shots of a prison, a school and a court building in order to express her sense of being trapped by her social situation.

Cinematic poems: Man Ray's *L'Etoile de mer* (1928), based on poetic images supplied by Robert Desnos, translates linguistic similarities ("Cybèle.

Si belle?") into visual similarities (a starfish filmed through a glass jar; a woman filmed through a distorted lens).

Cinematic simultaneity and interpenetration of different times and places: René Clair's dadaist film *Entr'acte* (1924) interrupts the temporal succession of the narration with shots from preceding segments; Abel Gance fragmented the sceen into multiple images in *Napoléon* (1925–27).

Cinematic musical researches: Fernand Léger's *Ballet mécanique* (1924) was constructed according to strict rhythmic rules and was accompanied by music by Georges Antheil.

Dramatized states of mind on film: Gance's *La Roue* (1921–1924) shows the growing alarm of train passengers on a runaway train by a mounting rhythm of cross-cutting between them and the train.

The liberation from mere photographed logic: Man Ray's dadaist film *Retour à la raison* (1924) is in fact a plea for the "reason of unreason": the film is a collage that combines rayographs (images made by exposing objects directly to photographic paper), play of light and shadow, and an animated version of Ray's painting, "Dancer/Danger."

Filmed dramas of objects: Hans Richter's dadaist film *Ghosts Before Breakfast* (1927–1928) shows the revolt of several objects against their "masters."

Filmed unreal reconstructions of the human body: Léger's *Ballet mécanique* opens with a shuffling of segments of a Charlie Chaplin puppet; Clair's *Entr'acte* superimposes a man's head on a ballerina's body.

Filmed dramas of disproportion: In Antonin Artaud's *The Sea Shell and the Clergyman* (1928), the clergyman's frock lengthens until it becomes a long train; a woman's tongue becomes a rope.

Filmed feelings: Germaine Dulac proposed a cinema of feelings, in which the narrative is a subordinate element: "To be visual, to reach the feelings through harmonies, chords, of shadow, of light, of rhythm, of movement, of facial expressions, is to address oneself to the feelings and to the intelligence by means of the eye."[22]

Filmed words-in-freedom: Marcel Duchamp's *Anemic cinema* (1926) combines words on rotating disks.

By the time Buñuel and Dali made *Un chien andalou* in 1928, many of these inventions had already become mannerisms. The critic Jacques Brunius lists several "avant-garde" techniques of the time (quick cutting, superimpositions, photographic distortions, soft focus, and gauze) with mounting irritation, observing that "it was soon impossible for one actor to look at another . . . without seeing his face transformed into a crescent moon."[23]

Un chien andalou reacts against this foregrounding of visual technique in preferring the straight cut and a minimum of image distortion; at the same time, the visual image remains foregrounded in relation to the narrative which is continually undercut by structural dislocations.

The narrative frame of *Un chien andalou* is its most important structural

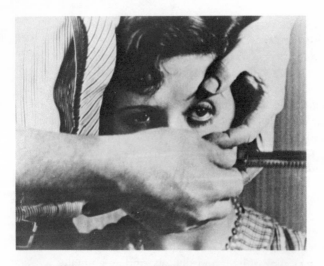

24, 25. Prologue / Luis Buñuel
and Salvador Dali, *Un chien
andalou*

element, even though the film does not observe consistency of narrative
time, place, character, or semantic universe. Objects do not have fixed
locations within an imaginary "diegetic" or narrative space constructed by
the viewer; instead, they seem to determine the progress of the discourse,
turning up in each of the successive diegetic spaces established by the
camera-narrator. Yet without this narrative frame, *Un chien andalou* would
be just another of the avant-garde films that Buñuel deplored. The film's
thrust is to frustrate the narrative expectations of the viewer and maintain
him or her in that state of tension that characterizes the surrealist aesthetic
experience. This can best be shown in a step-by-step analysis of the
"frame-breaking" aspects of the film.[24]

6. Androgyne in superimposition /
Luis Buñuel and Salvador Dali,
Un chien andalou

Un chien andalou opens with a "prologue" titled "once upon a time." This conventional narrative opening is undermined, however, by the content of the prologue, containing the famous slicing of an eye by a razor (plates 24–25). The next title announces the narrative time "eight years later."

The central male character now appears, a cyclist dressed in feminine clothes and wearing a striped box around his neck. He is so insubstantial that the camera films through him (plate 26); at one point he even appears as two figures on the screen, in the background as well as the foreground. When he falls in the street, a young woman comes running down from an upstairs apartment. Then by means of a close-up shot on the striped box, a spatial transition is made to the apartment, where she spreads the man's clothes out on the bed (including a striped tie in striped paper that she takes out of the box). For a while she stares fixedly at the bed "in the attitude of someone holding a wake for the dead." Then she turns around and perceives the same young man, now dressed in a conventional suit, staring at a hole in his hand infested by ants.

Transition is made to the street outside, by means of four graphically similar shots that are juxtaposed: the round swarm of ants in the man's hand, a sea urchin, a woman's underarm hair, and a "swarm" of people forming a circle around a second young woman in the street (plates 27–30). This woman is playing with a truncated hand lying in the street by poking it with the end of her stick. A policeman puts the hand into the familiar striped box and gives it to her. Clutching the box, she is run over by a car as the first couple watch from the upstairs apartment.

This last event seems to change the attitude of the couple in the apartment. The man tries to attack the woman sexually, using first force and then persuasion. He picks up two cords and moves toward the woman. The cords

27–30. Graphic matching / Luis Buñuel and Salvador Dali, *Un chien andalou*

are soon shown to be attached to two corks, two priests, and two animal carcasses that are lying on grand pianos (plate 31). The woman runs out of the room, only to find herself in an identical room, and the clothes laid carefully on the bed have become filled by the body of the cyclist (plate 32).

The next title proclaims that it is "around three in the morning." An older "friend" comes to wake the cyclist, and divests him of the female garb until he is once more clad in a suit. As the "friend" turns away, he becomes a "younger self" of the cyclist. A title informs us this is happening some "sixteen years before." The "younger self" hands two schoolbooks to the cyclist and turns to go. The books become pistols in the cyclist's hands and he shoots down his "younger self."

As the murdered young man falls down, he falls against the bare back of a woman in a meadow. Passers-by come and carry him off. A straight cut makes the transition back to the room, where the young woman is looking in vain for the cyclist. Intermediary shots of a death's head moth displayed on the wall make the transition to the young man who has reappeared in the

31. The love-offering / Luis Buñuel and Salvador Dali, *Un chien andalou*

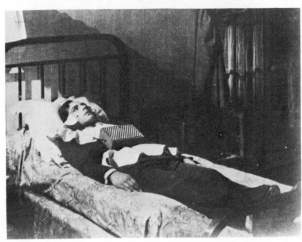

32. Androgyne with the striped box, generative mechanism of the narrative / Luis Buñuel and Salvador Dali, *Un chien andalou*

room. Again their relationship is one of confrontation; the young woman runs out a door that this time opens onto a beach. She waves to a third person and goes off with him. Waves wash the striped box and feminine clothes of the cyclist to shore. The final title proclaims that it is "in the spring;" the man and woman are up to their chests in sand, blinded, and covered by insects.

The continual dislocation of narrative time, space and character make it impossible for a spectator of this film to experience the identification with a character and situation that occurs in the aesthetic reception of narrative films. Even the room where much of the action takes place is filmed so as to produce this disorientation. As the woman gets up to go to the window in the first segment ("eight years later") the camera moves more than 180° so that door A appears to be door B (see the floor plan) by occupying a similar

space in the background of the shot. The woman leaves through door B; a "match on action" shows her going through some double doors that lead to stairs. The result is that the viewer constructs a diegetic space in which door B leads to the double doors. This spatial information is later contradicted when the woman goes out door A to the double doors (in the segment titled "around three o'clock in the morning"). The viewer's revised frame for the diegetic space is contradicted once again when door B opens onto the beach in the segment "sixteen years before." Even more problematic is the moment when the woman escapes through door A and closes it on her pursuer's hand; the doorknob is on the wrong side of the door! In actuality, this matching shot is photographed from door B; both views are from *inside* the same room. This explains why the woman can appear to leave and enter a room exactly like the one she has left (plates 33 and 34; camera 1 and camera 2 on the floor plan).

In the prologue segment, a man seen stropping a razor steps from his room onto a balcony. He looks up and a shot of the moon is shown in a point-of-view eyeline match; yet there is no assurance that this is not a false match.[25] A subsequent shot in this same segment of a man preparing to cut the eye of a woman is not in the same diegetic space: the second figure is wearing a striped tie, whereas the first figure was not. When the eye of an animal is cut instead of the woman's eye, we have moved to the third or fourth diegetic space.

Because the possibility of narrative is continually held out despite the

33, 34. False match / Luis Buñuel and Salvador Dali, *Un chien andalou*

structural dislocation, the spectator is forced to continue to look for meaning; the nature of the discourse itself becomes the object of examination as the viewer tries to "make sense" out of the flow of images. Buñuel has disclaimed any "meaning" in the film's progression, stating that the work is supposed to reproduce the effects of the "psychic automatism" Breton defined as the essence of the surrealist mode of thought. "Nothing, in the film, symbolizes anything," he wrote, "the only method of investigation of the symbols would be, perhaps, psychoanalysis."[26]

It would appear that psychoanalytic concepts can offer some insights into the effects the structural dislocations of the film exert upon the spectator. The continual breaks in the narrative frame have to be compensated by the spectator's efforts at understanding. This demands a shift in cognitive strategies used by the perceivers. The constructive or "frame-making" aspect would seem to yield to a psychoanalytic approach that would study the film's mechanisms through the unconscious processes of displacement, condensation, figurative representation, and symbolization.[27] Of these, the last would seem to be the least fruitful (and the one emphatically discounted by Buñuel): the idea that the film is an encyclopedia of sexual symbols: female (the eye, the box, mouths, orifices, circles of all sorts) and male (the razor, hands, the necktie, the revolvers); sexual activity (being run over, bike riding). More telling is the fact that the film operates through an associative principle that makes manifest a series of displacements (changing identities, places, times) and condensations (metaphoric semantic clusters such as the graphic matches, plates 27–30, or the combination of corks, priests, pianos and donkeys, plate 31; metonymic clusters such as the striped tie in a striped box wrapped in striped paper). These frame-making elements of the film will be discussed in chapter three.

The effect of *condensation* in this film is to give primacy to the image over the narrative progression, so that the spectator is held in fascination by the

cinema as visual spectacle. The fact that he or she is not permitted to get involved with the "story" heightens this effect. *Un chien andalou* thus makes the spectator re-experience the pure delight in seeing which characterizes the authentic surrealist relationship to film. Breton has described this special relationship in his essay "Comme dans un bois" ("As in a Wood"). According to this account, Breton and his friend Jacques Vaché used to spend their Sunday afternoons going from one theatre to another in the city of Nantes without ever seeing a film from beginning to end. In order to further subtract their involvement in the film's narration, they would eat, drink, and hold conversations throughout. What fascinated them was the "nighttime" atmosphere of the theatre in which the spectator, before the moment of his involvement with the fiction, passes through a state of unconscious receptivity that corresponds to the priviledged state of surrealist consciousness: between the moment he sits down until the moment of involving himself in the fiction unwinding before his eyes, the spectator passes through a critical point as captivating and as elusive as that which unites wakefulness to sleep.[28]

In *Un chien andalou*, the foregrounding of the screen image creates the experience of "de-familiarization" (*dépaysement*) which, for Breton, constituted the supreme surrealist experience of cinema. For conventional films, this de-familiarization had to be artificially induced by retaining a conscious distance from the narrative ("the willful creation of the greatest possible discordance between the 'lesson' which the film pretends to teach and the attitude of the receptor"[29]). *Un chien andalou* induces the experience of de-familiarization by its internal structural dislocations.

The process of *displacement* is linked by Freud to the censorship of the unconscious. The substitutions of identity, place, and time effected by displacement in *Un chien andalou* seem especially significant in view of Buñuel's later work (for instance the elusive female with multiple identities in *Cet obscur object du désir*). The refusal of the film to fit into a narrative frame is a formal device mirroring insatiate sexual desire.

Much of Buñuel's career has been spent in criticizing the frames of our romantic expectations. In this way *Un chien andalou* plays against not only aesthetic expectations of form, but frames of social interaction, thus crossing over from art into life according to the accepted canon of Surrealism. Perhaps for this reason Buñuel described his film as a "passionate appeal to murder."[30]

Frame-breaking as foreground shift

If a work of art is viewed as a system whose parts are at once internally related within the system of the work and externally related to their corresponding parts in other works, then it becomes possible to define

changes in the relative importance of some parts to other parts. Since the evaluation of what is most important ("foregrounded") in a work is based on the perception of the audience, this change has to do with the covert signals of the text—the way it speaks to the cognitive strategies of the reader or perceiver (Jauss' "gelenkte Wahrnehmung"). Breaks in frame involving a change in foregrounding have to do with the cognitive organization of works; however, in cases where the foregrounded element is a part of the "real world" the break in frame mediates between work and world as well.

The concept of a shift in foregrounding originates in Russian formalism with the idea of a shift in the function of an element within the overall aesthetic system of a text. In the evolution of literary forms, functional shifts provide techniques for de-automatizing the perceptions of readers.[31] In Dada and Surrealism, the shift most frequently used to jolt the audience out of passivity was the foregrounding of the materials of the medium.

In literature, the dadaist experiments with typography shifted the perceptual activity of the reader from the message onto the medium; it is not surprising to find examples in Tzara's manifestoes. Later surrealist experiments focused more on the sound associations of words; Robert Desnos generated a poem out of the sound associations of Marcel Duchamp's pseudonym "Rrose Sélavy" (a sound deformation of "Rose, c'est la vie") while Michel Leiris built up an imaginary dictionary out of sound play ("révolution: solution de tout rêve").[32]

In film, Jean Goudal noted in 1925 the foregrounding of technique in avant-garde film and predicted a subsequent stage: "The artists will repel the last support of technique and will demand the right to present, without any sort of constraint, the very *material* which is at the basis of their art."[33]

This prediction had already been realized in 1921, when Hans Richter produced his dadaist film *Rhythm* 21. In his desire to reduce his art to essentials, Richter had hit upon the idea of using the screen itself as the basic compositional element in his film: "In the square I had a simple form which established by its nature a 'rapport' with the square of the movie screen. I made my paper squares grow and disappear, jump and slide in well-controlled tempo in a planned rhythm."[34]

The spectator of Richter's film is made to question the illusion of foreground and background in film, since the relationships between the shapes are continually changing. The film breaks the frame of visual illusion by undercutting the viewer's traditional orientation toward the screen image, usually stabilized by the presentation of visual information from a coherent perspective. Richter's use of "negative" images as "positives" in this film goes one step further in foregrounding the process of photograph developing and drawing attention to the celluloid material itself.

All these are ways of "frame-breaking" that remain within the parameters of the work.

Frame-breaking as decontextualization

The "ready-made" and the "surrealist object" interrogate the relationship between the work and the world. Marcel Duchamp's "Fountain" decontextualizes the material of art in that an everyday object (in this case, a urinal) is invested with an aesthetic function by virtue of being chosen and named by the artist. The ready-made defines itself as an act of apperception which anyone is free to exercise, that sharpens the dadaist state of mind.[35]

Max Ernst used the collage method to question existing cultural artifacts and linguistic clichés by lifting them out of their context. Ernst's "The Hat Makes the Man" (1920) transforms a proverb that has special resonance in German literature through Gottfried Keller's nineteenth-century tale *Kleider Machen Leute* ("clothes make the man"). Ernst translates this into visual pun: a series of illustrations of men's hats from a catalogue is arranged so as to form manly silhouettes (plate 35). The accompanying text is decidedly tongue-in-cheek: The "stapelmensch" is a "man made out of a stack" (of hats) but also a "strutting man" (from German *stapeln*) as the figure on the right demonstrates.

He is laid out on the page like a diagrammed leaf with his "venations" (*Nervatur*), showing him to be not only "fittingly dressed" (*kleidsam*) but also "fittingly covered" (*bedecktsam*) and "fittingly naked" (*nacktsam*). As the hats are joined together with watercolors, his outline is "watershaped" (*wasserformer*); like the hats themselves, he is also "nobly-shaped" (*edelformer*). In French, the text concludes that the hat makes the man ("le chapeau ça fait l'homme") and "le style c'est le tailleur." This is a double pun: Ernst's collage and paint (his style) have created the man's suit (*tailleur*); but "the style is in the tailor" is another possible translation of this line. Thus Ernst questions not only received notions of masculinity but also artistic convention by decontextualizing the elements of his collage.

Frame-breaking as linguistic dissociation

For Antonin Artaud, the problem of modern man was the problem of language. A recurrent theme in his writings is the bankruptcy of verbal langauge and written literature: "All writing is garbage (The 'Nerve Meter').
. . . Written poetry is valuable once, and after that it should be destroyed ('An End to Masterpieces'). . . . For me clear ideas, in the theatre as in everything else, are dead and finished ('Mise en Scène and Metaphysics'). . . . our purely verbal theatre which is ignorant of everything that constitutes theatre ('On the Balinese Theatre'). . . . To give predominance on stage to spoken language or verbal expression . . . is to turn one's back on the physical necessities of the stage and to reject its possibilities ('Oriental Theatre and Western Theatre')."[36]

35. C'est le chapeau qui fait l'homme ("The hat makes the man") / Max Ernst, 1920

In the third issue of *La Révolution surréaliste,* Artaud, who had become director of the Bureau for Surrealist Research, published the first account of the Bureau's activities, proclaiming: "I write this only for aphasics and for all those for whom words have fallen into discredit."[37] Aside from Breton, Artaud was perhaps the most brilliant theorist among the surrealists, for he realized that if rationality were to be attacked, the attack must be led against language itself. In the theatre, he proposed to break down language, giving to words only "the importance they have in dreams."[38]

The "alchemical theatre" Artaud proposed was to break the spectator's frames—expectations of language as well as those generated by the dramatic genre. Because the spectator was to be forced into awareness, Artaud called this a "theatre of cruelty":

> I use the word cruelty in the sense of an appetite for life, or cosmic rigor and implacable necessity, in the gnostic sense of a whirlwind of life which devours the darkness, in the sense of the pain without whose ineluctable necessity there would be no life . . . effort is cruelty, existence by effort is cruelty . . . everything which acts is cruelty. It is through this idea of action pushed to the limits, to extremes, that the theatre must renew itself.[39]

Artaud envisioned the creation of a new language that would take form onstage during the performance, and in which words would play a very minor part. Instead, he proposed a "spatial language, a language of sounds, shouts, lights, onomatopoeias" in which words would be retained only for the incantatory quality of their intonations.[40] The result of this violent

56

attack on the spectator's frames was to be "a bloody spurt of images in the head of the poet as well as the spectator."[41]

Le Jet de sang ("The Spurt of Blood"), a short dramatic piece first published as part of *L'Ombilic des limbes* in 1925, illustrates many of these points both thematically and formally. The dissociation of language is conveyed by the failure of the sketch to create any recognizable plot or even dramatic tension: although the characters try to make up for their failure to communicate by assuming positions of physical proximity, screaming at one another and shouting obscenities as a shortcut to communication, the chasm is unbridgeable. In the opening scene, two young people attempting to declare their love in so many words are interrupted by a stream of objects from the sky:

> A silence. There is heard the sound of a huge wheel turning and making a wind. A hurricane divides them in two.
> Then one sees two stars collide and a series of legs of living flesh falling together with feet, hands, heads or hair, masks, colonnades, porticoes, temples, and alembics which fall, but more and more slowly, as if they were falling in space, then three scorpions one after the other, and finally a frog, and a scarab which lands with exasperating, nauseating slowness.[42]

Later in the play, from the same source (the heavens) an enormous hand (of God) reaches down, and is bitten by one of the characters. The action sends a spurt of blood all over the stage, thereby equating the objects enumerated above with the "jet de sang" of the title. Clearly, these are the images Artaud is alluding to in *The Theater and Its Double*: the rain of incongruous and obscene objects is from God ("Heaven has gone mad!" the young man screams) whose beginning was the Word. Dismemberment and randomness (the hurricane and the wheel) have replaced ordered creation, a chaos that denotes the radical dissociation of language. Mirroring this disjunction, the coupling of the characters in this play is not procreative but cannibalistic and terrifying: a knight attacks the breasts of a wet nurse shouting "Give me my gruyère" (Swiss cheese). The young man previously mentioned, distracted by the death of his bride (who is also said to be his sister), begs the attacking knight not to hurt Mama, whereupon the wet nurse lifts her skirts to show scorpions swarming in her vagina. The image of sexual disorder complements the disorder of representation.

In a later short dramatic sketch, *The Philosopher's Stone* (1931), Artaud links the procreative act, after the dismemberment of the central male character, to alchemy. If any alchemical metaphor can be said to permeate *Le Jet de sang*, it is that of *separatio*, unredeemed by any subsequent constructive stages (such as those found in *The Sea Shell and the Clergyman*). *Le Jet de sang* stems from an earlier moment in Artaud's career when the possibility of recombination was not yet clear to him. That he did

eventually envision the creation of a new language is evident from later writings in *The Theater and its Double*, where the theatre of cruelty is equated with the production of images from the liberated unconscious:

> I want to substitute for articulated language a language of a different nature, whose expressive possibilities will be equivalent to the language of words, but whose source comes from a point further back in thought and less accessible.
>
> The grammar of this new language is yet to be found . . . it comes from the necessity of the word rather than from the word already formed . . . it poetically reenacts the process which gave rise to the creation of language.[43]

By situating the new language of images in the deeper recesses of thought and equating its processes to those of language creation itself, Artaud intuitively arrived at a theory of language that has received widespread acceptance today; namely, that metaphoric processes are frame-making processes fundamental to language learning and language creation. Rather than being merely destructive in its emphasis, his theory envisages, rather, the moment when the spectator, radically disoriented by the "dissonances" of the sensory stimuli, will be forced into a new awareness by the integration of those stimuli into a new language "frame": the overlapping of images and movements will lead, by the collision of objects, silences, shouts and rhythms, to the creation of a veritable physical language based on signs rather than words.[44]

Conclusion

The frame-breaking mechanisms of dadaist and surrealist works underscore their dialogical form, according to which they simultaneously restate and question the frame expectations their readers or viewers brought to them. Although this may be true in some sense for all works of art, the aesthetic experience called forth by dadaist and surrealist works operates within a more radical disjunction: it aims at the ultimate destruction of the frame itself, transforming the perceiver's initial recuperative gesture into one of creative frame-making (through the creation of new genres, through metaphor, and through different modes of topicalization that will be discussed in chapters three and four). Ultimately, the dialogical form of the relation between the work and the recipient extends beyond the work itself into the world. The incessant questioning that dadaist and surrealist works demand of their perceivers constitutes an injunction to them to alter their perception of reality.

three

The language: frame-making

The alchemist's breaking down of raw materials was dictated by his ulterior goal of recombining them into forms that were new: if matter could be disciplined and taught, there was no reason it should not learn the ultimate transformation (that is, if the teacher were good enough). Metaphorically at least, these successive transformations of matter might be likened to the creation of new forms in dadaist and surrealist works. The metaphor applies to the reader or perceiver as well: if the subject could be taught to construct new frames, this activity might carry over into life and lead to an alteration in his or her perception of reality. The radical nature of this alteration makes it equivalent to the transformation of common metals into gold.

In frame theory, the reading or perception of a work is viewed as an inductive process in which the reader/perceiver tries to "match" perceived conceptual structures with conceptual frames stored in memory. In the matching process he or she employs a "search" technique, calling up one frame after another until a match is made. If no frame to which the conceptual structure can be matched exists in memory, then he or she will attempt to learn a new frame whose characteristics will be hypothetically deduced from the context of the material being evaluated. This frame-*making* operation is the focus of the present chapter.

The most coherent model of frame-making is provided by Teun A. van Dijk's theory of macro-structures. According to this theory, supported by research in human memory and recall, frames are derived by processes of reduction that are both selective and integrative. In the process of *selection*, readers delete "accidental" information (information not useful for the building of a frame) and "constitutional" information (information useful for frame-building but that may be discarded after it has served its purpose). In the process of *integration*, the reader makes generalizations from accrued information and combines these generalizations into hierarchies that define the overall structure of the information.[1] Frame-making is a process that builds from the bottom, combining perceived units of information from smaller frames (sub-frames) into larger ones. A typical hierarchy, enumerated from the bottom up, might be: sentence, topic, theme, genre. To each of these elements in the hierarchy there is a corresponding frame; in relation to the higher frame, each lower unit is a sub-frame.

The reading process functions in reverse: first the most general kinds of frames are postulated, and sub-frames are filled by default assignments; if the actual information of the texts contradicts the default assignments to the extent that the frame must be rejected, the reader begins from the bottom, building a new frame through the hierarchical ordering of information described above.

In Jauss' terms, frame-making would correspond to the "fusion of horizons" adopted from the author of *Truth and Method*, philosopher Hans Georg Gadamer. Gadamer's definition of "understanding" involves a dialectic of question and answer: "The voice that speaks to us from the past—be it text, work, trace—itself poses a question and places our meaning in openness. In order to answer this question, we, of whom the question is asked, must ourselves begin to ask questions. We must attempt to reconstruct the question to which the transmitted text is the answer."[2]

Gadamer goes on to say that the question cannot be reconstructed without reconstructing the historical horizon. But in fact the reconstructed horizon will not be the original one: the historical horizon outlined in the reconstruction is not a truly comprehensive one. It is, rather, included within the horizon that embraces us.[3]

In the process of understanding, a fusion of horizons—between the original question to which the text provided the answer, and the present question the readers address to the text—takes place. The fact that the reader brings extra-literary as well as literary expectations to the text assures that his or her understanding will result in added knowledge, both literary and of the world.

This definition of "understanding" as a construction of the question to be asked of a specific text corresponds rather well to Minsky's definition of a frame as a "collection of questions to be asked about a hypothetical situation." It is a virtue of Jauss' reading of Gadamer to have acknowledged the creative and constructive possibilities of the fusion of horizons that allows not only the violation of fulfillment of norms, but also the construction of norms through literary experience."[4]

Dadaist and surrealist works elicit several types of frame-making on the part of their readers or perceivers: the creation of new genres; topicalization (learning new patterns for identifying the topic of the discourse); and recontextualization (learning to deal with new contexts).

Frame-making as the creation of new genres

In many dadaist and surrealist works, structural dislocations are complemented by another aspect: the arrangement of elements into a new structure. The result is the creation of a new genre; since a genre is a type of frame, the creation of a new genre is a kind of frame-making.

Within frame theory, a genre is defined as a set of procedures to be applied to the work in a problem-solving process that will generate the intended meaning. Reading and perceiving are conceived as procedural activities; the procedural definition of understanding results in a fundamental difference between the frame theory of genre and conventional genre theory that defines genre as a set of characteristics inherent in the work itself.[5]

The effect of new genres is to force the reader or perceiver to modify his or her cognitive strategies of perception. In addition, new genres may cause the reader/perceiver to redefine the relation between work and world, particularly if the new structure incorporates from the world material hitherto not acceptable for works of art.

André Breton's *Nadja* is a work that at the outset seems somewhat baffling to readers.[6] In itself, it creates a new genre whose outlines need to be deductively ascertained. *Nadja* also redefines the relation between fiction and reality; indeed, Breton's avowed purpose is to make writing closer to life ("Life is other than what one writes," 71) and to write a book that will offer a transparent view of the author: "I insist on knowing the names, on being interested only in books left ajar, like doors . . . I myself shall continue living in my glass house . . . where I sleep at night in a glass bed, under glass sheets, where who I am will sooner or later appear etched in diamond" (18).

The first part of *Nadja* examines the relation between certain real-life experiences and the nature of the automatic message, which, it will be remembered, attempts to capture the moment of consciousness between waking and sleeping. The narrator's concern in this part is to "re-frame" lived experience so as to extract the essence of personality. The question that preoccupies him is stated in the first sentence: "Who am I?"

The procedure used to extract the "figure" of experience from the undifferentiated stream of lived moments is a classic example of the cognitive "frame-making" process as theorists of memory and cognition have described it. The narrator's strategy is one of selection and integration: in the first place only those experiences that give him the feeling that the moment, or a similar one, has been lived before, are selected for analysis—this procedure effectively strips away all "accidental" attributes of the experiences in order to concentrate on the qualities that make them belong to a group; secondly, each separate moment is integrated into the overall frame of "automatic" experience which it is up to the reader to construct. Out of a series of fragments, the reader is expected to extract the overall "figure." Here and in later parts of the book, some of the fragments are paintings, drawings, or photographs, a circumstance requiring the integration of visual as well as verbal information.

The following moments are identified by the narrator in the process of selection:

1. The statue of Etienne Dolet that induces "unbearable discomfort." (24)
2. The fortuitous encounter with an unidentified young man during the first performance of Apollinaire's *Couleur du temps*; subsequently the narrator begins corresponding with poet Paul Eluard who turns out to be the same young man. (24–27)
3. The narrator's ability to predict the appearance of the sign "Bois-Charbons" on the streets of Paris. (27–28)
4. The appearance of a woman at the narrator's hotel who "recommends" the person who has sent her as someone who would "like to launch himself in literature." The person turns out to be Benjamin Péret. (28)
5. The parc du Procé in Nantes. (28–29)
6. Robert Desnos in the "époque des sommeils" when he would put himself in a trance-like state to produce "automatic writing." (31–32)
7. The "magnetic pole" along the Boulevard Bonne-Nouvelle to which the narrator continually returns without knowing why; and the film *The Grip of the Octopus* in which a Chinaman enters President Wilson's office "followed by himself, and by himself, and by himself." (32–37)
8. The experience of seeing films in the tenth arrondissement while picnicking among the spectators. (37)
9. The "Théâtre moderne," where third-rate plays could be seen in a dilapidated decor and a sort of twilight atmosphere. (37–39)
10. The desire to meet a naked woman in the woods; the experience of seeing a naked woman stroll about in the "Electric Palace" theatre. (39)
11. The child-murderess in the play *Les Détraquées*, a play whose transcription by the narrator gives rise to a dream in which a huge insect devours his head. (39–49)
12. The experience of meeting a young woman in the street and a bookstore salesgirl who speaks about Rimbaud. (51–55)
13. The woman who wants to present her glove to the Centrale Surréaliste. (55–56)
14. Louis Aragon notices that the letters on the front of a hotel, "Maison Rouge," are arranged in such a way that from a certain angle they read "Police"; the same day, the lady of the glove takes the narrator to see an anamorphic painting that from one angle appears to represent an angel, and from the other, a vase. (56–59)

As all of these are presented as "surrealist" experiences by the narrator, it is up to the reader to integrate them into a picture of what would constitute such an experience. The narrator supplies the clue for this act of integration in the recounting of fragment 11 where he wonders what the relation is between the play *Les Détraquées* and the dream about the insect. As is the case for *Un chien andalou*, the principle of organization is that of unconscious processes that Freud elaborated upon with respect to dream-work, slips of the tongue, and jokes.[7] The narrator says: "Since the production of

dream images always depends on at least this double *play of mirrors*, there is, here, the indication of the highly special, supremely revealing, 'super-determinant'—in the Freudian sense of the word—role which certain powerful impressions are made to play" (51).

Certain aspects of the episodes the narrator relates are "overdetermined" (Freud's English translators have preferred this term to "super-determined") because of the similarities between them and other episodes, or because of their assimilation into the structure of dream mechanisms (displacement, condensation, figurative representation, and symbolization).

Displacement, the replacement by allusion or the displacement of an important thing by a less important one,[8] is the mechanism at work in fragments 2, 4, and 12. These recount fortuitous encounters with strangers who later turn out to be important people in the narrator's life or to have a relationship with people important to him. In these three episodes it would appear that the second type of displacement is operative: an episode that was felt to be unimportant, extraneous to the narrator's interest and central preoccupations, turns out to be of central importance.

A second type of fragment deals with effects of condensation. According to Freud, this is brought about by the unification of elements.[9] The 14th fragment is an example of condensation: the two words "maison rouge" are condensed into one, "police," and an anamorphic picture unifies the images of an angel and a vase.

Fragment 1 is an example of the mechanism of figurative representation,[10] in which the meaning of the words "it hurts" is transposed to a statue of Etienne Dolet. "Dolet," literally interpreted, gives this meaning in Latin.

Symbolization, on the other hand, underlines fragments 11 and 13:[11] in fragment 11 the murder of the child and the insect that devours the narrator's head are both castration symbols; in fragment 13, the woman's glove becomes a source of anxiety for the narrator who sees its donation as an irrevocable separation. It also functions as a castration symbol: "I don't know what there can have been, at that moment, so terribly, so marvelously decisive for me in the thought of that glove leaving that hand forever" (56).

Fragments 5, 6, 8, and 9 are not specifically related to dream mechanisms; instead they describe the state "between waking and sleeping" that produces surrealist images. Breton persisted throughout his life in describing "receptive places" such as the "parc de Procé" in Nantes mentioned in fragment 5—places Marie-Claire Bancquart has labeled "le génie du lieu."[12] The other fragments in this series describe the trances of Desnos, and the "aids" to the privileged mental state of Surrealism provided by the cinema and by theatre-going experiences.

This leaves three fragments unaccounted for, two of which are similar. Each recounts a form of repetition: fragment 3 notes that the narrator is repeatedly able to predict the message and placement of certain street signs;

fragment 7 describes repeated visits to the same spot in Paris, with the vague feeling that "it(?) will happen here," and the Chinaman who infinitely repeats himself. Both these experiences appear to describe processes of displacement in which the promise of the coming together of reality and desire is held out but never quite achieved. The experience of the "same" remains irretrievably "other," in the sense that the repetition is never absolute (even the Chinaman who is followed by himself within the same space is differentiated by different moments in time). This is a type of displacement by *allusion*; the goal of reaching the still point where desire and object become one is at once held out and denied through repetition—a tension Freud considered fundamental to the function of the libido.[13]

If desire should be satisfied—a state described in fragment 10—then everything would cease: "I have always, beyond belief, hoped to meet, at night and in a woods, a beautiful naked woman. . . . It seems to me that everything would have stopped short—I would not even be writing what I am writing (39)."

This "meeting," the expression of the ultimate surrealist objective of finding the perfect correspondence between the subject and his unconscious desire—or rather the bringing of desire to consciousness and the concurrence of surrealist consciousness and reality—may be taken as the essence of the surrealist quest;[14] Breton implicitly alludes to this quest again in his essay "Comme dans un bois" which describes the surrealist cinema experience.[15]

The integrative process the reader performs in constructing meaning out of the correlation of the different fragments is a form of training for the effort demanded of him or her in the second part of *Nadja*. In this part, presented in the form of a diary, the narrator focuses on his relationship with Nadja, a young woman encountered fortuitously on the street. The diary form, however, is misleading; this part is as fragmentary as the first; the dated entries cover only one week in October, while the relationship lasted over a year in narrative time. Like the fragments of the first part, these entries are principally recollections of experiences whose essence has been extracted through the process of memory.

Psychologists who have studied memory distinguish two types, episodic and semantic, which are of some relevance here. Episodic, or "short-term" memory, is the limited memory that one has temporarily at one's disposal for the word-for-word recall of recent experience. Information is stored cumulatively in semantic or "long-term" memory, which organizes information into hierarchical constructs so that it may be recalled when needed.[16] The process of organizing information, according to some theorists, is similar to the process of "frame" construction; indeed, "frames" are conceptual units stored in semantic memory.[17]

The narrator's story of Nadja is a story already processed and stored in

semantic memory—the "figure" of the experience has been constructed. The effect of the fragmentary form of the text, however, is to force the reader to "reprocess" the experience so that he or she retraces the steps in the act of construction. Yet the fragments do not offer "raw" data; by their organization they implicitly guide the reader (Jauss' "gelenkte Wahrnehmung") so that he or she will construct the appropriate interpretative schema.

The organization of the fragments, duly perceived by the reader, assures the selective aspect of the construction of meaning; their integration is ruled by the same principles that rule the integration of the first part's fragments. The first part of *Nadja* thus constitutes a lesson in "how to read" which is to be applied to the more complex structure of the second part.

Again the text advances through mechanisms of the unconscious. Displacement by substitution is effected for both characters: for Nadja, the narrator assumes the place of mentor of which there have been a whole series; she herself identifies with "Hélène," a character in Breton's *Poisson soluble* (79). Displacement by allusion—when reality comes close to coinciding with desire without ever doing so—occurs when Nadja uses a metaphor the narrator has just read in a book (86); when Nadja casually mentions a name that Paul Eluard has been searching for (98); when Aragon sends the narrator a postcard illustrating a metaphor that had just occurred to Nadja (93).

The multiple plays on the word "dauphin" (dolphin) are an example of condensation with particularly rich overdeterminations:

> I propose we dine together. There must be a certain confusion in her mind, for she has driven not to the Ile Saint-Louis, as she supposes, but to the Place Dauphine, where curiously enough, another episode of "Poisson soluble" occurs: "A kiss so quickly forgotten." (The Place Dauphine is certainly one of the most profoundly secluded places I know of. . . . Whenever I happen to be there, I feel the desire to go somewhere else gradually ebbing out of me. . . .) We leave the garden and lose no time getting to another bar, in the Rue Saint-Honoré, which is called Le Dauphin. Nadja remarks that we have come from the Place Dauphine to the Dauphin (in that game which consists in finding a resemblance with some animal, people usually agree that I am a dolphin). (80–89, passim)

The word "dolphin" forms the core of condensation out of which flows a multitude of associations. These include a nickname of Breton (one which has resonance in alchemical symbology); an episode from *Poisson soluble* (reminding us that a dolphin is also a fish); an experience of "le génie du lieu" (he cannot leave the Place Dauphine); and an implicit statement that the figure of the lived surrealist experience is characterized by the temporal simultaneity of dreams (Place Dauphine merges with the bar Le Dauphin).

The second part of *Nadja* concentrates heavily on the correlation between

verbal and visual information (in the form of drawings, paintings and photographs). For the most part these are subsumed under the mechanisms of either symbolization or figurative representation. As symbol, the hand occurs both in Nadja's drawing depicting the face of a woman and a hand (121) and in her words: "That hand, that hand on the Seine, why is that hand flaming over the water: It's true that fire and water are the same thing. But what does that hand mean?" (85) Some pages later, the author includes a reproduction of de Chirico's painting, "The Enigma of Fate," in which a gloved hand figures prominently. The overdetermination of this symbol is strengthened by the fragment about the glove in the first part of the book and the photograph that accompanies that fragment. In later passages, the hand appears to be more than just a symbol of castration anxiety; it grows into a symbol for sexual union (the alchemical fire and water in the passage cited above) and the surrealist "amour fou."

Finally, the work of figurative representation is the origin of many of the drawings and paintings: Nadja's drawing of herself as Mélusine and Breton as an eagle (two animals well known in alchemical iconology); and her drawing of "La Fleur des amants" (The Lovers' Flower) that figuratively translates one of her expressions: "The heart of a heartless flower" (71).

The third part of *Nadja* (147–160) makes it clear that the procedures of integration, now learned by the reader, are to be applied to his or her own life. Just as the narrator's friendship with Nadja enabled him to experience the leap of perception that separates the conventional way of interpreting lived reality from the surrealist insight, so the reader's experience of the book will help him or her learn the surrealist mode of thought. "Nadja" is no more than a catalyst, a sign for that perfect coincidence of reality and desire that constitutes the essence of the surrealist search. In Freudian terms this would mean the end of all displacement: "All I know is that this substitution of persons stops with you, because nothing can be substituted for you, and because for me it was for all eternity that this succession of terrible or charming enigmas was to come to an end at your feet (158)." The radical break of the surrealist mode of thought is explained by this moment of perfect fusion between desire and the real. This fusion is represented on the formal plane by what Walter Benjamin has called the "creative combination of the personal and the poetic."[18]

In terms of the alchemical metaphor, the fusion is the moment of radical transformation at which the elixir, obtained through laborious stages of apprenticeship, is able to turn metal into gold. Among these stages, *coniunctio*, the preparatory union between opposites represented as male and female, is the key one for Breton. In his philosophy women have a redemptive role, even though they are finally consumed in the process of the poet's transformation. Breton's final statement in *Nadja*: "Beauty will be convulsive or not at all," reflects the sad wisdom of the poet who must

consume that which he loves in order to attain the radical transformation of consciousness.

Frame-making as topicalization: literature

Genre frames are the highest-level modes of organizing artistic works. At a lower level are thematic frames, deduced from the "topic" of a discourse. Although every instance of topicalization in texts is a kind of "frame-making," surrealist works have unique modes of discourse organization that create topics in unique ways.

Conventionally, topics are defined through the linguistic devices of semantics and syntactics, and the material device of segmentation (paragraphing). The study of discourse topics is the study of continuity in and between sentences and entails the consideration of such concepts as foregrounding (what information is most important) and the hierarchization of information (which elements serve to organize others). Linguistic discourse theory makes it possible to provide the following abstract model of topicalization:[19]

Semantic devices include the substitution of pronouns and other proforms for words previously mentioned; anaphora; deixis; associative relations between meaning units belonging to the same "semantic field"; and redundancy, or repetition.

Syntactic devices include the organization of semantic units by grammatical hierarchization (subordination and coordination); parallelism; and functional perspective (foregrounding).

Segmentation devices include the organization of syntactic units into larger segments; spatial form (continuity through parallelism between segments); and functional perspective within segments.

These devices may be cognitive as well as structural, a fact that underscores the difficulty linguists and psychologists alike have had in experimentally proving the existence of discourse "rules." It should be stated at the outset, however, that the categories are intuitive. An attempt to prove the existence of the categories by producing a computer-simulated discourse may be found in chapter four.

Surrealist works use topicalization; however, in order to identify the topic of a surrealist discourse, the reader/perceiver is required to learn new strategies. In general, surrealist works are less cohesive than conventional works because they omit many of the devices of topicalization, keeping a minimal few. On this level, as on the level of genres, these works explore the limits of their frames.

Surrealist "automatic writing" is a case in point. The text "Eclipses" forms part of *Les Champs magnétiques* ("Magnetic Fields") composed by Breton and Philippe Soupault in 1919.[20] This "automatic" text is in the form of prose, or a prose-poem since one should probably pay attention to

the double meaning of the title ("champs" can also be read as "chants,"—
"songs"). It derives its discourse structure neither from a consistent time/space
system nor from any sense of logical causality. There is, therefore, no "plot."
Nor are there any characters who are present for any length of time. The
impression of continuity relies, instead, on relatively few devices of
topicalization: redundancy in the form of an identifiable narrative voice (the
"I" and "we" of the discourse); anaphora; a limited number of semantic
fields; and spatial form. The first few lines of "Eclipses" can serve to
illustrate these points:

> The color of fabulous greetings obscures even the least rasp: calm of the
> relative sighs. The circus of leaps despite the odor of milk and curdled
> blood is full of melancholy seconds. There is however a little further on a
> hole of unknown depth which attracts all our gazes, it's an organ of
> repeated joys. Simplicities of ancient moons, you are learned mysteries for
> our eyes injected with commonplaces.
> To this city of the north-east belongs without doubt the delicious
> privileges of picking on the mountains of sand and fossils these serpentine
> spasms. One never knows what sort of condensed liquor will be brought
> to us by the girls of this goldless country.

The opening paragraph already contains an instance of the pronoun "we"
that will recur in the singular and plural at various stages.[21] In the absence of
other consistent characters, the repetition of the "I/we" pronoun becomes a
foregrounded element in the discourse, supplying a minimal amount of
continuity.

A second type of continuity is provided through the associative networks
created by the presence of words belonging to the same "semantic fields."
Although the definition of semantic fields is somewhat controversial, there
seems to be general agreement among linguists that they are a device of
discourse organization. For van Dijk, a semantic field is a kind of topic that
"hierarchically organizes the conceptual (propositional) structure of the
sequence."[22] Other linguists define a semantic field as consisting of a "lexical
field and a conceptual core."[23] Whatever the definition, the difficulty in
ascertaining the presence of a semantic field in a text derives from the fact that
the "core" concept may never be named: with what justification can one
then claim that the unnamed concept is responsible for the cohesiveness of
the text?

The question is one relevant to "Eclipses," which relies on semantic
associations between words for some of its cohesion. Indeed the mechanism
of "automatic writing" itself, an associative mechanism, is one which would
naturally tend to foreground this topicalization device. Close reading reveals
that a number of words in the first paragraph can be associatively linked to
the "core" concept of alchemy. The "simplicities of ancient moons" are said

68

to be "learned mysteries." The alchemical nature of these mysteries is indicated by the presence of a moon (the alchemical female symbol), and of a serpent (symbol of the metamorphosis of matter) in the word "serpentine." "Condensed liquor" suggests an alchemical distillation, while "goldless country" refers to a country in which elementary matter has not yet been transformed to gold. Later alchemical references in the text include: *chemistry, metallic, fire, the circuit of slow reddenings, intense bubbling, burned, labyrinth, resuscitates, silver, chemical, ferruginous water, cycles*. Some of these words refer to the alchemical process, some to metals used in the process, some to symbols of the alchemical union of elements or to symbols of the alchemist's quest.

Possibly the reader will overlook the first alchemical references. But later encounters with others will cause him or her to postulate the existence of the alchemical theme. Then the whole text will be reinterpreted in light of this realization. This constructive activity of the reader creates an "information network" by which new information in the text is understood according to previous information, and old information "reprocessed" in light of the new information until the core—or "frame"—has been constructed.

The other two dominant semantic fields in the text are those of geography/topology and astronomy/astrology; like the alchemical elements, they allow the construction of thematic frames.

The remaining devices of topicalization in "Eclipses" are less extensive. However, they contribute a great deal to the cohesion of the text, even though this cohesion is of a fragementary nature. The semantic device of anaphora occasionally serves to create "local" topics which become the focus of one or two paragraphs. But the topics are soon abandoned, nor do any of them recognizably turn up later. The deictic markers that serve to organize the time and place of events with reference to one another and to the speaker are disorienting since markers such as "these," "here," and "after" are used arbitrarily. The result is the creation of an illusion of deictic coordination that the reader tries in vain to unscramble. Similarly, the syntactic ordering of information by grammatical coordination and subordination creates the illusion of organization; but again, the attempt to establish any sense of temporal progression or spatial orientation is futile. The form of continuity is present without supportive content. Furthermore, in terms of segmentation, the organization of the discourse in paragraphs provides a kind of spatial form; interestingly, all the sentences that are asyntactic (grammatically unsound) except one occur in paragraphs of their own, and this parallelism creates continuity between them.

Despite the minimal continuity of the discourse of "Eclipses," it manages to avoid the pitfalls of "non-sense" through its device of topicalization. The reader, primarily through the "I/we" voice and semantic association, is perceptually manipulated so that he or she does not abandon the "frame-

making" attempt altogether. The result is another surrealist lesson in cognitive uncertainty.

Frame-making as topicalization: film

The topicalization devices of film are slightly different from literary ones. Anaphora in film most frequently occurs in the form of repetition; but closeup shots of an object or person previously seen may be construed as anaphoric as may the conventional device of presenting a scene with a long shot followed by a medium shot. Deixis is present in every shot of a film in the sense that the camera always films from somewhere; *within* a shot, most of the information about the objects present, if verbalized, would give evidence of semantic fields, but this is probably not an interesting observation for film. More telling are associative relations *between* shots, particularly if the contents of the shots belong to different narrative spaces.

Syntactically, topicalization devices have to do with various ways of juxtaposing shots so that their contents are felt to establish a comparison in the mind of the viewer. Juxtapositions may either create a sense of the same topic undergoing changes that are temporally or conceptually differentiated, or different topics undergoing changes that are felt to be temporally or conceptually related. In film, foregrounding follows clearly defined perceptual rules: brightness, motion, and size are all ways of foregrounding topics.[24]

The topicalization that derives from segmentation in film follows the model of syntactic topicalization except that units of meaning, rather than the physical attributes of shots, are involved. This might mean that information within a single shot creates shifts in topicalization (for instance if first the foreground, then the background, is focused). Or topicalization might be the result of the comparison between shot sequences. The segmentation of film, in any case, is not congruous with the physical division of a film into "shots" but rather with perceived units of meaning. In fact, to use a circular argument that does a good job of pointing out the intuitive nature of discourse theory, film segmentation is primarily the result of topicalization itself.

In the construction of the "topic" frame of a film, the perceiver will have to accommodate all of the film's semantic, syntactic, and segmentative aspects. Necessarily, he or she will proceed by the "weakest link" principle; those elements that cannot be accommodated by the hypothesized frame will be the focus of the principal constructive activity of the perceiver, who will try, inductively, to find a pre-existing frame in which they will fit, or, deductively, to produce a new frame.

Buñuel's and Dali's *Un chien andalou* utilizes topicalization in ways similar to the devices of "automatic writing." Once again, deixis is

disorientative (concepts of "here" and "now" are constantly shifting, and there is no way to order the topics coherently in narrative time or space). The temporal and spatial disorientation is also contributed to by "breaks" in syntax, such as the false matches that enable the female character to go out the same door into different diegetic spaces: once into a room identical to the one she has just left, and once onto a beach.

On the other hand, the film uses far more anaphora than "Eclipses" since the characters, though they shift their identities, remain consistent for relatively longer periods. In terms of segmentation, the film is clearly divided into episodes (denoted, it is true, by misleading titles). Segmentation plays a greater cohesive role than it does in "Eclipses," since each episode is assertively related to the preceding ones by titles, even when this relation is felt to be illogical by the viewer.

Principally, the cohesion of *Un chien andalou* is due to the same two elements of topicalization that are at work in "Eclipses": the "first person arranger" and semantic overdetermination. The presence of the "first person arranger" in *Un chien andalou* is felt in a narrative marked by continual transgressions, so that the viewer is continuously thrown back onto the visual plane, as explained in chapter two. The concept of "arranger" is taken from modernist narratives in which there is no clearly defined narrator, but rather an organizing "presence" responsible for the combination and articulation of the discourse.[25] Semantic overdetermination is achieved by repetition; by the devices of condensation, displacement, figurative representation and symbolization as explained in the previous section; and by semantic field association.

The frame-breaking aspects of the film have already been discussed; at issue now are the frame-making aspects which will make it possible to give an interpretation of the film. This interpretation focuses on the major topics derived from an analysis of the film's devices of topicalization. Here the scenario that Buñuel published in *La Révolution surréaliste* is of interest because it makes it possible to pursue semantic topicalization through the written word as well as the visual image. Any attempt at frame-making must concentrate on those elements that, on the surface, are the least interpretable, since it is these the frame must account for. They can be identified by recourse to the film's historical reception. A comparative study of interpretations of the film offered since its release allow identification of its most problematic elements as follows:[26]

1. the sliced eye
2. the androgynous bicycle rider
3. the striped box
4. the man pulling two cords, to each of which is attached a cork, a priest, and a grand piano on which lies the carcass of a donkey

5. the death of the younger self by pistols that are metamorphosed school-books
6. the man's falling down in a meadow after being shot
7. the box and clothing washed ashore
8. the man and woman buried in sand at the end

In order to explain these elements, it is necessary to quote the portions of the scenario that correspond with them:

1. The razor blade traverses the eye of the young girl and bisects it (*en le sectionnant*).
2. An individual, dressed in a dark gray suit, appears on a bicycle. His head, shoulders, and hips are encircled with white lace mantlets.
3. A rectangular box with black and white diagonal stripes is attached to his chest with cords. The individual pedals mechanically, without holding the handlebars, his hands on his knees. . . . Matched cut to the box whose oblique stripes are superimposed on the rain. A pair of hands holding a small key open the box and take out a tie wrapped in tissue paper. It is important to note that the rain, the box, the tissue paper, and the tie all have oblique lines of varying widths. . . . Standing by the bed, the young girl contemplates the accessories that the individual wore: mantlets, box, and stiff collar with a tie of a plain dark color: all arranged as though the objects were being worn by someone stretched out on the bed. The young girl finally decides to pick up the collar and replaces the plain tie with the striped one she has just removed from the box. . . . In the middle of the circle, this young girl, using a stick, tries to pick up a severed hand with polished fingernails that is lying on the ground. One of the policemen comes up to her and lectures her sternly; he bends down, picks up the hand, wraps it carefully and puts it in the box.
4. One sees moving across the frame: first a cork, then a top hat, two brothers of the Christian school, and finally two magnificent grand pianos (*pianos à queue*). The pianos are filled with the carcasses of donkeys whose legs, tails, rumps, and excrements spill out over the sounding board (*caisse d'harmonie*). When one of the pianos passes before the camera, a large donkey's head is seen lying on the keys.
5. The newcomer goes directly over to the bed and imperiously orders the individual to rise. He obeys with such bad grace that the other is obliged to grab him by the mantlets and force him up. After having torn his mantlets off one after the other, he throws them out the window. The box follows along with the cords the victim tried in vain to rescue from the catastrophe. . . . The individual who wore the mantlets, menacing the other with his pistols, forces him to put his hands up; despite the latter's obedience, he fires his two pistols at him.

6. From afar the wounded man is seen falling, no longer in the room, but in a park. Next to where he is falling sits a motionless bare-shouldered woman seen from the back, bent forward slightly. As he falls, the wounded man tries to seize and caress her shoulders; one of his hands, trembling, he turns toward himself; the other just touches the skin of her bare shoulders. Finally he falls to the ground. Long shot of some passers-by and some guards who rush to his aid. They pick him up in their arms and carry him through the woods. Have the passionate lame man (*le boiteux passionné*) intervene.

7. The waves gently spew out at their feet, first the cords, then the striped box, then the mantlets, and finally the bicycle.

8. Now one sees a desert with no horizon. Planted in the center, covered up to their chests in sand, the individual and the young girl appear, blind, their clothes torn, devoured by the rays of the sun and a swarm of insects.

The position of the box and clothing at the beginning of the film (after the "prologue") and near the end foregrounds this element in the discourse, in such a way that it establishes itself as the primary "topic." Moreover, this topic is repeated throughout the film: the policeman in the street puts the hand into the box (3); and the authoritarian person throws it out the window (5). The repetitions are not merely visual: the intervention of the "passionate lame man" ("le boiteux passionné" [6] is a word-play on "boîte"—"box."

Visually and verbally, the box is an element in the film that is topicalized. In addition, it is the focus of all four dream mechanisms: latent condensation made manifest on the surface of the narrative (the trio of striped tie/striped paper/striped box); displacement (it is associated with nearly every character: the androgynes, the woman, the authority figure, the lame man, the blind couple in the end); figurative representation ("boîte/ boiteux"); and symbolization (the hand or the necktie in the box equals coitus; the stripes on the box, recalling the necktie, make it an androgynous symbol). Moreover, it is topicalized through every possible device: anaphoric repetition, syntactic juxtaposition, and segmentative parallelism.

By far the strangest sentence in Buñuel's and Dali's script is the sentence "Faire intervenir le boiteux passionné" ("Have the passionate lame man intervene"). The "boiteux passionné" is of course, Oedipus: the lame man sent away from home as an infant who later, in an act of passion, killed a man who turned out to be his father, and married a woman who turned out to be his mother. Though the old man walking with a cane scarcely plays a part in the narrative, his presence provides another visual clue to the Oedipal theme since he walks on three legs (the riddle of the Sphinx: "What creature goes on four feet in the morning, on two at noon, on three in the evening?") Without wanting to impose a strict mythic interpretation on Buñuel's and Dali's film, it does seem that many of the film's elements play

on Oedipal fantasies: the murder of the authority figure (that the authority figure changes into a version of the main character's younger self may reflect the reciprocal nature of the son's rivalry with his father); the finding of sexual identity followed by blindness (8) (prefigured in [1]); the motherly attitude of the main female character; the presentation of sexuality as conflict (4). Verbal word-play also helps to explain segments in terms of sexual conflict (1 and 4): the man slices the eye "en le sectionnant" (*sex*ionnant); the sexually frustrated man pulls two grand pianos, or "pianos à queue" on which rest two donkeys with tails or "queues" ("queue" is a French slang word for male sex organ). The presence of Oedipal fantasies in *Un chien andalou* — revealed through a study of its techniques of topical-ization, which is a form of "frame-making" — explains the spectator's intuitive feeling that the film is an authentic transmission of unconscious thought.[27]

The Oedipal theme or frame-making element in this film is supported by a psychological effect deriving from its structural dislocations — the frame-breaking aspect described in the previous chapter. Psychoanalytic theory of cinema posits two levels of spectator identification in film: primary and secondary. Secondary identification results when the spectator identifies with a character and situation. But the nature of the film image also facilitates an identification with the moving image itself, a fascination with the visual: this is called "primary identification."[28] The French film theorist Christian Metz has argued that the fictiveness of the film "performance" (the absence of real actors, since they are represented as mere mirror images on the screen) facilitates primary identification because the spectator does not feel himself observed. The fictionality of presence reinforces the voyeur-ism of the cinematic experience, since voyeurism thrives on the separation between the observer and the observed. The film presents "a missed rendez-vous between the voyeur and the exhibitionist" and the actor is not the accomplice of the voyeur, as would be necessary in a theatrical strip-tease. Thus, Metz argues, the film experience is "more oedipal," closer to the "primal scene": like the child who watches his parents' lovemaking through the keyhole, the cinema spectator is alone, ignored by the spectacle, and segregated from it spatially.[29]

In denying the viewer the possibility of secondary identification by the structural dislocations of the narrative, *Un chien andalou* focuses his or her attention on the realm of "primary identification," which, like the Oedipal fantasies explored in the film, is related to the unconscious that Surrealism sought to liberate.

Frame-making as recontextualization

The previous discussion of frame-making mechanisms has confined itself to considerations within the system of literary or artistic conventions or

conventions of language. A third type of frame-making mechanism has to do with the pragmatic character of works, or their relation to the world (the context). Van Dijk notes that pragmatic factors cannot be dissociated from the historical situation of reception, since "the actually constructed macrostructures may be different for different language users, or different for the same language user in different pragmatic contexts or social situations."[30]

The question of context is crucial to dadaist works that depended heavily on audience reaction for validation. The decontextualizing function of the "ready-made" has already been discussed. Perhaps even more important, however, is its "recontextualizing" function—the way in which, according to new standards of aesthetic perception, it could be considered a work of art. Marcel Duchamp's defense of his ready-made "Fountain," a urinal submitted to and rejected by the Society of Independent Artists, makes the point: "To those who say that Mr. Mutt's exhibit may be Art, but is it the art of Mr. Mutt since a plumber made it? I reply simply that the *Fountain* was not made by a plumber but by the force of an imagination."[31]

The ready-made is pragmatically oriented, relying on the changed perception of the viewer and art critic for its status as a work of art. Part of the dadaist strategy was to manipulate that perception so as to change the contextual frames of the public. An example is offered by the events surrounding the first presentation of René Clair's film, *Entr'acte*, which was to provide the intermission entertainment during Francis Picabia's ballet *Relâche*. This was commissioned by the avant-garde impresario and director of the "Ballet Suédois," Rolf de Maré, in 1924.

Picabia began a publicity campaign more than five months before the performance. Clair's film was actually finished by the end of June and presented to Picabia for his approval by July 4, but this fact was carefully concealed from the public so as to arouse curiosity about its production.[32] Over thirty newspapers and art journals in Paris carried an announcement about the film between June 23 and August 10. The authors of the press release, which many of the articles reprinted, clearly intended to mystify and intrigue the public:

> The next season of the Ballet Suédois will present an alternation of dance and cinema. The scenario of the film which will be projected is by the painter Picabia. René Clair is the director. Among other originalities, one will be able to see "the dance of the matches" and a take-off on a funeral procession whose hearse will be drawn by a camel. (*Eclair*, July 1, 1924)

Other announcements played up the dada origin of the spectacle, quoting the artists as saying the film would be "abracadabrant" (*Le Gaulois*, July 7), "avant-garde" (*France Bordeaux,* July 5), or promising that it would offer something never before seen on the screen (*Liberté*, July 12).

After this first round of publicity had died down, the artists announced in mid-August that the film was finished. Again the news was widely reported, even outside Paris. The *Journal* in Antwerp, Belgium, reported that "The film is awaited with lively curiosity" (September 5). On October 2, *L'Ere nouvelle* carried an article by Pierre de Massot, a dadaist sympathizer, who reported that he had been permitted to preview the film:

> Yesterday I was present at the secret showing of a film by Francis Picabia which is to be projected during his ballet *Relâche.* . . . I expected to be surprised, because Picabia never does anything like anybody else. But these are not mere surprises: an extraordinary new path to new realms has been opened.
>
> I am not allowed to be more precise. I won't tell anything because surprise will be considerable and the reaction of the public unexpected. . . .
>
> Imagine for a second that this film is a machine gun and that the music of Erik Satie which will accompany it resembles thunder. And see, over the city, this great light which resembles a conflagration!

On November 1, a little over two weeks before the scheduled opening, the journal *Films* published the first picture of *Entr'acte*, which it described as an "instantaneist" film. Notes by Clair and Picabia accompanied the pictures. Picabia's in particular read like one of his dadaist manifestoes:

> *Entr'acte* is a real intermission ("entr'acte"), an intermission of every-day imbecility, an intermission of the boredom of monotonous life and conventions full of hypocritical and ridiculous respect. *Entr'acte* is an advertisement for the enjoyment of the moment, an advertisement also for the art of advertisement, if you will. . . .
>
> *Entr'acte* doesn't believe in much—in the enjoyment of life, perhaps; it believes in the pleasure of invention, it respects nothing if not the wish to burst out laughing, because laughing, thinking and working are all of equal value and equally indispensable.[33]

An interview with Clair and Picabia was carried on October 31 by the journal *Comoedia*. Clair betrayed preoccupations of an aesthetic nature ("On the screen, there should be no convention, no prejudice, anything which is not life is useless") while Picabia, ever conscious of the work as public spectacle, threw out the defiant statement: "You say they will react with cat-calls! So much the better! I'd rather hear them yelling than applauding."

According to Clair's report, the audience, already familiar with dadaist tricks, came to *Relâche* on opening night half suspecting it wouldn't open ("relâche" is the French term designating canceled performances). As it happened, the lead dancer, Jean Borlin, was in no condition to go on stage and the first performance had to be canceled: "Dressed in white ties and

tails, with bare shoulders, furs and diamonds, the guests got out of their cars beneath the marble pillars of Bourdelle only to learn that the play would not go on. There was a delightful outcry, mingled with the comments of people in the know: 'We might have known . . . it's the apotheosis of Dada . . . the best trick yet by that clown Picabia.'"[34]

Relâche did open, on December 5, 1924. The success of Picabia's publicity campaign can be judged by the widespread coverage of the event in the press. Evidently, every newspaper and art journal of note felt obliged to comment. Critical reaction fell into one of two extremes—no critic was moderate in his praise or mitigating in his condemnation. Negative reviews called the performance "boring," "soporific," "triste,"[35] and the *Mercure de France* commented:

> In offering us *Relâche,* the Ballets Suédois have crossed a special Rubicon in order to sink into a transcendental and swampy permissiveness. We wonder what the authors of this mournful joke can possibly have been thinking of . . . the cinematographic entr'acte of René Clair had as its principal and rather gross pretext the pursuit of a hearse at the speed of an Orient Express. The cogenital inanity of Mr. Satie's music had the advantage of adding only a confused noise to the murmurs, catcalls, and hee-haws of a public which, having come to enjoy itself, tried in vain to pretend to enjoy the show. (January 1, 1925)

Much of the positive critical reaction centered around *Entr'acte* and emphasized its novel exploration of cinematic form. *Bonsoir* (December 7, 1924), the *Journal littéraire* (December 27, 1924), *Menestral* (December 12, 1924), and *Les Maîtres de la plume* (January 1, 1925) all declared *Entr'acte* to be the most interesting part of the evening.

For the sympathetic spectator, the most engaging part of *Entr'acte* was the second half of the film which depicts a runaway hearse. Many of the shots gave the viewer the sensation of being aboard a rapidly moving object—in particular the shots of a roller coaster ride that is photographed from a moving car. This radical experimentation with point of view and with viewer identification was noted by reviewers. René Jeanne, in *Les Nouvelles littéaires,* commented: "[the film] grabs the spectator without leaving him time to think, imposes itself on him almost physically and leaves him, after the last image, rubbing his eyes and asking himself what has happened to him, as though he had been suddenly awakened from a dream" (December 13, 1924).

Predictably, those critics unable to assimilate the new "frame" offered by *Relâche* and *Entr'acte* complained of boredom and imcomprehension:

> This spectacle and this music are not scandalous, but morose and without refinement, painstakingly boring, affectedly incoherent. Neither ballet, nor film, nor sketch, *Relâche* is a combination of all of these. It's a

stale mixture which borrows from the music hall and the cinema things of beauty which it destroys with mournful pleasure. In dedicating themselves to free theatre, Mssrs. Picabia and Satie had every right except the right to bore us. (*Eclair,* December 8, 1924)

The negative criticism evidently delighted Picabia because it gave him a chance for more press: on December 20, 1924, *Paris Journal* carried a "Response to critics: one more cardinal sin" signed "Francis Picabia the Vain." Gleefully he remarks: "Even though *Relâche* is 'empty,' 'idiotic,' 'vain,' everyone wrote columns and columns about it. . . ." He accuses the critics of being unable to comprehend what is new and innovative: "The important people, members of the council, weightily inform us that our work contains nothing new! My friends the critics, I think I can see what it is that you call new—it's the novelty of three years ago, which you are finally getting used to."

Relâche was a mixed-media event that demanded an effort of contextualization on the part of the spectator: the realization, for one, that film and dance could be parts of the same entertainment; and the ability to learn the new type of spectator identification demanded by the experimentation with cinematic point of view in *Entr'acte.* Those who could not construct the proper frame were bored. The failure to contextualize produces a type of "cultural indigestion" amusingly illustrated by the critic writing in the *Revue de Paris*:

> As a studio performance at Montparnasse, this would have been a success . . . but it does not have the quality that the public expects in the theatre. It has the consistency of an *hors d'oeuvre,* nothing more. It is spicy, but the taste does not linger. . . . A public which spends money wants something solid in exchange . . . avant-garde spectacles are insubstantial. . . . Theatrical productions used to produce calm and relaxation, today they seem to incite us to be unstable, to live with no assurances about tomorrow, between what can be no longer and what has not yet come into being.[36]

The above reaction is a perfect statement of the confusion of one who, having been forced to discard old frames, cannot yet integrate new ones.

Conclusion

The critics who reacted positively to *Entr'acte* dramatized the difficulty in continuing to shock the public once the element of shock has become expected: frame-making is such a pervasive activity that it is hard for the radical artist to keep ahead of it.

Perhaps for this reason, Breton and Soupault at one point planned the ultimate redefinition of the relation between art and life; this was to be the

fourth act of their play *S'il vous plaît*. In the written version, the authors merely informed the reader that they did not want the fourth act printed.[37] Aragon reports, however, that Breton and Soupault planned to play Russian roulette on stage as their fourth act: "For about three weeks the presence of death was among us."[38]

That Breton and Soupault did not, in fact, do so shows that their activities remained within the traditional frames by which society defines the function of art works, even though they challenged, and partially altered, that function. But in fact the frame-breaking and frame-making devices that characterize dadaist and surrealist works and which are elicited in the responses of their readers and viewers are similar to the function of all art works:

> Art, as an adaptive mechanism, is reinforcement of the ability to be aware of the disparity between behavioral patterns and the demands consequent upon the interaction with the environment. Art is rehearsal for those real situations in which it is vital for our survival to endure cognitive tension, to refuse the comforts of validation by affective congruence when such validation is inappropriate because too vital interests are at stake.[39]

four

Surrealist metaphor and thought

In his *Second Manifesto of Surrealism* of 1930, Breton stated that Arthur Rimbaud's expression, "alchemy of the word" (*alchimie du verbe*) should be taken literally. For the surrealists, this meant not only transforming language, but changing reality through language. The catalyst for this transformation was to be the imagination, which, after the model of Rimbaud, was to be liberated by the "long, immense, reasoned derangement of the senses."[1] Only the mind trained in the surrealist mode of perception could learn to make the qualitative leap into the alchemist's *age d'or* in which the external world assumes the appearance of the poet's internal desire. Breton's theory of "convulsive beauty" in *L'Amour fou* underscores the paradox of the surrealist quest: the object that becomes the focus for the poet's experience of "convulsive beauty" must fulfill three conditions: it must be discovered by chance (the "magic of circumstances"); it must answer in some veiled way to the poet's desire (so that he can, on reflection, understand its erotic attraction for him); it must combine contradictory attributes, e.g., explosive/immobile, strength/fragility, animate/inanimate.[2]

The third condition is properly alchemical: the surrealist object in itself contains the transforming properties of metamorphosis, and is able to be one thing and another at the same time. Again, the inspiration was Rimbaud, who, in *l'alchimie du verbe*, spoke of the transformative powers of visual and verbal hallucination: "I accustomed myself to simple hallucination: I plainly saw a mosque in place of a factory, a drum school made up of angels, carriages on the roads of the sky, a salon at the bottom of a lake . . . then I explained my magical sophisms with the hallucination of words!"[3]

A favorite surrealist game was "L'un dans l'autre" ("one inside the other") in which one player picked an object and described it in terms of analogies that the other players had to decode. The following passage by Breton describes a "lock of hair":

> I am an evening dress of a substance so light that my weight is no more than that of the finest handkerchief held in the hand. In form, I am closely related to the quarters of the moon. The person who owns me can either wear me or keep me in a closed place and take me out in moments of solitude, for specific purposes. Sometimes perfumed, I can only choose

between two, or at the most three, colors which can present themselves in all the variations of their scale.[4]

This game of substitution is a game of metaphor; like so many other surrealist activities, its driving force is the alchemical concept of metamorphosis in which one element changes into another. Anna Balakian has defined the epistemological basis of surrealist metaphors in terms of alchemical concepts: "Things and beings are not *like* other qualities or states; through the alchemy of the word they *become* something else, and the metaphor through which they are transformed draws them not from parallel spheres but from forms that are logically unrelated."[5]

The metaphorical mode of thinking can be applied to experiences as well as objects; Breton's *Nadja* and *L'Amour fou* can be read as catalogues of such experiences. Common to all of them are the elements of frame-breaking and frame-making that define the perceptual qualities of the experiences: they are moments of integration, of synthesis between the world and the mind.

For Breton the synthesizing medium is language. In affirming that "language was given to man so that he may make surrealist use of it,"[6] and in claiming that reality can be changed through language, Breton is making several assumptions about the relation of language and reality that are still a matter of considerable theoretical dispute. The first is that language becomes a cognitive tool for exploring reality. The world is a "cryptogram" the poet must decipher by combining the disparate elements of reality into images.[7] The creation of these images is described in scientific-experimental terms: the combination of elements releases a "spark" because of the "electrical current" resulting from the unification of their opposite poles. In the surrealist theory of images, Breton says, resides the surrealist attitude toward nature itself.[8]

Secondly, language can also change reality; as Octavio Paz says, Breton wanted to "recover the origin of words, the moment in which speaking is synonymous with creating."[9] Essentially, this is a magical conception of language, as Breton himself admitted: "Consciously or not, the process of artistic discovery . . . is indebted to the form and the very stages of progression of high magic."[10]

For Breton, the magical system of analogies is equivalent to metaphor:

> Poetic analogy shares with mystical analogy the transgression of the laws of deduction in order to make the mind apprehend the interdependence of two objects of thought situated on different planes . . .[11] esoterism . . . offers the immense advantage of maintaining in a dynamic state the unlimited field of comparisons at man's disposal, which makes available to him those relations capable of uniting the most disparate objects and partially reveals to him the mechanism of universal symbolism.[12]

In contradistinction to magical practices that project language onto the physical world, however, the surrealist practice projects language onto man's *perception* of the physical world. Reality is changed because the perception of reality is changed. Breton's third assumption is that language divides up the continuum of experience; to use language is to limit oneself to the modes of perception already inherent in that language. This view of language, commonly known as the "Whorfian hypothesis,"[13] is the starting point for Breton's politics of transformation: through metaphor, man can evade the cage of language that imprisons him. Again, the concept is alchemical: just as in alchemy matter is said to germinate, so language, restored to its original life, will become productive: "Il faut que le nom *germe* pour ainsi dire, sans quoi il est faux" ("The word must germinate, so to speak, or it is false.")[14] Breton's cognitive view of metaphor finds expression in the current distinction between "vital" and "dead" metaphor, according to which the "vital" metaphor is the vehicle for fresh perceptions, the "dead" metaphor an image that has lost its original powers of apperception.

To these three assumptions should be added a fourth: nowhere does Breton make the distinction between "literal" and "figurative" use of language; instead, the value of the surrealist image is that it is to be taken as a statement of surrealist reality. For Breton, the vitality of metaphor is really only a subset of a much larger ambition, that of restoring the vitality of language, the correspondence between word and world. Artaud, in the preface to *The Theatre and its Double*, wrote that this relation had become lost: "If the sign of the times is confusion, I see at the base of this confusion a break between things and the words, ideas and signs which are their representation."[15] Later, Breton wrote in a similar vein that "decadence" comes about when signifiers survive their signifieds: the form of language persists even though its meaning has been lost. The purpose of the surrealist operation on language is to "regain in single leap the moment of the birth of the signifier."[16]

Implicitly, Breton makes the claim that metaphoric operations are basic to the processes of language, a claim that has strong defenders (as well as detractors) in contemporary linguistic theory. In order to appreciate the full force of Breton's intuitive grasp of this argument, it is necessary to quote from the *First Manifesto*: "The mind which plunges into Surrealism relives with glowing excitement the best part of its childhood. . . . It is perhaps childhood that comes closest to one's 'real life' . . . childhood where everything . . . conspires to bring about the effective, risk-free possession of oneself. Thanks to Surrealism, it seems that this opportunity knocks a second time."[17]

Much of the evidence for the assertion by linguists that metaphoric operations lie at the base of language use relies on the observation of language learning in children. On such observations David E. Rumelhart

bases his assertion that "figurative" language and "literal" language are processed in the same way, noting that for children metaphor is one method of learning language.[18] In her study on infant cognition, Barbara Leondar shows how metaphoric operations are part of the child's cognitive development, enabling him or her to construct categories of meaning by the comparison and hierarchization of concepts. Leondar shows how the child's encounter with new concepts is an experience of metaphor: a child who has very different schemata for the concepts "daddy" and "dog" will have to learn a new hierarchy of conceptualization upon being told that a "dog" may also be a "daddy." This relation, initially perceived metaphorically as a clash between two incompatible categorical systems, subsequently becomes literal for the child: the newly learned conceptual scheme for "daddy" will eventually conceal its figurative origins. Similar processes regulate our relationship to language as a whole: "A configuration half-perceived, a relation fully grasped, a concept newly emergent must be named metaphorically. Once such a newly discovered phenomenon is well understood—once extricated from its originating context, its details specified and its boundaries established—the metaphor will vanish into the literal lexicon, its heuristic work completed."[19] Seen in this way, metaphor becomes a kind of "frame-making" activity, as Rumelhart implicitly suggests:

> We say that a statement is literally true when we find an existing schema that accounts fully for the data in question. We say that a statement is metaphorically true when we find that although certain primary aspects of the schema hold, others equally primary do not hold. When no schema can be found which allows for a good fit between any important aspects of the schema and the object for which it is said to account, we are simply unable to interpret the input at all.[20]

Rumelhart and Leondar emphasize the use of metaphor as a learning device. Max Black goes one step further in Breton's direction by stating that metaphor "can sometimes generate new knowledge and insight by changing relationships between the things designated." Black's "interaction theory" of metaphor divides the elements of a metaphoric expression into a "focus" (words used unconventionally) and a "frame" (words used conventionally); in the metaphoric interaction, the "frame" takes on some of the characteristics of the "focus"—it is *re-framed*. Similarly, the "focus" is reinterpreted in light of the "frame." Since Black regards the "focus" as a "system rather than an individual thing" the process of understanding metaphor operates much as the "dog-daddy" complex analyzed by Leondar does: a metaphor is an interaction between conceptual systems. Black gives the example of Wallace Stevens' remark "Society is a sea" as being "not so much about the sea (considered as a thing) as about a system of relationships . . . signaled by the presence of the word 'sea.'"[21]

Like Black, Rumelhart, and Leondar, Breton belongs to what has been termed the "constructivist" school of knowledge, according to which knowledge of reality arises from the interaction between the perceiver's existing knowledge and new information. The basic assumption of this school is the idea that language, perception, and knowledge are interdependent, and the theory of metaphor that follows from this assumption holds that metaphor adds to the understander's and the creator's knowledge of the world by creating a new perception. By way of contrast, another school of metaphoricians regards metaphor as a deviance from "normal" language that calls the reader's attention to language itself.

The surrealist attitude is "constructivist" because the surrealist attack on conventional language goes further than to criticize literary norms; the whole of man's symbolization processes is called into question, in particular the relation between man and the perceptual categories that mediate between him and reality. For Breton, the most serious handicap these categories impose upon man is his separation from his own desire, which must at all costs be recovered. Like Freud, who invented the "talking cure," Breton believed that man could regain contact with his unconscious through words. The cognitive import of surrealist images is emphasized in the *First Manifesto*:

> The surrealist atmosphere created by automatic writing, which I have wanted to get within the reach of everyone, is especially conducive to the production of the most beautiful images. One can even go so far as to say that in this dizzying race the images appear like the only guideposts to the mind. By slow degrees the mind becomes convinced of the *supreme reality of these images*. At first limiting itself to submitting to them, it soon realizes that *they flatter its reason, and increase its knowledge accordingly.*[22] (italics mine)

Breton is making an argument here for the cumulative effect of metaphors in surrealist "automatic writing"—a reference to their "frame-making" function. In the following section, Breton's "constructive theory" of metaphor receives a closer look that repays the effort of analysis because, as the critic Walter Benjamin notes: "Here the field of literature was exploded from the inside, as an intimate circle of friends pushed 'poetic life' (*Dichterisches Leben*) to the limits of the possible."[23]

A construction theory of metaphor

Anyone who has had the experience of learning a foreign language radically different from his or her mother tongue has experienced on a personal level some philosophical notions about the relationship of language to reality. The speaker of an Indo-European tongue who begins to learn Japanese is confronted with the following set of verbs and rules:

yaru: someone gives something to a person equal or inferior to him
ageru: someone gives something to a person superior to him
kureru: someone equal or inferior to the speaker gives something to him
morau: someone receives something from a person equal to or inferior to
 him
itadaku: someone receives something from a person superior to him[24]

The following sentence uses the polite "*itadaku*":

Boku ga	*sensei ni*	*hon*	*o*	*yonde*	*itadaita*
I	teacher	book		reading	received (the favor of)

In colloquial English, this translates to "I had the teacher read the book."[25]

This example illustrates the way that language embodies the thought of a culture. It is not just that a culture lexicalizes the concepts that it needs (as in the familiar example of the many different Eskimo words for types of snow); it is also that concepts, once lexicalized, continue to exert their influence on the way reality is perceived by the members and on those who attempt to enter the culture by learning its language.

Learning a language is one way to extend the contours of one's thought; changing one's own language is another. In translating the above Japanese expression into English, suppose the translator wanted to give his readers some understanding of the foreign concepts involved. One solution would be to use cumbersome English paraphrases, as in the "literal" translation "I received the favor of the teacher's reading the book." Another would be to expand the English language so as to incorporate the Japanese concepts. The latter option would involve a metaphor, or, to put it another way, the expression used would be perceived by the reader as metaphorical. For example, the most polite use might be conveyed by the verb "bestow": "The teacher bestowed upon me his reading of the book." To an English-speaking person, this sentence appears slightly ludicrous—there seems to be a disproportion between the verb "bestow," the nature of the gift, and the relation between the giver and the receiver. The use of this particular verb in this context metaphorizes the relationship between teacher and student, bringing up cultural associations of patronage and power and investing the reading with a reverential aura.

For the translator's purpose, however, the metaphoric expression "the teacher bestowed upon me his reading of the book" translates what is a non-metaphoric expression in Japanese. The expansion of English meaning passes through metaphor but is pointed toward the moment of incorporation when the expression will become non-metaphorical in English as well, joining the company of such "dead" verb metaphors as "he fielded the question," or "the lobbyists jockeyed for favors."

In the current example, this "de-metaphorization" is not likely to occur; our society, rather than becoming more polite, is becoming decidedly less so

and it is probably utopian to think that students will ever show teachers this much reverence. The example illustrates, however, the relation between metaphor and fictionalization: metaphor is the vehicle for a "fictional world" within which the reader is invited to consider an unconventional situation "as if" it were conventional.[26]

A reader who understands a metaphor adds to his or her knowledge of the fictional world proposed by the text. Metaphors are similarly used in science to convey knowledge about the real world. Paradoxically, a metaphor only functions if it is taken literally—as though it were a factual statement. This is what is meant by the "interaction theory of metaphor"—when metaphor is treated as though it were a factual statement, both terms of the expression are affected. In the above example, "the teacher bestowed upon me his reading of the book," the result of taking "bestow" literally in this context not only elevates the act of giving and the relationship between the teacher and the student, it also subtly changes the meaning of "bestow" by removing restrictions on its use. Unless the expression enters permanently into the language, this stretching of the word's semantic extension is only temporary; it is nevertheless an observable event in the particular context of its occurrence.

The way metaphoric meaning is contextually defined is only a slightly more dramatic demonstration of the way language can convey any meaning at all. Language does not signify because of a one-to-one relation between word and object or reference; rather, any given language divides up the field of reference among a limited number of words. The words themselves are signifiers, and the mental entities they designate, signifieds. The meaning of a sign is contextually defined in language by its relation to other signs; moreover the portion of the field of reference it designates can change over time, since languages do not remain static.

A change in a sign's meaning is therefore a double process: on the one hand, it entails a shift in the referential relation of the sign and the world; on the other hand, it has an effect on other signs, since it restricts or expands their "slice of the pie" of reference. The mechanism of metaphor is no different. It entails a shift in the semantic compatibility between two signs—a shift that adds to the reader's knowledge of the real or a fictional world. Thus metaphor *as a process* lies at the structural base of language.[27]

Metaphor is an instance of "frame-breaking"—it calls upon the constructive mental activity of the reader who must try to make sense out of word combinations that he or she knows to be semantically incompatible. If there are sufficient contextual cues, the reader will be able to grasp the knowledge conveyed by the metaphor; otherwise, he or she will be left with the impression of linguistic nonsense.

What allows a writer to produce apparently meaningless sentences with the confidence that the reader will make sense of them? This phenomenon

can be explained if we imagine that the writer and the reader have a sort of contract. The writer of the text "agrees" to surround the metaphor with just enough meaning so that it can be deciphered, and the reader does the constructive mental work because he has been promised the reward of increased knowledge. It is the writer's task to make the "fictional world" to which the metaphor belongs coherent, while the reader reaps the reward by virtue of application. In order for the metaphor to be successful, the terms of the contract have to be met. The reader's task is to "construe the world so as to make sense of the utterance."[28]

So far no one has tried to define the contractual basis for metaphor; the only definition of a similar contract is the one developed by H. Paul Grice in his analysis of conversation.[29] Teun A. van Dijk, in turn, has extended Grice's definitions to literary discourse.[30] On the basis of their theories, it is possible to propose a construction theory of metaphor that sets forth the contract underlying the metaphoric operation. Like Grice's theory, the "construction theory" would have four maxims loosely modeled after his own:

1. **Quantity** (Grice: "Make your contribution as informative as is required; do not make your contribution more informative than is required")
 a. The terms of a metaphor should not be so semantically incompatible that the metaphor cannot be understood;
 b. A metaphor should display sufficient semantic incompatibility between its terms to require constructive activity on the part of the reader.
2. **Quality** (Grice: "Try to make your contribution one that is true")
 a. A metaphor should be in a relation of non-contradiction to the fictional world presented by the surrounding discourse.
3. **Relation** (Grice: "Be relevant")
 a. Do not mix metaphors (Example: "There's a dead cat on the line somewhere and when it all comes out in the wash, he's not going to be the goat").
4. **Manner** (Grice: "Be perspicuous; avoid obscurity of expression, ambiguity, prolixity, be orderly")
 a. A metaphor may violate norms of semantics, but not of syntax;
 b. A metaphor should contribute to the reader's cognitive experience;
 c. A metaphor should not be merely ornamental;
 d. A metaphor should be ambiguous—there must be tension between the conventional meaning of its terms and the meaning constructed by the reader.

The last maxim of manner is actually in contradiction with Grice's conversational model; this is because he considers metaphor to be a form of contract-breaking, whereas the above schema outlines the inherently contractual nature of metaphor.

The schema has the advantage of combining a semantic theory of metaphor, according to which the terms of a metaphorical expression are semantically incompatible, with a pragmatic theory that examines the way metaphors are used. In linguistic theory strong disagreement exists between those who assert that metaphor must be explained as a deviation in semantic application and those who hold that the apparent deviation of metaphoric language is in reality a form of language use that can be accounted for by considering the metaphor in relation to the words surrounding it (the "co-text") and in relation to the conventions of linguistic usage (the "context").[31] Because literary discourse itself is subject to observable norms or "frames" in the form of genre, topicalization, and theme, literature offers a field of observation in which the semantic and pragmatic aspects of metaphor are equally foregrounded.

The construction theory postulates that metaphor-making follows what Grice has called the "Cooperation Principle"; if the maxims outlined above are not adhered to, the reader is alerted to the fact that the non-adherence has a meaning—what Grice calls an *implicature*.

It can easily be seen that the infringement of one of the maxims within the overall Cooperation Principle will engender different metaphor types. The first type is simply a bad metaphor, produced by what Grice calls "opting out," and "clashing" or "violating" maxims. More interesting types result from the "flouting" of a maxim for intentional effect—what Grice calls *exploiting* a maxim.

An infringement of the maxim of *quality* would imply that the proposition underlying the metaphor is in a false relation to the fictional world of the surrounding discourse (the notion of "true" that Grice ascribes to the maxim of quality becomes, in fiction, "true to the fictional world of the discourse"). The reader of a literary text in which such a metaphor occurs might conclude that the narrator or character responsible for the utterance is mad or at best unreliable. An example is provided by the ravings of the psychotically depressed Septimus in Virginia Woolf's *Mrs. Dalloway*.

The maxim of *relation* emphasizes the "topic-comment" structure of the metaphor proposition. If the maxim of relation is infringed upon for intentional effect, the result is the creation of a fictional world that sets up its own unconventional norms governing the comments that are appropriate for a given topic. The prose of Marcel Proust offers a sophisticated type of metaphor "mixing"—the comment attached to a first topic becomes the topic for the next comment, and so forth. A circularity is established in which the "metaphoric" status of any one element is questionable—a demonstration, pushed to extremes, of the idea that a metaphor only functions when taken "literally," i.e., when the distinction between "focus" and "frame" is temporarily lifted. In *A la recherche du temps perdu*, women are flowers as often as flowers are women.

Violations of the maxim of *manner* give rise to different sorts of

implicatures. James Joyce, in *Finnegans Wake*, occasionally violates syntax when creating metaphors ("only in chaste"—the correct word, *jest*, exists as an implicature). Purely ornamental metaphors are used by poets when they wish to mock poetry; for instance, E. T. A. Hoffmann created mock-poems in his short story "The King's Bride" to make fun of the overly sentimental author Amandus von Nebelstern. An unambiguous metaphor is of course generally called a "dead" metaphor. Raising a dead metaphor is also a form of implicature—the character who is unaware that a metaphoric expression has become conventionalized betrays an ignorance of language.

The question of "dead metaphor" is a difficult one owing to the fact that the property of metaphor is to be taken "literally." For this is just what happens when a dead metaphor becomes the object of comic play (if, in response to the command "get lost," a character runs toward an impenetrable forest). The answer to the problem seems to be that a "dead" metaphor is one on which the "contract" has run out—it is "dead" because it is no longer understood as a propositional statement.

A final type of infringement remains—*quantity*. It is here that surrealist metaphor belongs. In the *First Manifesto*, Breton proposed a semantic analysis of the surrealist image: "It is, as it were, from the fortuitous juxtaposition of the two terms that a particular light has sprung, *the light of the image*, to which we are infinitely sensitive. The value of the image depends on the beauty of the spark obtained; it is, consequently, a function of the difference in potential between two conductors."[32] In insisting that the value of the image depends on the "difference of potential between two conductors," Breton is underscoring a maxim of *quantity*: the semantic incompatibility must push against the very limits of sense.

Later, however, he goes on to assert the pragmatic value of this exercise ("Language has been given to man so that he may make surrealist use of it"). In surrealist works, the metaphorization of language has both pragmatic and semantic implications.

Surrealist metaphor: literature

The manner in which "automatic writing" uses semantic and pragmatic elements to elicit frame construction on the part of the reader can be observed in four recent critical studies of Breton's *Poisson soluble*. In all cases but one, a misapprehension of the pragmatic force of Breton's text has resulted in the critic's being caught in the trap that was set for him; the *process* of his reading is correct while his interpretation of that reading is false.

Two of the readings, Laurent Jenny's "La Surrealité et ses signes narratifs" ("Surreality and its Narrative Signs")[33] and J. M. Adams' "La Métaphore productrice" ("Productive Metaphor"),[34] address themselves specifically to sequence twenty-seven of *Poisson soluble*, which is worth quoting in full:

(1) Once there was a turkey on a dike. (2) This turkey had only a few days to bask in the bright sun and he looked at himself with mystery in a Venetian mirror placed on the dike for this purpose. (3) At this point the hand of man, that flower of the fields that you have already heard of, intervenes. (4) The turkey who answered to the name of Threestars, as a joke, didn't know which way his head was screwed on. (5) Everyone knows that the head of a turkey is a prism with seven or eight faces, just as a top hat is a prism with seven or eight reflections.

(6) The top hat swung back and forth on the dike like an enormous mussel singing on a rock. (7) The dike had no reason for existing since the sea had forcefully drawn back that morning. (8) The whole of the port, furthermore, was lighted by an arc light the size of a schoolchild.

(9) The turkey felt he would be lost if he couldn't touch the heart of this passerby. (10) The child saw the top hat, and since he was hungry, he went about emptying it of its contents, which in this particular case was a beautiful jellyfish with a butterfly beak. (11) Can butterflies be said to be similar to lights? (12) Obviously; that is why the funeral procession stopped on the dike. (13) The priest sang in the mussel, the mussel sang in the rock, the rock sang in the sea and the sea sang in the sea.

(14) So the turkey stayed on the dike and since this day has frightened the schoolchild.[35]

Jenny's analysis begins by identifying the narrative frame suggested by the opening line. His subsequent strategy is to attempt to recuperate all the text's elements according to this frame, which he posits as the basis of the text's referentiality. He construes semantic incompatibility between words as a break in the referential, narrative frame. According to his reading, elements that cannot be compatibilized with the dominant frame constitute the "surreal" elements of the text. "Surreality," in his view, finally breaks the narrative frame apart in sentence 6, when the metaphor of the previous sentence becomes the new topic: "The mimesis of the story is devoured by the indices of Surrealism."[36]

But this break of the frame is neither final, nor sudden: even earlier Jenny notes the "'futility' of the representation that appears 'empty' and 'full' in turn without the reader being able to decide once and for all."[37] Later, in sentence 9, the "turkey" that had been established as a topic in the first sentence makes a reappearance. This reestablishes the narrative frame "as though to deny the indices of surreality." Jenny notes, in addition, that the last sentence is a partial recuperation of the frame since it brings the sequence to an appropriate narrative closure.[38]

In other ways Jenny's reading dramatizes the frame-making activity elicited by the surrealist text, as he is led to "compatibilize" the elements according to other frames, including semantic fields and discourse registers.

For instance, semantic fields enable him to systematize the lexis of the text according to the core concepts *rural* (turkey, flower of the fields, butterfly),

sea (dike, mussel, rock, port, jellyfish), and *burial* (funeral procession, priest).

The discourse registers allow him additional recuperative moves, since they call up "intertextual" frames that the reader is familiar with: the technical language of zoology ("jellyfish with a butterfly beak"); meta-commentary ("Can butterflies be said to be similar to lights?"); popular ballads ("at this point the hand of man . . . intervenes"). The presence of metaphors is in itself said to be an intertextual sign of "poetic" discourse.

Jenny concludes that "automatic writing" operates under multiple constraints, rather than being the result of the free play of words: "Automatism is far from being synonymous with maximum creativity."[39]

J. M. Adam's reading arrives at quite different results through essentially similar processes of frame-making. In this instance, an anagrammatical frame allows him to postulate the equivalence between the lexis of the text and mythological figures. "Dindon" (turkey) becomes "Dido," the queen of Carthage, while the "écolier" (schoolchild) is "Enée" (Aeneas); the missing "n" for "Enée" is supplied by the superfluous "n" of "dindon."[40]

Once this frame is established, many of the sentences can be understood according to the reader's knowledge of the myth of Dido and Aeneas. Words like "forme" and "énorme" are anagrams for "Rome" which Aeneas will inhabit, while "Troie" (Troy) is contained in "Trois-étoiles" (Threestars). Sentence 9, "The turkey felt he would be lost if he couldn't touch the heart of this passerby," becomes Dido's plan for seducing Aeneas.

Neither Jenny nor Adam make claims for the finality of their interpretations, preferring to evade any real confrontation with the text's meaning by stating that their reading is a form of play. Jenny writes that "The meaning ceases to make pretensions of substance, of 'truth.' The meaning is form. The meaning is play."[41] Adam concludes that the *Poisson soluble* is "insoluble."[42]

A more philosophic note is struck by Robert Ariew in an article published in the *Association for Literary and Linguistic Computing Bulletin*.[43] This study attempts to plot the presence of two semantic clusters—those centering around the "female" element of water and the "male" element of fire—in *Poisson soluble*. Water is associated with the unconscious, fire with the conscious; this division, though hardly susceptible to proof, does have parallels both in alchemy and in Breton's *Nadja*. The alternation of water and fire elements from segment to segment and their relative predominance at specific points in the text lead Ariew to conclude:

> The periodic nature of the water images in the *Poisson soluble* shows uncertainty, hesitation. The desire to plunge in the dream world fluctuates . . . the periodic, unstable behavior of the fire images also indicates an uncertainty. A lack of commitment to the rational processes is evident . . . the *Poisson soluble* is not purely an experiment into the subconscious

world. . . . On the contrary . . . the surrealist experience is a blend (or rather a struggle) of the rational and the subconscious . . . at the end of such an experience the rational mind re-emerges unscathed or only slightly changed . . . the conscious, wilful poet does exist in the *Poisson soluble*, and plays a major role in it.[44]

Can these three readings be compatibilized? In the end, it does not matter, since each correctly performs the injunction of the surrealist text: to look for frames, to engage in constructive mental activity despite the obstacles posed by the structural dislocations and semantic incompatibilities of the text. Jenny comes the closest to an intuitive understanding of the pragmatic import of the surrealist text when he asserts: "The play on words . . . makes an essentially dynamic reading obligatory."[45]

The final study, Michael Riffaterre's "Semantic Incompatibilities in Automatic Writing,"[46] rightly concentrates on the *reading* elicited by the "automatic" text—a reading characterized, Riffaterre suggests, by the "automatism effect." This effect is created by discrepancies between the frames established and the semantic and discursive elements of the text. The reader is forced into a series of "rationalizations" in order to try and make sense of the reading. He is forced back onto his own knowledge, so that any frames he has at his disposal will be useful for the deciphering process: "The text's grip on the reader is exactly that of subconscious memory itself."[47]

The interpretations of "automatic" texts are therefore potentially infinite, although the structure of the reading is well-defined. The reading of a surrealist text is a matching process in which the reader tries to account for the regularities and anomalies according to frames stored in memory. Jenny, Adam, and Ariew go wrong in trying to salvage the "order" of the text. Riffaterre rightly insists instead on the phenomenon of "disorder." Yet in another sense he does not go far enough, preferring, like Jenny, to deny the referentiality of the text and to ascribe the semantic incompatibility between lexical items and the discursive discrepancies to "literariness." Instead, it should be seen that the mode of reading is itself referential—it teaches the reader, not just to search his memory for old frames, but to construct new ones. The "automatic" text refers, through the mechanism of reading it activates, to the mode of thought that can best be characterized as "poetic revelation," in which the experience of language becomes a training ground for the reader's subsequent experience of the world.

The picture of "automatic writing" that emerges from the studies just mentioned is of texts that allude to conventional discourse structures while flaunting the semantic incompatibilities between their individual elements. The reader who confronts these texts is led to engage in constructive mental activity centering around frames that have semantic as well as syntactic implications. The metaphors in "automatic writing" cannot be dissociated from the overall narrative or other discursive frames, since they are partially

compatibilized by semantic field systems that are extended beyond the sentence level.

Riffaterre describes the lack of logical relation between words in "automatic writing" as "semantic incompatibility"; yet this still does not resolve the problem of defining semantic incompatibility linguistically and accounting for the fact that semantically incompatible combinations of words can be understood as metaphors. For a better understanding of this process of metaphorization, a componential theory of semantics allowing the encoding of words according to a limited set of semantic features is helpful. Under such a system, acceptable combinations of words can be controlled by matching rules (selection restriction rules) while semantic incompatibility can be defined as a violation of those rules (selection restriction violations). A metaphor under this system is a semantically incompatible combination of words capable of undergoing a process of compatibilization because of the surrounding context.[48]

In a componential system, nouns are given a code that classifies them according to a number of attributes ("features"). For instance, in classifying a noun, it is necessary to decide whether it is human, or living, or has spatial extension. Nouns that do have spatial extension will furthermore be classifiable by size, convexity, and concavity. Non-substantial nouns, on the other hand, can be events, states, or mental entities.[49]

In practice, the code of a noun will determine which verbs and adjectives can be combined with it (matched to it). In a normal matching process, a verb can only match a noun which is coded "yes" or "maybe" at every corresponding point of the verb's semantic code. "Semantic incompatibility" in a componential system means that two words that should not have matched are found together in a text. The restrictions governing word combinations have been "ignored."

In addition to its semantic code, a noun may also be given a "possession code" listing the features of those things it can possess. Correct matching will ensure that the noun only possesses things normally attributable to it. Finally, the "semantic field" code of a noun is an extension of the componential principle to semantic fields; here, nouns are encoded according to their adherence to a limited list of "core" concepts.

A componential system offers the possibility of producing models of texts by reproducing the matching process. This can be done either to generate "normal" texts or to make models of deviant ones. A model of a surrealist text would try and reproduce the same types of "mis-matches" found in "automatic writing" by making changes in the codes used in the matching process. If the mechanisms of the text are of sufficient predictability as to allow for a fairly comprehensive linguistic description, then a text-generative model—one that would simulate the "automatism effect" by computer methods—should be able to produce texts that would be accepted by readers as examples of "surrealist automatic writing."

Because *disorder* is an element of the "automatic" text, such an approach is preferable to the recuperative methods of Jenny, Adam, and Ariew. Computer-generated texts can simulate disorder as well as order; moreover, the computer model offers an experimental method of text analysis according to which the model can be continuously improved as the descriptive powers of the theory yield more and more accurate results. Naturally, the model will never be as aesthetically pleasing as the original; but the successive stages of its elaboration make it possible to judge the value of the theory by ever closer approximations. The model proposed below is based on an analysis of Breton's and Soupault's "Eclipses," whose discourse structure was discussed in chapter three.

The semantic organization of "Eclipses" is somewhat parallel to its syntactic organization. The preceding chapter showed how the "form" of continuity is maintained without many of the conventions readers habitually associate with the concept of continuous discourse; similarly, certain forms of semantic consistency are maintained in "Eclipses" at the same time that most of the conventions normally accompanying those forms are violated.

In "Eclipses" consistency is partially aided by the grouping of nouns in semantic fields, as previously mentioned; on the other hand a prominent feature of the text is the systematic violation of selection restrictions in word combinations within individual sentences. Most of the violations fall into a limited number of types: possession, subject-verb matches, noun-adjective matches, and "is" clauses. Some typical mis-matches are given below (for a fuller explanation of the terminology and procedure, see the appendix):

subject-verb matches
—*of a human attribute to a verb requiring a human subject* ("sentiments blanch")
—*of a non-living noun to a verb requiring a living subject* ("the cloud comes running," "balls of cotton give birth")
—*of a non-substantial noun to a verb requiring a substantial subject* ("theories dance")
—*of a non-human (but human-sized) noun to a verb requiring a human subject* ("smoke-fumes arrange a rendezvous")
—*of an animal to a verb requiring a human subject* ("an insect forgets himself")

noun-adjective matches
—*of a non-durative adjective with a durative noun* ("relative sighs")
—*of an adjective normally attributed to a human with a non-human (but human-sized) noun* ("melancholy seconds," "sentimental clouds")
—*of an adjective normally attributed to a living thing with a non-living noun* ("breathless record")
—*of a non-mental adjective with a mental noun* ("current dreams")

—*of an adjective normally attributed to spatially extended nouns with a noun lacking spatial extension* ("obscure silences")

possession
—*of a substantial by an insubstantial* ("organs of joys," "promontory of our sins")
—*of a living attribute by a non-living thing* ("murmurs of stars")
—*of a human attribute by a non-human* ("cares of parasites")
—*of a large object by a smaller one, except in the case of humans* ("church of lobster")

"is" clauses
—*equation between a non-human and a human noun* ("the dream is a villain")
—*equation between a non-living noun and a living part* ("the star is an eye")
—*equation between a non-substantial noun and a substantial one* ("the bouquet is an abuse")
—*equation between a concave noun and a convex one* ("the hole is an organ")

The computer research, which was divided into three stages, showed the gradual approximation of the model to the original and marked the progression from the production of "nonsense" strings to surrealistic metaphors capable of producing the "automatism effect."

In the first stage, a program was written to combine randomly selected words into sentences. Each sentence contained only one mis-match (of the types outlined above). These were produced by changing the noun code so that it would match an improper verb or adjective according to the typology previously established, or by changing the noun's possession code so that it would possess improper objects, attributes, or states.[50] The resultant sentences read like nonsense strings except where the lexis permitted a "metalinguistic" reading in which the sentences could be interpreted to refer to the generation process or the reading process:

> *The chateau's approval dazed the languid spider* (mis-match of possession: a human attribute is possessed by a non-human).
> *The spider trembled* (mis-match of an intransitive verb: a verb normally matched to a human is matched to a non-human subject).
> *The brain ended the imperceptible approval* (mis-match of a transitive verb: a verb normally matched to a human is matched to a non-human subject).

The following sentences could be read metalinguistically:

> *The imperceptible understanding damaged the brain* (the mis-matched adjective seems to refer to the minimal sense of this computer output).

The splendid story lacked the imperceptible understanding (this appears to refer to the difficulty readers have with the text).

In the second stage, discourse continuity was added in the form of pronouns; compound sentences were created by the addition of "and" and "but." The result was the creation of a rudimentary narrative frame, contributed to by the consistency of verb tense. At the same time, the allowance for up to one mis-match per clause assured that the narrative would be "surrealist" in nature:

> *An imperceptible fish came. He dissected a limber spider* (mis-match of a transitive verb in sentence 2: a verb normally matched to a human is matched to a non-human subject—fish—represented by the pronoun "he" ["fish" is coded as "male" in the data]).
>
> *The imperceptible spider began. She found a barren stick, and she built an imperceptible chateau* (mis-match of an adjective in the first clause of sentence 2; and of a transitive verb in the second clause of that sentence ["spider" is coded as "female" in the data]).
>
> *I mated that elaborate spider. She obtained the ring, and she entreated the reader. She gabbled. She brought about a stopping, and she went back to the ring. I wept, and she talked* (mis-match of an adjective in sentence 1; of two transitive verbs in sentence 2; of an intransitive verb in sentence 3; of the first transitive verb in sentence 4; of the second intransitive verb in sentence 4).

Sentences with "and" or "but" often read like causality, adding to the narrative continuity of the discourse:

> *The story's madman talked, but a ready candalabra fell* (mis-match of an adjective in the second clause).
>
> *That splendid movement damaged the imperceptible chamberpot, and a bridge moaned* (mis-match of an intransitive verb in the second clause).

In the third stage, semantic field continuity was added to the program by giving each noun a semantic field code that could be matched with the semantic field code of a noun from the previous sentence. This code could be used to select new nouns. Thus the random selection of a human in the first sentence could result in the subsequent selection of human emotions or body parts (and vice-versa); or the random selection of a building could result in the subsequent selection of roofs, parapets, and rooms (and vice-versa).

Semantic field continuity made it possible to generate linked metaphors when a mis-matched possession became the noun used as the basis for the selection of the next noun:

> *A story's madman winked. A spider's body fell, and a reader began.*

In this sequence, "madman," which is a possession mis-match to the noun "story," calls up the noun "body" by a semantic field match. "Body" properly matched "spider" in a correct possession match; thus a metaphoric use of a word becomes a generative mechanism for the narrative progression of the text—a typical feature of surrealist discourse.[51]

Like the sentences of the original text, "Eclipses," the sentences from the second and third stages of the computer program are examples of metaphoric meaning that can be compatibilized by the reader. This is because they are embedded into a discourse displaying enough continuity to allow the construction of conceptual frames to accommodate the violation of conventional semantic codes. This suggests that the text modelling approach is one way in which one might investigate the role of cognitive frames in the organization of experience.

A construction theory of film metaphor

The film medium generates the same sort of "frame" expectations as literature; these are based on cultural knowledge (including knowledge of "frames" peculiar to film) as well as knowledge common to the phenomenology of human experience. In film manuals, it is common to speak of "framing" an object, meaning to organize the object, with or without its surroundings, within the space of the image. Although this is not the sense in which "frame" is used here, it does point out that considerations of perceptual organization are a fundamental part of the communicative message of film.

In terms of cultural "frames," the way film narrative organizes images into a discourse is related to language mechanisms. The construction theory of language posits that the language of a culture divides reality in definable ways; this act of lexicalizing the real world ultimately colors the perception of the world by the users of the language. Linguistically influenced perception must carry over into any art form that attempts to communicate through a discourse, since the parameters of topicalization, action, and description will be common to any discourse of that culture.

However, the "frames" peculiar to the film experience may enter into conflict with frame expectations generated from the phenomenology of human perception. Film is a coded sign system that must be learned, as experiences with "naive" viewers have demonstrated. Viewers with no previous experience in narrative cinema will tend to foreground any sort of motion in preference to narrative topics, because of the perceptual orientation of the human eye.[52]

In film the identification of the "topic" of discourse is related to the viewer's ability to make the distinction between the figure and the ground of the image. As defined by Rudolf Arnheim, the figure/ground distinction

refers to the perceiver's splitting up the content of a two-dimensional image into a three-dimensional structure when this will make for a simpler explanation of the perceptual information.[53] Many Gestalt assumptions about visual perception—such as the identification of the figure on the basis of good continuation, convexity, and contour—are helpful in establishing the figure in film images. But the variations in film perspective (e.g., the going from a closeup shot to a long shot) require other practical detection devices for the identification of the figure: percentage of screen area occupied, frontality (non-distortion), luminosity, and the presence of motion.

The "topic" of a film discourse is a figure that becomes the focus of attention. Gestalt theory calls this "convergence."[54] In narrative films where a person is the "topic," the actions of that person usually constitute the "comment." The combination of topic and comment creates the film narrative, or diegesis.

In literary texts, the discursive aspect of metaphor points the reader toward the creation of a "fictional world" in which the metaphor is compatibilized. Film metaphor poses special problems because the elements to be integrated into the fictional world are visually present. As concrete visual information, they lose the advantage of abstraction that many verbal images have. If a woman is to be compared to a rose in a film, it will be a specific rose, not just the abstract idea of one.

One type of film metaphor ("diegetic metaphor") takes an element from the diegetic space of the narrative and foregrounds it so that the viewer "topicalizes" it in a way that relates it semantically to the main topic.[55] Another type ("non-diegetic metaphor") juxtaposes the "topic" with a non-diegetic element presented as a "comment": a crowd at a subway entrance juxtaposed to a flock of sheep.[56] Although the effect of such juxtapositions can be quite humorous, their import is usually didactic. Sergei Eisenstein, who used the cinema for the ideological manipulation of his public, was fond of such metaphors by juxtaposition, while Chaplin and others used the device for comic effect (as in the example above, from *Modern Times*).

Whatever their status, film metaphors reveal the presence of an intrusive narrator who invites the spectator to correlate the information of the diegesis with that offered by the diegetic or non-diegetic metaphor. As in literature, understanding metaphor requires an act of construction on the part of the viewer.

This constructive activity can most easily be observed in the case of recurrent metaphors that stimulate the "frame-making" activity of the viewer through the reinforcement of repetition. Buñuel's *Los Olvidados* (1950) relates several days in the life of a street gang in Mexico City led by Jaibo, a juvenile delinquent. Jaibo, who has just escaped from a reformatory, murders Julian, whom he suspects of having turned him in, with the aid of

Pedro, a younger boy. After Pedro denounces him, Jaibo murders him as well before being shot to death by the police. Recurrent diegetic metaphors are provided by the chickens and roosters, natural inhabitants of the diegetic space (an urban shanty-town) that gradually build into a matrix of complex associations. The occurrences can be divided into twelve separate instances:

1. The gang of delinquent boys, led by Jaibo, attacks a blind man. As he lies in the dust after the boys have left, a chicken comes up to him and lets out a screech.
2. The preceding scene cuts immediately to Pedro who has gone home and is fondling a chicken who has just laid an egg.
3. Jaibo warns Pedro not to tell the police it was he who killed Julian; after the departure of Jaibo, chickens go by in the background.
4. At home, Pedro has a dream that begins with the sound of chickens clucking. In his dream, a hen flies down from the ceiling; Pedro looks under his bed and finds the bloodied body of Julian. Chicken feathers rain down on the body.
5. Pedro is at home petting a hen and some chicks when a neighbor's rooster lands on the fence with a screeching sound. In the background, Julian's father can be heard demanding that his son's murderer be found.
6. Pedro tries to tell his mother he has found a job; she yells at him as he tries to kiss her hand; a loud screech is heard as the neighbor's rooster again invades the yard. Pedro's mother beats the rooster with her broom; this reminds Pedro of Jaibo's murder of Julian with a stick. As in that scene, he shouts "Enough, enough!"
7. Jaibo comes to seduce Pedro's mother; he observes her squatting on the floor with some baby chicks.
8. Pedro's mother sends him to a chicken farm after learning that he has stolen a knife; at the farm he steals eggs, and when the other boys denounce him, he reacts by killing two chickens with a stick.
9. Pedro is locked up; in the "cell," he draws the outline of a flying chicken on the wall.
10. The Farm Director asks Pedro if he killed the chickens because he really wanted to kill him but didn't dare. When Pedro answers in the affirmative, the Director warns him that "even chickens can take revenge."
11. The blind man chases Pedro out of his house, where he has taken refuge. "Ojitos," a young boy who was living with the blind man, is forced to leave as well; as he leaves, the sounds of chickens and a rooster are heard in the background.
12. As Pedro returns to the loft where he has been sleeping, a chicken cackles. Jaibo is there waiting for him. After Jaibo kills him, a chicken walks over his body.

The first three instances are not construed as metaphoric by the viewer, but the accumulation of later instances, particularly those marked by symbolism (the dream in 4; the parallelism with Julian's killing in 6 and 8) force the viewer to reinterpret these earlier appearances of the "chicken metaphor." By the end of the film, any chicken or rooster appears metaphoric, even though the instances noted in 11 and 12 are not strongly marked.

Semantically, the "chicken metaphor" is complex, having overtones at once of aggression (1, 6, 8, and 12), love and sexuality (2, 7), or a combination of the two (4, 5). In the course of the diegesis, the helpless hens become identified with woman and with Jaibo's victims, while the aggressive rooster is identified with Jaibo. Through this identification, the "chicken metaphor" becomes a prediction device; in 3, the chickens restate Pedro's powerlessness in relation to Julian; in 9, Pedro's drawing of a flying chicken portrays his desire for liberty. In 10, the parallel between killing helpless chickens and harming those less powerful than oneself is verbally expressed by the Farm Director. Thus the stage is set for Jaibo's killing of Pedro, ominously noted on the sound track in 11 before the murder is accomplished in 12. In this way metaphor becomes a form of discourse continuity.

Among the twelve instances noted, some have a relatively strong metaphoric connotation, others a relatively weak one. A strong connotation arises when the chicken element is topicalized in the discourse, a weak one when it remains untopicalized, and so fails to activate the viewer's "frame-making" activity. However, subsequent topicalization may encourage the viewer to modify the memory frame of the earlier instances thus making them metaphoric in retrospect.

In addition, the film style of an individual director may cue the experienced viewer early on to topicalize certain elements (and hence to become aware of their metaphoric import). In Buñuel's films, for instance, domestic animals are recurrent metaphors for family relations (helplessness, dependency, and mothering). These include dogs (a small dog that gets kicked in *L'Age d'or*; a farmer's dog tied to a farm wagon in *Viridiana*; the "mangy dog" imagined by the dying Jaibo in *Los Olvidados*); donkeys (the dead donkeys in *Un chien andalou* and *Las Hurdes*); and cows (the cow on the bed in *L'Age d'or*; the cows standing behind Buñuel's mother in his screenplay, "A Giraffe"[57]).

Surrealist metaphor: film

Writing about the Marx Brothers film *Monkey Business*, Antonin Artaud comments that the last scene exemplifies the "dissonance" that he seeks to create for the spectator in his own "theatre of cruelty":

> It is only at the end that things get out of hand and that objects, animals, sounds, master and servants, host and guests, everything comes

to a boil, goes mad, and revolts, amid the ecstatic and lucid comments of one of the Marx brothers, excited by the spirit which he has finally managed to unleash and of which he seems to be the dazed and temporary commentator. Nothing could be at once so hallucinatory or so terrible as this kind of manhunt, this final showdown, this chase in the twilight of a cattle barn, a stable with spider webs hanging everywhere, when men, women and animals go berserk and land in the middle of a pile of incongruous objects whose *movements* or *sounds* will each be used in turn.[58]

In the scene described by Artaud, Groucho and Chico have arrived at an old barn where they know a kidnapped girl has been taken. Instead of behaving like rescuers, however, they settle down for a picnic in the hay—re-framing the event from "melodramatic rescue" to "picnic." This picnic is interrupted by one of the kidnappers, and the fight begins. It proceeds by piling one gag on top of another: Harpo and Chico turn a wagon wheel as though it were a roulette wheel and deal out blows to the "winners"; Groucho grabs a carriage lamp and uses it as a microphone while he comments on the "fight," supplying advertisements in between his coverage; Harpo sits backwards on a horse and directs the battle with Napoleonic gestures; Chico sits on a cow and sounds the rounds of the "boxing-match" with a cowbell. The fight is thus successively re-framed as a gambling game, a boxing match, and a military battle. The viewer must be simultaneously aware of all of the "fictional worlds" activated by these metaphors in order to appreciate the comedy.

The similarity between jokes and metaphors, so engagingly dramatized in this film, has been noted by many who have written on the subject of metaphor. In *Le Rire*, the philosopher Henri Bergson writes that "there is but a slight difference between the play on words, on the one hand, and the poetic metaphor or the instructive comparison, on the other."[59] The philosopher Max Black contends: "There is an important mistake of method in seeking an infallible mark of the presence of metaphors. The problem seems to me analogous to that of distinguishing a joke from a non-joke."[60]

In Surrealism these two devices—humor and metaphor—come together in "black humor," which Breton defines as the "superior revolt of the mind."[61] Max Ernst explained the mechanism of surrealist collage as a product of black humor: "It seems to me one can say that collage is a hypersensitive and rigorously true instrument, like a seismograph, capable of registering the exact quantity of possibilities for human happiness in each epoch. The quantity of black humor contained in each authentic collage is found there in the inverse proportion of the possibilities for happiness."[62]

Black humor is abundant in *La Femme 100 têtes*, where shipwrecked passengers bear their fate with equanimity (plate 18) and God comes as an apprentice to the alchemist (plate 14). Collage, with its juxtaposition of

elements from different contexts, is the visual equivalent of Breton's surreal-
ist image; indeed metaphor used as black humor is frequent in Breton's and
Eluard's "Eclipses." The so-called "eclipse" announced in the title is the
buried sun that burns at the center of the earth. In a mockery of leisure
society that parallels the armchair seafarer of *La Femme 100 têtes*, Breton
and Eluard describe the departure of certain ladies for the center of the
earth: "Some nice fire-damp explosions are in the offing as, with heads
lowered, the elegant ladies leave for a voyage to the center of the earth. They
have been told about buried suns."[63] The voyage described by the poets is
not helped by the fact that the crocodiles are "redemanding the suitcases
made with their skins"—a demand that may serve to shape our understand-
ing of Ernst's fleeing traveler (plate 6).

In a surrealist film such as Buñuel's *L'Age d'or*, the inclusion of disparate
elements within the same sequence, or even within the same shot, has the
effect of an animated collage. The humor in these juxtapositions is used for
ideological effect, in order to affirm the superiority of the rebellious spirit
over the established orders of the church, family, and social conventions.
Artaud's conception of humor is similar:

> If the Americans . . . refuse to see these films as anything but humorous,
> and if they insist on limiting themselves to the superficial and comical
> connotations of the word "humor," so much the worse for them, but this
> will not prevent us from regarding the finale of *Monkey Business* as a
> hymn to anarchy and total rebellion. . . . And the triumph of all this is in
> the kind of exaltation, both visual and auditory, that all these events
> acquire in the half light, in the degree of vibration they achieve and in the
> kind of powerful disturbance that their total effect ultimately produces on
> the mind.[64]

In speaking of the "total effect," Artaud underscores the way this scene
pushes at the limits of sense, since the viewer is forced to accommodate
many simultaneous frames. Indeed, the scene he describes corresponds
rather well to his theory of sensory "overload," according to which the
theatre spectator was to be assaulted by sounds, lights, and movements. As
has been seen in previous chapters, a crucial element in Surrealism is the
preservation of a minimal frame that provides the basis for subsequent
frame transgressions. Without such a surrounding frame, the reader or
viewer would cease to be interested in the work, and the process of mental
transformation halted. In addition, there are limits to the amount of
information people can process at one time; although the viewer of *Monkey
Business* has no trouble dealing with three or four simultaneous frames, ten
would probably be too many.[65]

Buñuel's *L'Age d'or* (made partly in collaboration with Salvdor Dali)
illustrates many of these points.[66] The narrative frame is provided by the

actions of two characters whose passionate love disturbs the institutions of society. Overlaying this frame, however, are extraneous elements that multiply the discourse with metaphoric signification.

The film is divided into four diegetic segments. Seen as a whole, two of these appear to have a metaphoric relation to the segments that precede or follow them:

1. A documentary on scorpions.
2. The ceremony of the "founding" of Rome, conducted in a desolate landscape by government and religious officials in modern dress, and observed by the leader of a gang of bandits. The ceremony is interrupted by the cries of a man and woman making love in the mud.
3. The modern city. The man, arrested, is led down the street by two policemen. They release him when he proves that he is an important personage. Meanwhile, the woman is preparing for a formal reception at her parent's house. During the reception the lovers are momentarily united.
4. The Duke of Blangis and his three friends leave the Chateau de Selliny where they had locked themselves up for 120 days in order to celebrate a sexual orgy (based on the Marquis de Sade's *120 Days of Sodom*).

By juxtaposing these segments, Buñuel goes even further than he did in *Un chien andalou* to foreground the metaphoric discourse over the diegesis. Segment one, for instance, as the first element of the film, at first appears diegetic; only later does the viewer realize that it functions as an extra-diegetic metaphor for the second segment.

In this second segment, which, according to the intervening title, takes place "some hours afterwards," the bandits are shown to live in a habitat similar to the scorpion's—a hot, arid wasteland almost devoid of vegetation. Just as the scorpion burrows beneath stones, and "ejects the intruder who comes to disturb its solitude," so the bandits "hole up" in a dilapidated shack and come out only to attack the Majorcans who land on their shore. Unlike the scorpion who kills the rat, however, the bandits' attack on the Majorcans is unsuccessful. They are so weak, they never even get to the shore.

Assuming that it is no accident that the leader of the bandits is Max Ernst, the bandits themselves may be metaphors for the artist's attack on society. The scorpion's love of solitude coupled with his "virtuosity in the attack" then reflects back on the social role of art and the artist. Corroborating this supposition is an intertextual consideration: the scorpion's attack parallels the attack on the spectator in the prologue to *Un chien andalou* (where the aggressor is played by Buñuel himself). The enumeration of the bandits' instruments lends further support to the claim that they have metaphoric

status as artists: they are said to have a rather eclectic assortment of objects ("accordions, hippopotami, keys, climbing oaks . . . and paintbrushes").

The focus of the artist's attack on society (that the metaphoric discourse has represented as a rat) becomes clear when an austere company of government and church officials (the "Majorcans") disembarks for a ceremony on the shore. They had been preceded by the arrival of four archbishops (observed by the bandit leader) who have turned to skeletons by the time they arrive. This inaugurates the "black humor" that prevails throughout the rest of the film. In this segment, instances of "black humor" are provided by:

1. The interruption of the ceremony by the two lovers.
2. The man's kicking a small dog and crushing an insect.
3. A shot of the woman on a lavatory seat, juxtaposed with a shot of volcanic lava that looks like boiling sewage.
4. A title announcing the founding of "imperial Rome" followed by a shot of a pat of cement the governor places on a stone (in context, the pat of cement becomes associated with excrement).
5. A sequence of shots that move from the Vatican "the secular seat of the church" to a note stuck on a window-pane ("I've spoken to the landlord," etc.).

The third segment (the modern city) differs from the others in that extradiegetic elements begin to appear in the diegetic space of the narrative, producing the "animated collage" effect. These mis-matches would correspond to a possession mis-match in "automatic writing," if only because the "frame" situation can be equated with a "whole" while the extraneous element assumes the role of an unmatched "part." The mis-matches include a cow found lying on the bed in the young woman's bedroom; a mirror in the bedroom that reflects the open sky (rather than the young woman) and from which a breeze appears to blow; and a horse-drawn farm cart that lumbers through the salon (plate 36).

At the same time this segment continues to include instances of "black humor"—actions by characters that, because the cause-effect relation seems unhinged, are understood by the viewer as moments of anarchic (and anti-social) liberty:

1. A respectable-looking gentleman walks along a city street kicking a violin before him.
2. The hero of the story, before climbing into a taxi, kicks a blind man.
3. A maid comes rushing out of a burning kitchen into the salon where the reception is taking place and is ignored.
4. A father shoots his son for knocking down his cigarette; the salon guests assemble on the terrace to comment on this event.

36. Animated collage in film / Luis Buñuel, *L'Age d'or*

37. Black humor in film / Luis Buñuel, *L'Age d'or*

5. The hero of the story slaps the Marquise (the heroine's mother) who has accidentally spilled a few drops of wine onto his hand and knee. (plate 37)

The final shots of this segment combine both "black humor" and "animated collage" as the sexually frustrated and enraged lover tears apart the woman's bedroom, throwing things out the window that should not be there: the bust of a Roman Senator, a plough, a whole pine tree on fire, a live archbishop, and a stuffed giraffe.

Like the first and second segments, the third and fourth are linked in diegetic time by title: "At the exact moment when these feathers, torn out by his furious hands, covered the ground below the window . . ."—a link emphasized by the drum accompaniment that begins in the bedroom scene and continues uninterrupted almost to the very end of the film. In this final segment, Buñuel's play on the Marquis de Sade's *120 Days of Sodom* is an homage to Sade's rebellious quest for freedom of thought. This section is a metaphor for the freedom from social constraint the protagonists have sought throughout the film. Here too, "black humor" is not absent:

> A little girl, about thirteen years old, appears on the threshold, terrified, dressed in a long white dress. She is clutching at her breast with a blood-stained hand. She falls, exhausted, on the threshold. The Duke of Blangis slowly recrosses the drawbridge, picks up the girl tenderly, and assists her back into the castle. For a brief while, nothing happens. Then, we hear a terrible shriek coming from inside the castle. After a few seconds, the same character, impassive, comes out to join the others. (71)

In the interim, the Duke, who at first bore a strong resemblance to the conventional representation of Christ, has lost his beard. A final jab against religion comes in the last shot, accompanied on the sound track by a light "paso doble": "A snow-covered cross with the scalps of many women, white with snow, hanging from it and blowing fiercely in the wind" (71).

In the previous section it was noted that sound, as well as the image, may be used to produce metaphoric effects. Although *L'Age d'or* was one of the first sound films, Buñuel managed to use sound with great sophistication, leading one critic to remark:

> On the sound track alone, practically every device known to the modern cinema—interior monologue, overlapping and distorted sound, recurrent aural leit-motifs, appropriate music intensifying what is happening on the screen and deliberately inappropriate music producing dissociation from it—is to be found, and used so rightly and unobtrusively that for many years apparently it never even occurred to anyone to think the film very revolutionary in this respect at all.[67]

Whether synchronized as ironic commentary or asynchronous, sound is employed by Buñuel to disorient the viewer's conventional interpretation of

the images: the heroine talks of hiring six musicians but instead we see and hear an entire orchestra; at the height of romantic passion she murmurs ecstatically: "What joy! What joy! To have murdered our children!" (65). Sound is perpetually mis-matched with the image: it is used metaphorically. In this capacity, it contributes heavily to the distancing of the spectator from the action and undercuts any possible identification with the characters. The spectator is continually reminded of his or her membership in the bourgeoisie which the film attacks.

On the simplest level, there is often a humorous relation between the title of a piece of music and the segment that it accompanies: Mendelssohn's "La Grotte de Fingal" for the segment on scorpions; Mozart's "Ave verum" for the archbishops and the disembarking dignitaries; Debussy's "La Mer est plus belle" for the bandits' abortive trip to the sea; Mendelssohn's "Italian Symphony" for the Vatican shots; Wagner's "Murmurs of the Forest" for the episode where the mirror comes alive with natural objects.[68]

Music also supplies an ironic tonal counterpoint to the action shown on the image track. The first shot inside the bandits' den shows two bandits inexplicably trying to thread a rope through a pitchfork and a pole, to the accompaniment of Beethoven's "Fifth Symphony." The salon reception in the next segment is admirably synchronized to Schubert's "Unfinished Symphony"—the actors' movements are as carefully choreographed as a ballet.

Another device is ironic timing: violin music plays just as a man is seen walking down the street kicking a violin; birds begin to sing the moment the hero and heroine are alone in the park; their first kiss coincides with the first note of the orchestra playing Wagner's "Liebestod." In some cases, the music itself is made fun of: the loud pomposity of symphonic music cancels out the realistic sound of a wall tumbling down (in the Rome segment) or of a farm-cart rumbling through a drawing-room (plate 36).

Unsynchronized sound is also used, producing mis-matches that have the effect of metaphor. The mayor's speech does not match his lip movements, underscoring the futility of his words; Mozart's "Ave verum" does not come to a halt when the dignitaries discover that the archbishops have turned to skeletons, suggesting that they are perfectly happy with a decayed and corrupted church.

Buñuel's most powerful metaphor in the film uses sound to fuse the subjective consciousness of the two lovers and to unite them despite their physical separation. After the heroine chases the cow off her bed and out of the room, the cowbell is heard off-screen while she arranges herself before the mirror. This is followed by a shot of the hero being led down the street with the cowbell heard as an off-track sound (it is outside the diegetic space of the scene).[69] A dog that is *in* the hero's diegetic space begins to bark, and the barking continues over onto the next shot of the heroine. Wagner's

"Murmurs of the forest" starts up with this shot, and the sound of wind is heard as her hair begins to blow and floating clouds appear on the mirror. At this point, a blend of sounds is heard: the cowbell, the barking dog, Wagner, and the blowing wind. The combination of sounds from two distinct diegetic spaces is an optimistic comment on love's capacity to conquer time and space.

Though Buñuel shows in later segments that this love cannot prevail against the present condition of society, his unique homage to "l'amour fou" prompted the surrealists to publish the *L'Age d'or Manifesto* in which they proclaimed: "Buñuel has formulated a hypothesis on love and revolution which touches on the profoundest aspects of human nature."[70]

Conclusion

In his theory of the surrealist image, Breton wrote that the "value of the spark obtained" was a function of the "difference of potential between the two conductors." In the frame transgressions of *L'Age d'or*, the "animated collages" as well as the instances of "black humor" derive their force from the widely divergent worlds—visual, auditory, and behavioral—that they combine. The result is an ideological effect—the viewer feels that the film has "something to say" by making these combinations. Over and above the images of disjunction, *L'Age d'or* proclaims the return of the alchemical "golden age" in which precedence will be given to passionate love.

Since this love is conceived by the surrealists as a liberation of the unconscious, it was appropriate for Buñuel to make it the subject of a film in which the devices of humor and metaphor play so large a part. Freud, after all, had already pointed out the similarities between the mechanisms of jokes and those of dreams;[71] recently, Tzvetan Todorov has extended the parallels to the devices of metaphor and metonymy.[72]

In this sense "automatic writing," too, with its highly metaphoric discourse, succeeds in reproducing the structure of unconscious mechanisms, whether or not such texts are actually faithful transmissions of their authors' unconscious thoughts. Like films that force their viewers to accept a more libidinal form of identification ("primary identification") in the absence of consistent characters, "automatic" texts force the reader to regress into the childhood experience of language. This, in any case, was the way Breton described the metaphorical mode of thought that he prized so much: "It is perhaps childhood that comes closest to one's 'real life'. . . . Thanks to Surrealism, it seems that opportunity knocks a second time."[73]

five

Image and ideology: the dynamics of artistic exchange

In Surrealism, metaphor became the central mechanism for the pragmatics of disorientation espoused by the artists. Certain metaphors also functioned as models for dadaist and surrealist poetics. The "figurative alchemy" of Surrealism (the formulation is from Maurice Blanchot) has already been discussed at some length; two other metaphor-models, centering around images of the eye and the machine, functioned as large-scale figural complexes within Dada and Surrealism, making it possible to establish the exchange between the artists, poets, and filmmakers of the two movements.

Because of its perceptual function, the eye was frequently used to interpret theories of perception and inner vision. In this capacity it was often linked to another set of images centering on the machine, which came to represent the artist's inventive act and the constructed work of art. Combined, the images thematize the perceptual processes of the intended readers or perceivers. The presence of the images in so many works points to the fact that the dadaists and surrealists were among their own best readers, and that the transformative injunction of the alchemical model can be found to apply to their relations amongst themselves.

On the other hand, there is much in contemporary literature that can be understood as a "response" to the reading of dadaist and surrealist works; these relatively late flowerings of the ideologies of the movements will be discussed in the final section of this chapter.

Dada: the work as machine

The dadaists' attitude toward machines was ambiguous. On the one hand their abhorrence of military applications of technology made them turn away from "useful" machines; on the other hand, their works testify to a fascination with the mechanical. Their revolt against artistic convention extended to a critique of the social functions of art, and their reiterated insistence on the non-uniqueness of the art work comes close to what Walter Benjamin, in his essay "The Work of Art in the Age of Mechanical Reproduction," characterized as the modern art work's lack of "aura."[1]

Yet Benjamin is not absolutely right when he asserts that Dada sought to remove the aura from the work of art. Instead, the gesture of the artist was often to make an ironic comment by consecrating objects that could only be defined as "art" by a stretching of definitions. In a ready-made, such as the urinal Duchamp used for the creation of "Fountain," the aura exists within the artist's act of apperception, rather than in the work itself: "Despite the prevailing idea that Duchamp has abandoned art, the high spiritual plane on which all of his activity is conducted converts every product, whether a personally selected 'ready-made' or dada installation of a surrealist exhibit, into a work of art."[2]

This is merely an extension of the convention according to which the artist is the source of the work's "aura"—here, it is his gesture that turns everyday objects into art. In defense of "Fountain" Duchamp (writing under the pen name "Louise Norton") states: "Whether Mr. Mutt with his own hands made the fountain or not has no importance. He CHOSE it. He took an ordinary article of life, placed it so that its useful significance disappeared under the new title and point of view—created a new thought for that object."[3]

Art, in this tongue-in-cheek defense, is defined as a perceptual act legitimized by the artist—the meaning of a dadaist sculpture or painting lies not in its representation but in an intellectual perception. Such dadaist works as Duchamp's "To Be Looked at (From the Other Side of the Glass) with One Eye, Close to, for Almost an Hour" (1918) make fun of the perceptual activity that, in turn, is required of the viewer. Sometimes there is even a moral overtone: the title of Picabia's "L'Oeil cacodylate" (1921), a canvas signed by Picabia's dadaist friends, plays on the name of a medicine (cacodylic acid) in order to convey the impression that the work is a kind of "cure" for false perceptions (in this case, the idea that it is the artist's signature that validates the work). Picabia's own contribution to the painting is a large eye (plate 38) and a mock-eloquent defense: "This picture was finished when there was no more unfilled space. . . . I was told it was not a painting . . . I think that a fan covered with autographs does not become a samovar. That is why my painting, which is framed, and made in order to be hung up on a wall and looked at, cannot be anything other than a painting."[4] Picabia's defense centers around the contextual aspects of the work, defining its status as a painting by appealing to pragmatic considerations of use. As an outgrowth of this attitude, the dadaist work itself is often represented as a machine capable of empowering the viewer to make a breakthrough in perception.

Against the repressive, "productive" machine, the dadaists posed the "celibate machine," or machine that, producing nothing, is "pure invention."[5] Picabia's "Optophones" and Duchamp's "Rotoreliefs" integrate perceptual and mechanical themes by presenting themselves as machine-like

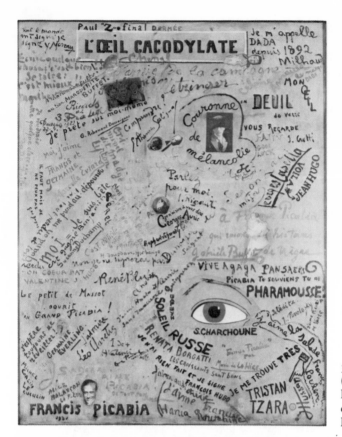

38. L'Oeil cacodylate ("Cacodylic eye") / Francis Picabia, 1921 (Centre National d'Art et de Culture Georges Pompidou)

disks with abstract designs. "Optophone II" has an eye in its center, reminding the viewer that the "optophone" was supposed to be a "telephone for the eye" (plate 39). Duchamp made some of his "rotoreliefs" into toys that could be set on top of record-players. As is the case with the "ready-mades," the aesthetic function of these works is not a matter of representation but of the perceptual activity they elicit from the viewer.

In "Optophone II" the sexual connotations of the eye are enhanced by the bodies of nude women arranged around the center of the circle.[6] In many dadaist works the "celibate machine" becomes a "desire-machine" of mechanized eroticism. Here it is possible to speak of literary parallels. In *Anicet*, Louis Aragon's narrator compares orgasm with the operations of machinery:

> Anicet junior becomes quiet at the very moment that he passes from desire to satisfaction. At first, his capacity for thought, too weak, abandons him at the heart of the matter. Then he attains a fugitive paroxysm, remaining there like a machine at its still point, like a boat at the crest of a

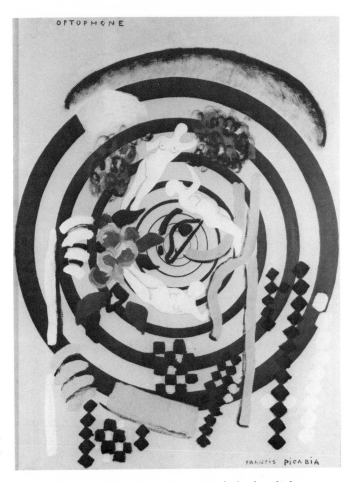

OPTOPHONE

FRANCIS PICABIA

39. *Optophone II* / Francis
Picabia, 1923 (Musée
d'Art Moderne de la Ville
de Paris)

wave. And suddenly everything crumbles within him. He feels the slight tremor which one feels in a descending elevator.[7]

Probably the most eroticized "celibate machine" is Duchamp's enigmatic work, "La Mariée mise à nu par ses célibataires, même" ("The bride stripped bare by her bachelors, even" or "The bride stripped bare by her bachelors loves me" [*m'aime*]). In constructing this work, Duchamp employed methods as precise as though he were conducting a scientific experiment. He collected dust on the work for a year, then carefully affixed some of it to the finished product; he devised new standards of measurement by dropping lengths of string on the floor and studying their fall patterns. Such everyday objects as a chocolate grinder were drawn a seemingly infinite number of times before being incorporated into the work.[8] Duchamp's "Large Glass" has a curious monumentality to it; it is certainly not without aura, being a

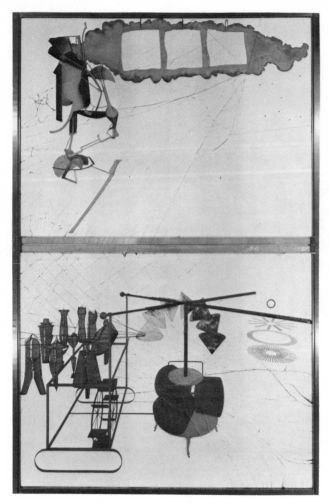

40. *La Mariée mise à nu par ses célibataires, même* ("The Large Glass" / Marcel Duchamp, 1915–23 (Philadelphia Museum of Art)

shrine of modern art (plate 40). But it is a work that cannot be dissociated from the context of its creation. Another work of Duchamp's, "The Green Box," functions as an explanation and commentary to the "Large Glass." Additional information is provided by the extensive notes, published later, that accompanied its conception and construction.[9]

The "Large Glass" is divided into two distinct sections; the top section is the "bride"; a rather waspish figure, she is crowned by several "blossoming" squares, commented on by Duchamp in his notes:

> The Bride is a motor. But before being a motor which transmits her timid-power—she is this very timid-power—This timid-power is a sort of automobiline, love gasoline that, distributed to the quite feeble cylinders,

within reach of the *sparks of her constant life*, is used for the blossoming of this virgin who has reached the goal of her desire.[10]

Duchamp's highly publicized mechanical procedures in the composition of this work made it the quintessential "celibate machine" of Dada.[11] Not only is the work mechanistic in its appearance and method of construction; passages from the accompanying text such as the one quoted above also read like the description of a machine.

Cinema is, of course, the ideal "celibate machine" as Duchamp seems to have realized in his representation of the bride's "cinematic blossoming." Benjamin writes that the cinematic medium is dadaist in its conception: "Dadaism tried to create with painting (or literature) the effects that the public looks for today in the film."[12]

Members of the dada group like Hans Richter were quick to realize the potential of the cinematic medium and to exploit its mechanical possibilities. His *Ghosts before Breakfast* (1921) exploits many of the technical tricks of the art: a firehose that rolls itself up, water that flows into a hose, a broken tea service that reassembles itself (reverse shot); men walking into a pole and disappearing (masked shot); and a branch that grows leaves within seconds; men and women who lose their beards and hair one after the other (stop-frame shots). Picabia's and Clair's film, *Entr'acte*, is a celebration of the cinema as machine that uses even more elements of the cinematic repertoire: slow and fast motion, superimposition, false match-cuts and rhythmic montage. Conceived as an anti-narrative, it is a perfectly functioning mechanical joke.

Cinema is also a "perceptual" machine since the camera, recorder of light stimuli, functions as an "eye." Man Ray turned this into a metaphor in *Emak.Bakia* (1926), where the photograph of a human eye is mounted onto a camera (plate 41), and Duchamp animated his "Rotoreliefs" in *Anemic Cinema* (1926), turning eye shapes into a visual pun.[13]

Surrealism: the work as process

In Surrealism the view of the machine becomes negative. The difference may be measured by comparing Aragon's *Anicet* (1921) to *Le Libertinage* (1924). Whereas Arthur, in *Anicet*, affirms that in his eyes "the most beautiful poems were eclipsed by diagrams, by machines" (17), the narrator-writer of *Le Libertinage* scoffs at works of art that resemble machines: "Sometimes I was like a child let loose in a machine shop: I pulled down the levers to see what would happen. Sometimes this made a huge shadow, or terrible sparks. For a while I was left at the mercy of these surprises. As a traveler is at the mercy of monuments and sites: one day he realizes the stupidity of his wonderment."[14] The machine model is no longer

114

41. The eye as perceptual machine / Man Ray, *Emak Bakia*

used as an end in itself; still, mechanistic models of composition are employed to help the artist liberate his unconscious. In place of the machine *artifact* Surrealism poses the machine *process*. The new literary model is Rimbaud, who wrote in his "Lettre du voyant" of 1871 that the poet must be a seer: "The poet becomes a seer by the long, immense, and reasoned derangement of the senses." "Automatic writing," which produces images described by Breton in terms of "mechanical sparks," follows this model; as Maurice Blanchot has written, "automatic writing is an engine of war deployed against language and thought."[15]

Conventional attitudes become identified with conventional sight; Breton and Soupault, in *Les Champs magnétiques*, write about "our eyes injected with commonplaces"; René Magritte criticizes "objective" vision in "Le Faux Miroir" ("The False Mirror," 1928) which depicts a huge eye inhabited by floating clouds (plate 42). Artaud speaks of the eye as the understanding the poet achieves in the midst of his delirium: "I give myself up to the fever of dreams, but with the intention of deriving new laws from them. I seek multiplication, finesse, the *intellectual eye* in my delirium, not spurious prophesy. There is a knife I do not forget."[16]

Though Artaud denies any intent of prophesying, the above lines, written in 1925, could be considered prophetic of the opening sequence of Buñuel's and Dali's *Un chien andalou*, in which a young man cuts through the eye of what at first appears to be a young woman (plates 24–25). The spectator's

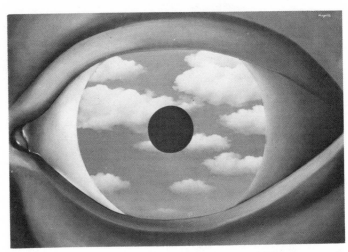

42. *Le Faux miroir* ("The False Mirror") / René Magritte, 1928
(Museum of Modern Art, New York)

reaction is invariably one of repulsion—a reaction produced even at the
second or third viewing, when the eye becomes clearly identifiable as that of
an animal. Georges Bataille explains this reaction by saying that the eye is
interpreted as the symbol of the self; therefore "the eye is an object of such
uneasiness for us that we could never bite into one."[17]

In a tome of essays collected under the title *Surrealism and Painting*,
Breton criticizes the role of the eye as passive spectator ("I affirm that the eye
is not *open* so long as it limits itself to the passive role of a mirror"[18]) and
proposes another function for it: active interpreter ("The ultimate function
of the eye . . . is to provide the guiding thread between things of the most
dissimilar appearance"[19]). This role of the eye as guiding thread is graphi-
cally rendered in Max Ernst's illustration to Paul Eluard's *Répétitions*
published in 1922 (plate 43).

As a dadaist turned surrealist, Ernst occupies an intermediary position
and some of his paintings seem to be hybrids of the two movements. In
Ernst's painting "Oedipus Rex" (1921), a hand holds an eyeball-shaped
walnut pierced by a mechanical object (plate 44). This painting bears a
graphic similarity to another Ernst drawing, "The Invention," published as
an illustration to Paul Eluard's *Répétitions* in 1922 (plate 45). Seen as a
dadaist work, the painting appears to posit a modern Oedipus brought to
ruin by technology. The apparatus that pierces the hand entraps it so that it
cannot be withdrawn into the window. If the work is "read" as a surrealist
work, however, Ernst appears to be establishing a link between inventiveness
and the powers of the unconscious. Oedipus takes on Freudian connotations
and the myth appears as a "felix infortunum"—an encounter with uncon-

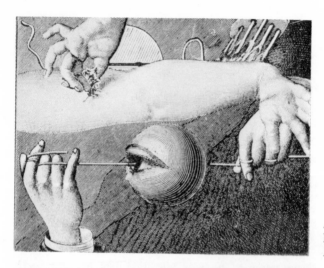

43. The eye as guiding thread / Max Ernst, illustration of Paul Eluard's *Répétitions*

44. *Oedipus Rex* / Max Ernst, 1921 (Private collection)

scious forces that ultimately prove liberating. In this interpretation the small spherical balloon that floats freely in the background may be taken as a symbol for liberated sight.[20]

Interpretation in this instance depends upon the "frames" of the viewer—the historical audience or the modern critic. The ambiguity of this work shows that perception can be an act of construction, or even of creation. "The great benefit of Surrealism has been to succeed in dialecti-

45. *The Invention* / Max Ernst, illustration of Paul Eluard's *Répétitions*

cally reconciling two violently contradictory terms in the mind of the adult: perception and representation," Breton writes,[21] while Eluard comments:

> For the artist, as for the most uncultured man, there are neither concrete nor abstract forms. There is only communication between what sees and what is seen, an effort of comprehension, of relation—sometimes of determination and creation. To see is to understand, to judge, to transform, to imagine, to forget or to forget oneself, to be or to disappear.[22]

In his poem "Vigilance," Breton uses the image of the eye as a symbol for the semi-conscious state between waking and sleeping that is ideal for the production of surrealist images: "In the hour of love and blue eyelids . . . I touch only the heart of things now I hold the thread."[23] Inner vision and love are also united in Breton's *Nadja* in which the heroine produces a drawing called "The Lovers' Flower" displaying four intertwined eyes. In Surrealism, love and sexuality are repeatedly associated with inner vision or the lack of vision: Buñuel's and Dali's *L'Age d'or*, in celebration of the "amour fou" so much praised by Breton, expresses the hero's amorous infatuation as a blinding (plate 46).

A recurrent surrealist theme is that it is necessary to blind oneself to "objective" reality in order to gain inner vision. Surrealism inverts the terms of blindness and sight, proposing various methods for acceding to true vision. Ernst proposed the *frottage* technique as a means of "liberation from blindness," a sort of visual equivalent to "automatic writing."[24] Many of the

46. Love as blindness / Luis Buñuel, *L'Age d'or*

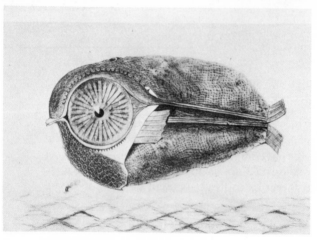

47. Frottage: a method of liberating oneself from blindness / Max Ernst, *Histoire naturelle*

frottages of *Histoire naturelle* (1925) play on the theme of vision and reveal eye images, as though the wood grain from which he made the frottages was actually looking at him (plate 47). But he shows his abhorrence for "objective" sight in *La Femme 100 têtes* when the heroine affirms her mastery by perching above a huge eye (plate 48)—monopolizing all vision while she plucks out the eyes of others in order to keep her secret (plate 15).[25]

The work of art becomes the means of initiation, a rehearsal for a kind of seeing the perceiver is encouraged to use on the everyday objects around him. Alain Jouffroy speaks of the "revolution in seeing" offered by Surrealism, which is parallelled by a revolution in consciousness: "Every year, a few paintings propose to us an initiation voyage which is never quite the same;

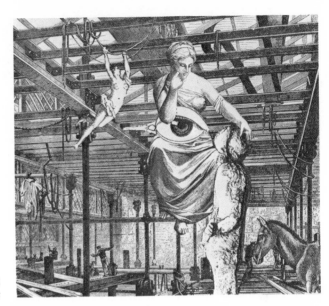

48. "She keeps her secret" / Max
Ernst, *La Femme 100 têtes*

every year, the invitation is expressed in slightly different optical terms: the revolution in seeing consists in the mental displacement which obliges us to revise our judgments and to readjust our sentiments in relation to an ideal level of perception . . . this total revolution of which I speak . . . is directed toward the overturning of all reality by means of individual consciousness."[26]

Art as initiation: we have rejoined the alchemical model, according to which wisdom must be safeguarded against the profane. The mystical "starred mole" (la taupe étoilée) that became a sort of mascot of Surrealism is also blind, and blindness enables him to "see" the inner vision of truth.[27] Although Breton widely broadcasted Lautréamont's dictum that "poetry must be made by all," the surrealist vision was only open to those who could turn away from "objective" reality and seek the "révolution du regard."

Three responding readers: Franz Mon, Julio Cortázar, and Maurice Roche

In his influential essay "Literary History as Provocation of Literary Theory," Hans Robert Jauss notes that one form of reader response is to write another work.[28] The ultimate success of the dadaist and surrealist enterprise can be measured by the international character of the group of writers who, in the post-war period, have met the challenge posed by dadaist and surrealist works by producing works of their own. Three of the most

prominent are Franz Mon in Germany, Julio Cortázar in Argentina, and Maurice Roche in France.

For Franz Mon the written text is supposed to provide the reader with an experience of limits. Through a discourse that progresses by means of permutations, mirroring, and sound shifts, meaning is stripped away, leaving only the "speech event"; the reader can identify only with the articulatory gesture of language itself. Mon's *Herzzero* (1968) is a discourse numbering 162 pages whose "continuity" is furnished by sound associations, puns, and various literary and linguistic frames: question-answer, dialogue, narrative, proverbs, names, children's rhymes, advertising slogans, songs, clichés, slang.[29]

Out of this debris, shapes gradually constitute themselves: the text provides new frames that are etched on the reader's memory and influence subsequent readings of the text. These frames, in turn, generate expectations so that the reading of Mon's text, like that of dadaist and surrealist works, becomes a cognitive exercise.

One of the ploys used by Mon is to make derivations of a primary text by replacing the lexis with elements that are phonetically similar. The reader then has the experience of reading a "nonsense" text that resonates with vestiges of the "sub-text" remaining in his or her memory. The following parallel sections from *Herzzero*—appearing within three pages of one another—can illustrate the point:

> but you, dear reader, would you trust yourself to travel along a horizontal bar with your hands and feet, a knife between your teeth, while somewhere in the neatly combed-through region someone may still sit, who, a gun between his knees, waits to be ferreted out and hoisted on high, a rope around his neck, at the end of the pole on which you are hanging, until he loses consciousness, without hurrying yourself. (83–84)

> drown yourself to traverse along a hospitable bascule with your harbor and fell, a knish between your teetotum, while someway in the nebulously concatenated register someone may still size, who, a guppy between his kneelers, waits to be festered out and held on the hike, a rosary around his nectar, at the entablature of the pomace on which you are traversing, until he loudens the conscription, without hurtling yourself. (86)[30]

Because the second text seems somewhat familiar to the reader, he or she does not find it unreadable; at the same time, the unusualness of the combinations focuses the reader's attention on the words themselves, restoring their freshness as though they had just been "thrown by the potter's wheel of the mouth and palate."[31] The result resembles Breton's description of the surrealist image, parallelled in Mon's critical writings: "Once the words have gotten together, it turns out that nothing belongs more together than those things which had nothing to do with one another."[32]

With heightened consciousness, the reader experiences a new reality: "The concurrence between distant things engenders a new reality which we would not have been capable of inventing, although we are in full agreement with it once it has been shown to us."[33] The "reality" of Mon's text is the reader's experience of reading—this is a text that cannot be either summarized or skimmed. The frames the reader applies to the fragments change as the discourse shifts under the pressure of phonetic resemblances and puns. Several times, the text playfully alternates between various lexemes containing the same root. For instance, permutations of "warten" (to wait) yield *erwarten, erwartung, des erwartete, das unerwartete* (to expect, expectation, the expected, the unexpected); while "stelle" (place) generates the series *vorstellung, gestell, unvorstellbar, angestellte, stellen, sich stellen* (concept, rack, unimaginable, employee, to set, to place oneself). At other times, the conversational or narrative voice fastens itself on a prefix or letter, without being able to pass it.

Another textual game is the presentation of endless alternatives in the attempt to forestall any narrative; Mon rewrites fairy tales, giving so many permutations that attention finally becomes focused on language rather than on the story:[34]

> when the man noticed that the lady of his heart had made herself scarce, he went after her with great leaps and bounds, but she saw him from afar, and so she threw a brush behind her. at once there was a large brush-mountain with thousands upon thousands of prickles, over which the man had to climb with great effort and considerable loss of time, but finally he got over it anyway. when she saw that, she threw her comb behind her. then a great comb-mountain sprang up with a hundred thousand teeth, but the man was able to hold onto them and finally got over them. then she threw a mirror behind her, and right then a mirror-mountain stood there, which was so smooth, that he couldn't possibly get over it. then he thought: I'll go home quick and get my revolver and shoot the glass into bits. so he ran quick, came back and shot and the lady the lady of his heart screamed and cried out: who shot in front of my mirror did he answer a gentleman knows to enjoy and be silent.(88)

Although some of these operations might seem dadaist (the word "dada" actually appears in the "d" series on page 45), the impetus is ultimately surrealist: Mon compares his methods of composition to those of surrealist "automatic writing," with the difference that here language is consciously manipulated in a state of "concentrated wakefulness" rather than being the product of the semi-wakeful state favorable to the production of surrealist texts.[35] Like the surrealist images produced in "automatic writing," the "constellations" of meaning Mon creates through the conscious combination of disparate elements are ultimately directed toward the reader.[36] The reader is even invited, in the preface, to change the text:

The text is given in two versions which are differentiated by their typefaces. One should read the left or right column sequentially. However no-one is prohibited from crossing over from the left to the right column or from the right to the left. Reading with a pencil and felt-tip pen is recommended. With the pencil, underline the places which belong together even if they are separated or in different columns. With the felt-tip pen, correct that which appears to need correction; add whatever occurs to you: not only quotation marks, but also words, sentences, idioms, proverbs, citations.[37]

It would be wrong to read *Herzzero* as a nihilist statement about the ultimate meaninglessness of language. Rather, there is a constructive critique involved: out of the accumulation of partial statements voices gradually constitute themselves, subside, and give way to other voices with messages of urgency. This technique, rather than being a mere formalist exercise, is an ideological statement about the world of electronic communications that surrounds us with a constant bombardment of writing, speech, and images—forms of verbal and visual manipulation. The way it is produced by Mon, the suggested meaning contains a critique of language, warning the reader implicitly against the too facile assimilation of its message. The artificiality of the construction of discourse, the way in which transitions between semantic frames are mediated by puns and phonetic similarities, helps the reader develop a critical attitude toward the ideas that grow out of the associative collage:

> but if the earth is a star
> it doesn't look like one
> it could become one though
> that depends on the development
> of the climate
> no, it depends on the sugar content
> in the bladder of an exactly
> delimitable stratum of
> society
> and if they begin to drink
> tea without sugar
> they don't drink tea anyway (53)

In the above passage, references to "them" have overtones of racist or class oppression, while the relationship between the astronomical classification of the earth and the sugar content in the bladder of a sector of society furnishes the basis for a nightmarish plan to make the earth a star. This plan, fantastic though it sounds, plays back for us the way social prejudice can give rise to dangerous and insulting collective actions:

because despite all changes
nothing more will change
unless one could manage to bring sugared
canned goods onto the
market
that would be worth the sweat on the brow of the
just. one would have to display them
visibly in public
in all public places
one would have to provide walls with
racks, on which these products
are arranged, so that everyone
can grab without hindrance
one would have to bring the schoolchildren by in
buses and the mothers' clubs
and the consumer organizations
and don't forget the army
naturally. because it makes you stronger. and
all the many underpaid state em-
ployees. that way they'll get some
spunk
and the doctors, the salaried doctors. if
they recommend it, it will be a success
if only the racks hold out
one would have to make them big enough
so that people could move about in them
freely
and there is no crowding. people spend
most of their time in
such racks
no one will notice anything. (154)

For this text, the narrative frame alone would be fairly useless as a basis for discovering meaning; rather, an active participation on the reader's part in recognizing the proverbs, slogans, idioms, and songs and in correlating the repetitions and variations is necessary. Reading is here a learning process that requires the reader to actively formulate new frame hypotheses—language, as the narrator explains, is the only reality.[38]

In Julio Cortázar's *Rayuela (Hopscotch)*,[39] first published in 1963 in Argentina, the protagonist Horatio Oliveira is sitting in a Paris café "anachronistically" reading *Êtes-vous fous?* by Breton's friend, René Crevel. With "all of Surrealism" in his memory, he is surrounded by young people reading "Durrell, Beauvoir, Duras, Douassot, Queneau, Sarraute" (112).

This rediscovery of Surrealism is characteristic of a number of writers of the 1960's and '70's whose works enter into a dialogue with their surrealist predecessors. In the works, one finds the familiar challenge to conventional perceptions, privileged places ("le génie du lieu"), the necessity of transforming language into a tool for the discovery of truth, and the relationship between the work and mechanical processes. Yet in each case, these attitudes and themes are changed according to the demands of a more modern epoch. Along with the similarities, the differences between the surrealist ideal and the systems of knowledge and aesthetics these works propose make it possible to identify a new tendency in literature that defines itself as much by its new orientation toward the reader as by its intrinsic qualities. The tendency of these works, written by readers of Surrealism, is to turn us into surrealist readers as well.

Like the narrator of Breton's *Nadja*, the main protagonist of Cortázar's *Rayuela* is searching for the figure of lived experience, a hidden meaning discoverable within reality, if the seeker can make himself sensitive enough to its signs. In the first chapter Horatio relates a series of occurrences that come close to the instances of "objective chance" in *Nadja*: "As for me, I'm already used to the fact that quietly exceptional things happen to me . . . finding great gray or green tufts in a pack of cigarettes, or hearing the whistle of a locomotive coincide *ex officio* in time with a passage from a symphony by Ludwig van." (8)

In much the same way as *Nadja*, *Rayuela* is penetrated with the idea of "génie du lieu"; Horatio is searching the city for a key to existence: "He guesses that in some part of Paris, some day or some death or some meeting will show him a key; he's searching for it like a madman" (133). The city of Paris becomes a metaphor for Horatio's metaphysical labyrinth, from which he can escape only through an alteration of consciousness, expressed as "ubiquity" in the context of the city metaphor.

Like *Nadja*, *Rayuela* possesses its "free genius" in the form of La Maga, a character who quite unconsciously lives in the sphere of irrationality overly intellectual Horatio cannot attain:

> There are metaphysical rivers, she swims in them like that swallow swimming in the air, spinning madly around a belfry, letting herself drop so that she can rise up all the better with the swoop. I describe and define and desire those rivers, but she swims in them. . . . It's not necessary to know things as I do, one can live in disorder without being held back by any sense of order. That disorder is her mysterious order, that bohemia of body and soul which opens its true doors wide for her. (96)

For Horatio, the alteration can only happen through a "leap," like the child's leap into the last square of a hopscotch game, called "Heaven." The

leap into "Heaven" is achieved when reality and desire coincide perfectly (what Horatio calls the "kibbutz of desire," 203).

Both themes—the transformation of consciousness and the attainment of desire—are surrealist, as is noted elsewhere in the theories of another character in the novel, according to whom "it would be possible to advance in knowledge provided that at a given moment one would reach a certain coefficient in love ... which would cause the spirit to crystallize suddenly on another level, become established in surreality." (135)

Unlike *Nadja*, however, *Rayuela* is immensely complicated by the splitting of its narrative point of view. The first two sections of the book, "From the Other Side," and "From This Side," alternate between first-person and third-person narration. Horatio's first encounter with La Maga is told in three different versions:

> I know that you were coming out of a café on the Rue du Cherche-Midi and that we spoke ... I followed you grudgingly then, finding you petulant and rude, until you got tired of not being tired and we went into a café on the Boul'Mich. (5)

> La Maga had appeared one afternoon on the Rue du Cherche-Midi. (11)

> It was a little bookstore on the Rue du Cherche-Midi, it was a soft sense of spinning slowly, it was the afternoon and the hour, it was the flowering season of the year, it was the *Verbum* (in the beginning), it was a man who thought he was a man. What an infinite piece of stupidity, my God. And she came out of the bookstore ... and we exchanged a couple of words and we went to have a glass of pelure d'oignons at a café in Sèvres-Babylone. (427)

That the reader is supposed to correlate these different versions is made explicit in the third section of the book ("From Diverse Sides") which consists of "expendable chapters": quotations from other works, songs, and poems, chapters outside the main narrative of the first and second parts, and fragmentary writings by the fictional character, Morelli. It is Morelli who gives Horatio his "key." After witnessing an accident involving an old man, Horatio visits the victim in the hospital and discovers that it is none other than Morelli, a writer who has become a sort of hero to the intellectual "Club" made up of Horatio and his friends. Horatio receives the key to Morelli's apartment as though it were the magical key out of the labyrinth, somehow found too late:

> Everything was wrong, none of it should have taken place that day, it was a lousy move in a sixty-piece chess game, a useless joy in the midst of the worst sadness, having to drive it off the way one does a fly, prefer sadness when the only thing that had come into his hands was that key to

happiness. A step towards something he needed and admired, a key to open Morelli's door, Morelli's world. (557)

Horatio does not find Morelli's key until he has lost La Maga; the search for the metaphor of Paris becomes meaningless for him, and he leaves for Buenos Aires, the focus of the second part of the book. Like the child who grows out of childhood before mastering hopscotch, Horatio comes upon his discovery when it no longer interests him. It is all the more ironic that Morelli's house on the Rue Madame is practically next door to the Rue du Cherche-Midi where he met La Maga.

If Horatio fails to enter Morelli's world, this is not true of the reader of *Rayuela*. He or she is provided with an aesthetic for reading the book in the fragments and notes of the third part. At the outset, the reader is told to read the "expendable chapters" after having finished parts one and two, or in another order provided by a "table of instructions." Many of the short "chapters" in part three comment on the idea of the "figure" Horatio seeks; but where he finds only absurdity in trying to trace the figure of reality, Morelli, in art, finds meaning and form:

> [Horatio] Little by little, Maga, we go along forming an absurd pattern . . . like two points lost in Paris that go from here to there, from there to here, drawing their picture, putting on a dance for nobody, not even for themselves, an interminable pattern without any meaning. (196–7)

> [Morelli] The book would have to be something like those sketches proposed by Gestalt psychologists, and therefore certain lines would induce the observer to trace imaginatively the ones that would complete the figure. (469)

The reader's task is to see whether he or she can make sense, as an outside observer, of the apparently absurd figure traced by the novel's protagonists; if the characters' actions and motions appear senseless to them, Morelli argues that in fact they are subconsciously tracing a figure whose interpretation is the necessary activity of any reader who is not merely "passive." The result of perceiving the figure is an illumination, in which "ubicuidad" (ubiquity) becomes "ciudad" (city)—Paris as the mandala, the metaphor of existence and of the work itself. A commentator of Morelli's book writes: "Reading the book, one had the impression for a while that Morelli had hoped that the accumulation of fragments would suddenly crystallize into a total reality. That without having to invent the bridges, or to sew the different pieces of the tapestry, there would suddenly be a city, a tapestry" (revised translation, p. 533 of original).

In Buenos Aires, Horatio again fails to find the moment of integration he seeks. The second part ends with Horatio standing in the window of an

insane asylum, staring down on a Hopscotch game toward which he thinks of jumping: ". . . telling himself that there was some meaning after all, even though it might only last just for that terribly sweet instant in which the best thing without any doubt at all would be to lean over just a little bit farther out and let himself go, paff the end" (349).

Rayuela suggests both the absurdity in trying to find the figure of reality while one is in reality (Horatio's fruitless quest) and the possibility of discovering that figure through art (Morelli's book) and artlessness (La Maga, the child's hopscotch game). According to the defense of the book's aesthetics presented in Morelli's notes, the novel has abandoned story-telling to the cinema (468) to become an abstract tool for intellectual discovery. The mechanical nature of the tool is underscored by the number series that prescribes the reading and the explicit comparison of the novel's aesthetic to photography (468). In the end, Cortázar's book adds up to an injunction to continue the search initiated by Surrealism, with the modern twist that there may be no meaning to be found.

In *Herzzero*, language and meaning come apart as the text dissolves under the pressure of phonetic repetition, syntactic disjunctions, and the continual substitution of frames; *Rayuela*, despite its fragmentation, holds out the possibility that the separate pieces of the puzzle may yet come together in a totalizing picture. Maurice Roche's *Codex* (1974) combines both tendencies, presenting a language disrupted by elements that betray the unconscious modes of thought underlying advanced civilization.[40] The purpose of the Rochian enterprise, as later stated in *Mémoire* (1976), is to capture once and for all the figure of civilization before it disappears: "I am the seismograph—no more nor less—of a civilization which turns back on its memory—by every technical and other means—before losing it altogether."[41] *Codex* (the book of law, but also the arbitrary code of our civilization) is one such fragmentary recapitulation. Its pages need not be read sequentially; in many cases, meaning arises from the rapprochement of distant pages whose similarities are perceived by the reader. Two such pages are 52 and 96 (plates 49 and 50). The first page illustrates the connection between basic survival, religion, and art in primitive culture: "Eating, creating religion and, on the surface, propping up art." Two types of hunger, sexual and alimentary, are shown by the branching text:

<div style="text-align:center">the prey,</div>

Always the same haunting spectre of
<div style="text-align:center">the thigh</div>

The arrow, symbol of conquest, points toward the stylized mammoth and the "Venus" or mother-goddess at the bottom of the page: religion, art, sexuality, and eating are all enlisted in the cause of survival; yet there is also a need to go beyond this ("passer outre").

flèche à triple rang
de barbelures...
symbole de conquête ?

ce qui reste du crâne
d'un cyclope

Toujours la même hantise du gibier
de la cuissOn l'a sous la main, une
texture de signes, de ci-
- la bouffe créant la religion et, catrices - un tissu tac-
en surface, supportant l'art : tile : d'accrocs - d'entailles.

anger (passer utre)

49. Maurice Roche, *Codex* (page 52)

The second page shows the result of this "going beyond" modern civiliza-
tion. Now the primitive arrow has been replaced by barbed wire—an art
object mounted on a stand for a museum exhibit about concentration
camps. The mammoth reappears as the symbol for a French department-
store chain; the Venus has been replaced by a Vietnamese girl cruelly
mangled by war. A mouth painted with lipstick has replaced the cleft stone.
Equivalencies are thus established between war and the primitive hunt;
between the prey, object of primitive consumption, and modern consumer-
ism; between the woman as reproductive tool and woman as pawn in the
war game; between a primitive symbol for sexuality and a modern view of
the body as a marketable commodity: the decorated mouth wears "the
eternal smile of death" (97).

At the bottom of the page, the connection between all these elements is
stated in such a way that our contemporary culture is shown to be a
perversion of the primitive one. The connection now is between capitalist
interests, torture, the mass media and religion that looks on benevolently.

*Barbelés de camp
sur socle en plâtre :
ready-made pour
exposition engagée
dans la mondanité*

**se payer à l'œil la tête du
chef sur l'écran de T.V.**

Impossibilité de confondre les vo_aleurs en place **avec les exploiteurs cultivant**
Propension à

interchangeables — inamovibles — imposant **le respect (les traditions)** *de*
la personne humaine-
un haut niveau esthétique à l'horreur du scoop **les convenances, quoi !**
routinier, à l'information nulle bien présentée ; **tout en entretenant**

le quotidien *contenant en profondeur la propagande* la confusion, **les bons sentiments
(pour le fond)
et quelques gracieu-
ses petites personnes
(pour la forme)**

 ammouth écrase
(ta gueule ! la ferme !) émoignons

Notre Père qui êtes os 🐝 - très regardant

50. Maurice Roche, *Codex* (page 96)

Whereas in the first passage the woman is invisible (she forms no beginning
letter of a word), now she forms the first letter of "témoignons" which has a
double meaning: it is a reference to the fact that the girl's hands and feet
have been cut off ("tes moignons," "your amputated limbs") and to
journalistic reportage ("témoigner," to report). With its double meaning
and visual illustration, this word continues the criticism of crass journalism
and mass media that is articulated in the passage above: "The horror of the
routine scoop, the well-presented story devoid of content: the daily news on
a foundation of propaganda and confusion."

Obviously the reader will have difficulty in applying a narrative frame
here. The frames that permit the discovery of meaning in these juxtaposi-
tions are, rather, those of cinema montage, chinese ideograms, and dream-
mechanisms (condensation, displacement, figurative representation).

In *Codex*, words are explicated as though they had been condensations of

latent thoughts. A favorite Rochian trick is the dismemberment of an innocent-looking word which then assumes a sexual or scatological connotation:[42]

<div style="text-align:center">

éri

CH

ier

</div>

The same thing may happen to a sentence:[43]

<div style="text-align:center">

viril

La perte d'un membre, surtout

de la famille

</div>

Typographical effects are used within words to isolate other "contained" words: con*fondu*. Punctuation is similarly employed: CON(!)TENU. Or the sound may give rise to two meanings: "sénescence—c'est naissance."[44] The typographical arrangement of a work can overturn its meaning, creating the dream-like collision of negatives:[45]

<div style="text-align:center">

Comment

taire

</div>

The use of different type faces within one word produces the same effect: medic*amenteuses* ("medicament"—medication and "menteuses"—lying) indicates that the cure is a hoax. Included in this group are instances of printer's corrections which allow a word to be interpreted in two different ways: con⸂ver⸃ser (converse and conserve).

A second type of dream work is displacement. Predictably, here the Rochian tactic is to uncover allusions in language where they are hidden and to bring out occulted elements. In the example given above Roche uncovers the hidden ideological messages of the popular press, advertising, and statements of official government policy. Thus the mammoth has a latent ideological content that the text makes manifest: "stylized mammoth crushing prices and workers" (97); the popular press that makes money from newspaper scoops is criticized by the image of the Vietnamese girl with her arms and feet cut off. The manifest content of these elements is explained in terms of latent ideological content brought to the surface as the product of a hypothesized displacement.

Under the third, Freudian category—figural representation—should be classified all the uses of letters for pictorial representation. In *Codex* the pictorial element in letters and type-faces is developed into a refined art, allowing the manipulation of meaning. In one composition (cited below), the "V" of "Sainte Vierge" (holy virgin) is transcribed so as to change

"vierge" (virgin) to "verge" (penis) and to deflower the "V" by means of the "i."

The Rochian corpus is one that seeks to instruct its reader by stages: if the model of dreamwork is useful for the immanent analysis of the text itself, it hardly suffices as a model for the reader's activity. It is here that the model of film becomes useful.

The transition between the two, surprisingly, comes from the Chinese language. Writing about the psychoanalyst's ability to interpret dreams, Freud himself refers to "a very ancient language and script," Chinese. In Chinese, he explains, the syntactic function of individual words in a discourse is not given; it is by context and through long apprenticeship that the reader can learn to understand the signification of a Chinese sentence.[46] This understanding, Freud maintains, resembles that displayed by the psychoanalyst familiar with his patient's world who can "read" his or her discourse even though its elements are presented without obvious connection.

Chinese is also used by the Russian filmmaker and theorist Sergei Eisenstein to describe the way in which film images can express thoughts. Eisenstein uses an example of the juxtaposition of two objects to create a third meaning that is not an object but a concept:

> The point is that the copulation (perhaps we had better say the combination) of two hieroglyphs of the simplest series is to be regarded not as their sum, but as their product, i.e., as a value of another dimension, another degree; each, separately, corresponds to an *object*, to a fact, but their combination corresponds to a *concept*. By the combination of two "depictables" is achieved the representation of something that is graphically undepictable.[47]

Eisenstein goes on to give examples for the verbs "bark," "scream," and "weep." An objection might be raised that these are in fact depictable, but the following more abstract examples can be used to support his assertion:

人 + 木 = 休 女 + 子 = 好
(man) (tree) (rest) (woman) (child) (affection)

This, according to Eisenstein, is what film montage does, "combining shots that are *depictive,* single in meaning, neutral in content—into *intellectual* contexts and series."[48] Eisenstein is not speaking here of cinema as a sign system but as a discursive system. The film image is by nature specific and attains the status of communicative message only in discourse; in this sense it is distinguished from the linguistic sign which is general and can become specific only in the discursive context.[49] Clearly then, Roche's use of

language is of the cinematic type: his sign language, figural representations, displacements and condensations are specific rather than general; they are objects, not signs. Within his discourse, they are combined semantically into propositional statements.

It would be possible to make a dictionary of the Rochian objects with, however, the following qualification: there are no sure symbols. The recurrent figures, drawings, and mechanisms are polysemous and only the context gives the meaning of any specific one of them. Individually, each "symbol" can have various meanings: the skull (death, memory, voyage); parentheses (mouth, vagina, lips); the hand (phallus, text—five fingers correspond to the five letters of French "texte."). Anagrammatical inversions also form part of the system: crâne/carne (skull/flesh—connection between coitus and death); derme/merde (skin/excrement, where "skin" also means parchment, the writing surface—connection between writing and excreting). The paraphrase of the figure below is offered as an example of the type of reading demanded of the Rochian text:

> *Inhibé. Stupide. En pleurs nichons dans l'être de ma-*
> *man. Sainte Enculina laissant passer la courbe d'une*
> *douleur (ainsi :* ⌒ *) après flagellation.*
> *_ Son air pénétré* **quand là, la** *. Son air pénétré à*
> *cette increvable à* **mettre en perce** *(qu'elle le fût, mise!)*
> *Avec doigté en dactyle* (-∪∪)**;**(━∙∙) *index sur la détente, la*
> *touche, titiller Veuve* **Cli_quot?** *écarter les parenthèses*
> *de la cupide donna* **Sainte (V)erge** *(la lettre presque en-*
> *clavée,* **zigoui** *par la* **se∝tion⌐guyotinée** *par la mor-phalleuse*
> *deuse donnant la ques..._(?) _.. ¦tion sans réponse en morse sur le bout*
> ¦ ◦ *se*

The death theme is represented in the skull motif figured by letters, parentheses, dactyls, morse code symbols; in the verbal play on "mort phalleuse" (phallic death) and "détente" (trigger of a gun).

The alcohol theme is expressed in "Veuve Cliquot" (a brand of champagne).

The female sexual parts are represented by parentheses (those surrounding the "V" in *Verge*; and surrounding the word *Cliquot* where *cli* stands for "clitoris"); by "nichons" (breasts); by the phrase "écarter les parenthèses" (separate the parentheses); by words of cutting ("guyotinée"— guillotined; "zigoui"—bayonetted); by the play on words "Sainte Enculina" that con-

tains "cul" or "ass"; by the representation of pubic hair at the bottom of the figure.

The male sexual parts are indicated by the figural representation of castration after the word "secxtion"; by the castration or cutting off of the word "morse" whose remaining "-se" is at the bottom of the figure; in the transformation of "vierge" (virgin) to "verge" (penis).

The theme of coitus is expressed in verbs of penetration ("son air pénetré"); in the second meaning of "détente" (orgasm).

In this discourse orgasm is likened to the opening of a champagne bottle (whose consumption is described on the following page as "uncontrollable fellatio"). The sex act itself is represented as violent and perhaps even fatal (castration for the male; penetration and cutting for the female). Sexual release through orgasm is likened to discourse (connection of the morse code to sexual foreplay, rape of the letter "V" by the letter "i"). The ideological content is anti-religious ("Sainte Enculina," "Sainte V(i)erge").

For the reader who likes to enjoy a good "tale," the Rochian text constitutes not just a challenge but an offense. Generously, the implied reader is offered a set of eyes (the "Eye Exchange Bank" of *Compact*[50]); and in *Mémoire*, the implied author wills his eyes to someone who very much resembles Roche's implied reader: "Item, my ladies, my eyes except for during sleep and dreams (neither dreams nor death can be willed), to a poor wretch living in darkness and who, when his sight is restored, will be able to appreciate *de visu* the surrounding filth and human meanness."[51]

The "target eye for aiming at," one of the many eyes on display at Roche's imaginary "Museum of Sight" in *Mémoire* is no more nor less than the eye of the reader, hit by the attack against language, already represented as an arrow in *Codex* and *Circus*:[52]

or
" l'aigle, mademoiselle ", même blessé à l'◑
— et le ⊗ perdu — ayant très mal (aï e !) est toujours, bien que malade, le sigle du rapace toutes griffes dehors :

One can't help thinking of *Un chien andalou*, that begins by cutting the eye of the specta(c)tor.

The rehabilitation of formal experimentation and innovation one finds in the recent critical writings of Helmut Heissenbüttel in Germany and of the Tel Quel group in France suggests a renewed awareness of form as the vehicle of meaning. Heissenbüttel in his essay collection *Zur Tradition der Moderne* and Julia Kristeva in *La Révolution du langage poétique* argue that the expression of revolutionary contents will have to go hand in hand with the revolution of forms.[53] Translating this in terms of the theory presented here, this amounts to saying that only if the reader is forced to create new frames during the understanding process will his or her perceptions be altered. Contents that fit into old frames do not demand a process of adaptation and change.

What is involved is an education of the reader who must learn non-representational modes of understanding. In Roche's works, representation dissolves into the materiality of the writing. For Roche, the paper is a skin to be tattooed. A reference to this may be found on the first page of *Codex*, that restates the last lines of *Compact*, Roche's first novel: "A texture of signs, of scars, a tactile tissue of tears, of incisions."[54] The text is something the reader must respond to without ignoring the materiality of inscription. Roche and Mon force the reader into a concrete awareness of the writing and reading process. Dada and Surrealism prefigured these practices as they attacked conventional modes of representation for similar ideological reasons.

The idea of forcing the reader into awareness has been formulated most convincingly by the Russian formalists of the twenties and thirties. Russian formalist theory equates the production of the text's "literariness" with the employment of techniques for "making things strange";[55] what is at issue in the texts discussed here, however, is not mere aesthetic enjoyment. The de-automatizing of perceptions is not just the aesthetic element of a text but also its use: if these texts are games, they are learning games, played by writer and reader alike for serious purposes.

Conclusion

Throughout this study, I have presented the argument that the enterprise of Dada and Surrealism can be defined according to a small number of semantic operations that guide the cognitive response of the reader or perceiver.

The interdependence of semantic operations in texts means that any given work can be approached through a wide variety of "frames." This was shown by the extensive analysis of *Nadja* and *Un chien andalou*. In chapter two, both works were examined from the point of view of their structural dislocations. Both break the frame of the narrative genre to which they at first appear to belong. In chapter three, it was seen that both works substitute other elements in the place of narrative organization. In *Nadja* Breton creates a new genre, a sort of "cognitive exercise book" aimed at training the reader to live according to surrealist modes of thought; Buñuel and Dali convey dream experience to the spectator by means of topicalization devices that focus his or her attention on a form of discourse organization resembling that of dreams.

Because of their orientation toward the perceptual training of the reader or perceiver, both works attempt to transcend the pleasurable or cathartic dimension of aesthetic experience and have implications for the future cognitive functioning of the reader or perceiver's attitude toward everyday lived experience. This relation between art and life in Dada and Surrealism was the determining factor in the selection of these movements for the theory elaborated here. All the other "frame" operations—contextual operations, foregrounding, linguistic dissociation and metaphor—share a cognitive dimension that may go beyond the aesthetic experience.

The mediation between art and life that is the function of so many dadaist and surrealist works is facilitated by the linguistic nature of everyday perception. Underlying my theory is the assumption that the various media employed are languages, in the sense that they are conventionalized modes of communication. Almost always, we use linguistic terms when speaking of other languages of art—such terms as "syntax," "ungrammaticality" and "metaphor" are in current usage among film theorists today.

In defense of these linguistic metaphors, it should be said that linguistic models appear to furnish us to some extent with our epistemic models. Freud argued for the theory that the unconscious is coded like a language; more recently Lacan has underscored the importance of language in psychoanalytic treatment. In the subject's acquisition of the capacity to symbolize the "other" with respect to the self the acquisition of language holds a

privileged place, second only to the accession to sexual identity in the development of the normal child.[1] It would thus appear that linguistic structures are biologically primary in the sense that in the history of the subject's development they arrive first, and serve as the model for all later acquisition of symbolic systems. Freud's application of the categories of dream-work to jokes and Todorov's extension of that application to rhetorical figures is thus not to be understood as the use of non-linguistic structures to explain linguistic ones, but as the positing of equivalent relations between linguistic structures of different levels.

If Freud and Lacan posit language as the organizing principle of the individual, Benjamin Lee Whorf extends the hypothesis to society as a whole: language and civilized modes of perception are inextricably bound together.[2]

In employing linguistic terms to describe non-verbal media, however, what is meant is not an assimilation of their structural elements into verbal structures but an extension of the meaning of the terms into a higher level of generality. The impossibility of one-to-one correspondence is demonstrated in film where physiological factors play as large a part in perception as the linguistic ordering of reality. "Language," when extended to cover another non-verbal medium such as film, becomes synonymous with "communicative system."

In communicative systems, artifacts convey information processed by the understanders and organized by them into "frames." Until recently, the existence of these conceptual frames could only be hypothesized; as both supporters and detractors of frame theory have pointed out, frames themselves determine the items selected to construct frames.[3]

Yet there may be a way out of the hermeneutic circle. Menakhem Perry has defended frame theory on gestaltist grounds, arguing that Gestalt rules of perception apply to the macro-structures of texts. Translated into textual strategies, Gestalt rules might be applied as follows: (a) the reader prefers those frames that link the greatest number of disparate, independent items; (b) precedence is accorded to the frame connecting the items most closely, allowing them the least degree of freedom; (c) precedence is accorded to the simpler frame, i.e., the more usual or conventional frame.[4]

The experimental verification of the operation of Gestalt principles in texts is an aspect of research into memory that has been pursued by Bonnie J. F. Meyer and Walter Kintsch. The experiments related by Meyer in *The Organization of Prose and Its Effects on Memory* led her to conclude, in part, that "the important aspect of a passage for the recall of its ideas is the pattern made by specific relationships."[5] Patterning may be considered here as equivalent to framing devices. Kintsch, in *The Representation of Meaning in Memory*, describes how long-term "semantic memory" organizes and stores information learned through short-term "episodic memory." To a

large extent, the categories of information organization in semantic memory correspond to frame concepts.[6]

Another method of experimental verification is the "organicist" approach of computer modelling. Terry Winograd compares the computer modelling of language to the activity of the genetic researcher in biochemistry: "There is no guarantee that the substances which are created or the processes which happen in the test tube correspond to the actual substances and mechanisms is a living organism, but the understanding which is gained through experimentation is invaluable in building models and performing experiments on living systems themselves."[7]

The computer model of surrealist metaphor proposed in my fourth chapter should be seen as a research tool rather than a perfected method of generating surrealist texts. No doubt Breton would refuse to recognize the sentences produced as authentically surrealist; but this is not the point. My attempt has been to produce an equivalent structure that would activate, in the reader, frame-making processes similar to those activated by the reading of surrealist texts.

The computer experiment falls midway between scientific research on the functioning of language and literary interpretation. My purpose has not been to propose any particular interpretations of texts but to show how interpretations might begin to be constructed by readers. The meaning of surrealist texts, films, and paintings, I would argue, lies not in the artifacts themselves, but in the process of activating the reader's frames through textual signals. The computer modelling approach should be understood as an act of translation broadly conceived—an attempt to create English language structures equivalent to those of the original.

The computational approach provides a conceptual framework within which linguistic variables are defined as accurately as possible. The computer program provides a method of control over the ability of the model to describe the reading process. Even so, the computer model is "subjective" in at least two respects: (1) the thirty semantic features selected for encoding nouns (see the appendix) are themselves the product of conventional ways of organizing reality; (2) the "success" of the generated sentences depends on the reader's willingness to agree that, given the limited objectives outlined above, they are analogs of the original texts they are supposed to model.

Despite these possible objections, however, frame theory may ultimately be of assistance in our conceptual adaptation to a new and pressing set of intellectual assumptions. We seem today to be in a situation similar to that experienced by the dadaists and surrealists more than half a century ago. Winograd, for instance, defends the "organicist" computer modelling approach on the grounds that we are experiencing "a change in world view which is one of the major intellectual events of our century," a world view described in Donna Haraway's *Crystals, Fabrics, and Fields*: "It is possible

to maintain that branches of physics, mathematics, linguistics, psychology, and anthropology have all experienced revolutionary and related changes in dominant philosophical perspective. The primary element of the revolution seems to have been an effort to deal with systems and their transformations in time; that is, to take both structure and history seriously without reducing wholes to least common denominators. Organization and process become the key concerns."[8]

As we try to adjust to these new realities, we can perhaps learn from Dada and Surrealism, understood as movements that questioned every aspect of communicative systems in the attempt to bring fundamental changes to man's relationship with the world. In doing so, we may choose the dadaist strategy, restricting ourselves, in the main, to an overt attack on everyday consciousness; or we may wish to ally ourselves with Surrealism that went deeper, arming itself for its attack on everyday perception with the weapons of the unconscious. Because Surrealism sought to change the cognitive apprehension of the world, it was quite properly alchemical according to Breton's formulation: "The whole point, for Surrealism, was to convince ourselves that we had got our hands on the 'prime matter' (in the alchemical sense) of language."[9]

The spirit of Surrealism was not new—Breton himself recognized many predecessors, "surrealists in spite of themselves." But in Surrealism was formulated, more coherently than ever before or since, man's unceasing quarrel with the linguistic order of the world—a world that is of our own making. Through the storm of this altercation gleams the hope that our cognitive abilities will be sufficient to permanently alter the world in which it is our fate to live.

Appendix. A computer program for generating surrealist "automatic writing"

The computer program for generating surrealist "automatic writing" is included for the person with an interest in the modelling of texts by computer methods. The language used is Spitbol, a fast version of the computer language Snobol–4. The user need only set the random number (the setting on this program is 1984) and type the program (lines 2 to 221) into the computer, minus the explanatory notes.

Lines 2 to 171 of the program define the various processes (called "functions" and "subroutines") that go into the generation of the texts. For instance, the "match subroutine" (lines 29 to 36) breaks the codes into segments that are then compared to see whether they will allow words to match one another. The "selnoun function" (lines 132 to 138) selects the subject for a new clause by one of two methods: randomly, or on the basis of the semantic field of a noun occurring in the previous clause.

The introduction of pronouns and semantic field continuity made it necessary to keep a record of the codes of recently used nouns: these codes were used to find the correct pronoun or semantic field noun for a subsequent clause. The record-keeping was achieved by the "addword subroutine" (lines 94 to 104) and the "pcheck subroutine" (lines 105 to 112). The "switch subroutine" (lines 113 to 121) allowed the computer to "forget" nouns that occurred two or three clauses back.

In order to avoid sentences with more than one conjunction and clauses with more than one mis-match, "flags" were set up that send the generative process off in another direction once a conjunction or mis-match has occurred.

The "np subroutine" (lines 139 to 165) is the central one in that it allows noun phrases to be constructed that are then incorporated into a sentence syntax. The noun phrases may have correct matching to verbs, adjectives, or possessives, or may contain up to one mis-match.

The program itself (lines 172 to 221) is a circular loop that continues generating clauses indefinitely until the number specified at the beginning of the program (under QSQ) is completed. Currently the program will generate 150 clauses before it stops.

The experimenter will also have to set up data cards for nouns, pronouns, transitive verbs, intransitive verbs, and adjectives. Verb and adjective codes should be set up so as to create only normal matches with nouns; mismatches are obtained by using a special noun code in which a few features have been changed.

The matching process is based on the noun codes. Each noun has a code of six fields, with 30 digits in each field. The fields are:

1. verb mis-match code (selects a "surrealist" verb mis-match for the noun)
2. adjective mis-match code (selects a "surrealist" adjective mis-match for the noun)
3. possession code (selects other nouns that can be possessed by the noun)
4. possession mis-match code (selects a "surrealist" possession mismatch for the noun)
5. basic code (selects subsequent nouns) on the basis of the "semantic family" of the noun)
6. semantic code (the code used to select subsequent nouns on the basis of the "semantic family" of the noun)

All the fields except number 6 are based on the same semantic feature system of 30 features, governing the following attributes:

1. extended (does the object or concept denoted by the noun have spatial extension?)
2. substantial (can it be touched?)
3. discrete (is it a mass noun or a countable noun?)
4. human (is it human?)
5. durative (is it an event capable of being timed?)
6. sequential/concurrent (is it a state or an action?)
7. valuative (does it have a positive or negative connotation?)
8. mental (is it a product of the mind?)
9. part (is it a part connected to a whole?)
10. group (is it a group?)
11–13. gender (is it male [111], female [100] or unsexed [000]?)
14–15. realization (is it singular [10] or plural [11]?)
16–17. person (is it a he/she [11] or an I [10]?)
18–20. mobile (can it move by itself?)
21. living (is it living?)
22–24. possessible (is it possessible by a human [110], an animal [100], or a plant [001]?)
25–27. concave (is it permeable [111], semi-permeable [110], or impermeable [100]?)
29–30. size (three sizes possible: small [100], human-sized [110], large [111])

There are three allowable digits for the codes: "1" (positive); "0" (negative); and "2" (indifferent). In the matching process, a "2" will match anything; a "1" will match a "1" and a "0" a "0".

Verbs, adjectives, pronouns, and articles are coded for how they would match nouns in correct matching. Transitive verbs have separate fields for the subject and the direct object.

1 APPENDIX

A COMPUTER PROGRAM FOR GENERATING SURREALIST "AUTOMATIC WRITING"

BY INEZ K. HEDGES, ARTHUR E. KUNST AND DAVID A. SMITH,II

THIS PROGRAM MODELS SURREALIST "AUTOMATIC WRITING" BY THE CONTROLLED
MATCHING OF RANDOMLY SELECTED NOUNS, VERBS AND ADJECTIVES. EACH
CLAUSE MAY CONTAIN UP TO ONE "MIS-MATCH" OF A NOUN TO ANOTHER NOUN
(POSSESSION), A NOUN TO A VERB, OR A NOUN TO AN ADJECTIVE. THE
CONTINUITY FROM CLAUSE TO CLAUSE IS USUALLY MAINTAINED—BY THE USE
OF PRONOUN REPLACEMENT OF A NOUN OCCURRING IN THE PREVIOUS CLAUSE,
BY CONJUNCTIONS, AND/OR BY SEMANTIC FIELD LINKING BETWEEN CLAUSES.
HOWEVER, THE PROGRAM ALSO ALLOWS FOR BREAKS IN DISCOURSE CON-
TINUITY, BASED ON THE PERCENTAGE OF SUCH BREAKS OBSERVED IN
THE SURREALIST TEXT "ECLIPSES."

 VARIABLES:

 LEXNO: NUMBER OF THE CURRENT NOUN
 SENTENCE: CONTAINS THE CURRENT SENTENCE
 PARAGRAPH: CONTAINS ALL SENTENCES GENERATED IN THIS RUN
 MFLAG: 1 IF A MISMATCH HAS OCCURRED; NULL OTHERWISE
 VFLAG: 1 IF THE CURRENT NOUN IS THE DIRECT OBJECT; NULL
 OTHERWISE
 CFLAG: 1 IF A CONJUNCTION HAS OCCURRED; NULL OTHERWISE
 QSQ: NUMBER OF SENTENCES TO GENERATE
 SEGS,QQ, AND QSEGS: CONTROL MATCHING OF CODE SEGMENTS
 RANVAR: SEED FOR THE RANDOM NUMBER GENERATOR

2 RANVAR = 1984
3 INPUT('INPUT','DATA')
4 QSQ = 150
5 &DUMP = 1
6 &ANCHOR = 1
7 &TRIM = 1
8 &STLIMIT = 500000
9 SEGS = 5
10 QQ = 6
11 QSEGS = SEGS * QQ

```
           *         THESE STATEMENTS INITIALIZE THE LISTS OF RECENTLY USED NOUNS
    12                DATA('NODE(NWORD,NLINK)')
    13                CURRENT = NODE()
    14                LASTC = NODE()
    15                AVAIL = NODE()
    16                AREAR = AVAIL
    17                LREAR = LASTC
    18                CREAR = CURRENT
           *
           *         THESE EXPRESSIONS ARE EVALUATED DURING GENERATION EACH TIME A LEXIS
           *         ENTRY FAILS TO MATCH.
           *
    19                AREFS = *(ALEX<FIND,3>)
    20                PREFS = *(PLEX<FIND,3>)
    21                NREFS = *(NLEX<FIND,7>)
    22                SREFS = *(NLEX<FIND,8>)
    23                AJREFS = *(AJLEX<FIND,3>)
    24                VIREFS = *(VILEX<FIND,3>)
    25                VTREFS = *(VTLEX<FIND,3>)
    26                PREFS = *(PLEX<FIND,3>)
    27                POSSREFS = *(NLEX<FIND,5>)
    28                MMPOSSREFS = *(NLEX<FIND,6>)
           *
           *
           *                         ***MATCH SUBROUTINE***
           *
           *         "MATCH" CHECKS TWO CODES TO SEE IF THEY MATCH.
           *
    29                DEFINE('MATCH(MATCHED,MATCHER,SEGS)I,S,P')
    30                PAT = BREAK('1')
    31                SEG = LEN(CO)                              :(MATCHEND)
    32 MATCH          I = LT(I,SEGS) I + 1                       :F(RETURN)
    33                MATCHED SEG . S =
    34                MATCHER SEG . P =
    35                (S + P) PAT                                :F(MATCH)S(FRETURN)
    36 MATCHEND
           *
           *
           *                         ***RANDOM FUNCTION***
           *
           *         "RANDOM" GENERATES A PSEUDORANDOM INTEGER .
           *
    37                DEFINE('RANDOM(NUM)')                      :(RANDOMEND)
    38 RANDOM         RANVAR = REMDR(RANVAR * 12621 + 21131,100000)
    39                RANDOM = RANVAR * NUM / 100000 + 1         :(RETURN)
    40 RANDOMEND
           *
           *
           *                         ***FIND FUNCTION***
           *
           *         "FIND" SEARCHES LEXIS ARRAYS FOR A MATCHING CODE .
           *
    41                DEFINE('FIND(MATCHED,AREFS,DEPTH,SEGS)H')
    42                LROWER = *(LEXIS<DIREC<FIN. >,QN>)
    43                LROWER2 = *(LEXIS<DIREC<FIND>,QN> LEXIS<DIREC<FIND>,QN2>)
    44                ROWER = *(INDEX<FIND,1>)                   :(FINDEND)
    45 FIND           FIND = RANDOM(DEPTH)
    46                H = FIND
    47 TRY            MATCH(MATCHED,EVAL(AREFS),SEGS)            :S(RETURN)
    48                FIND = GE(FIND,DEPTH) 1                    :S(HEAD)
    49                FIND = FIND + 1
    50 HEAD           EQ(FIND,H)                                 :S(FRETURN)F(TRY)
    51 FINDEND
           *
```

```
   *
   *                          ***READ FUNCTION***
   *
   *     THIS READS IN A ONE OR TWO-DIMENSIONAL ARRAY .
   *
52             DEFINE('READ()H,I,J,K,CARD')
53             DEPTH = TABLE()
54             CODING1 = BREAK('/') . *READ<I> LEN(1)
55             CODING = BREAK('/') . *READ<I,J> LEN(1)    :(READEND)
56 READ        READ = ARRAY(INPUT)
57             PROTOTYPE(READ) BREAK(',') . H LEN(1) REM . K  :S(READ1)
58             H = PROTOTYPE(READ)                            :(READ3)
59 READ1       J =
60             I = LT(I,H) I + 1                       :F(CARD4)
61 READ2       J = LT(J,K) J + 1                       :F(READ1)
62 CARD        CARD CODING =                           :S(READ2)
63             CARD = CARD INPUT
64             DIFFER(CARD,'STOP')                     :S(CARD) F(DEPTH)
65 READ3       I = LT(I,H) I + 1                       :F(CARD4)
66 CARD2       CARD CODING1 =                          :S(READ3)
67             CARD = CARD INPUT
68             DIFFER(CARD,'STOP')                     :S(CARD2) F(DEPTH)
69 CARD4       CARD = DIFFER(CARD,'STOP') INPUT        :S(CARD4)
70             DEPTH<READ> = I                         :(RETURN)
71 DEPTH       DEPTH<READ>  = I - 1                     :(RETURN)
72 READEND
   *
   *
   *                          ***SELPNP SUBROUTINE***
   *
   *     "SELPNP" SELECTS A PRONOUN TO BE USED AS THE SUBJECT OF A CLAUSE.
   *     THE PRONOUN IS EITHER "I" OR IS FOUND BY MATCHING WITH A NOUN
   *     SELECTED RANDOMLY FROM THE LISTS OF RECENTLY USED NOUNS .
   *
73             DEFINE('SELPNP()L')                     :(SELPNPEND)
74 SELPNP      L = GE(2,RANDOM(3))  NLINK(CURRENT)
75             L = IDENT(L)  NLINK(LASTC)
76             L = IDENT(L)  NLINK(CURRENT)
77             DIFFER(L)  GE(4,RANDOM(5))              :F(I)
78             OUTPUT = SELPNP
79 SPLOOP      GE(RANDOM(10),6)  DIFFER(NLINK(L))      :F(SPLEND)
80             L = NLINK(L)
81 SPLEND      LEXNO = NWORD(L)
82             OUTPUT = LEXNO
83             PNP()                                   :(RETURN)
84 I           OUTPUT = 'I'
85             SENTENCE = SENTENCE 'I '
86             LEXNO =  1                               :(RETURN)
87 SELPNPEND
   *
   *
   *                          ***PNP SUBROUTINE***
   *
   *     "PNP" FINDS A PRONOUN WHICH MATCHES LEXNO AND INSERTS IT INTO THE
   *     CLAUSE AS THE SUBJECT .
   *
88             DEFINE('PNP()')                         :(PNPEND)
89 PNP         ADDWORD(LEXNO)
90             OUTPUT = 'PNP'
91     WORD = FIND(NLEX<LEXNO,7>,PREFS,DEPTH<PLEX>,SEGS)
   +                                                   :F(ERROR)
92             SENTENCE = SENTENCE PLEX<WORD,2>        :(RETURN)
93 PNPEND
   *
```

144

```
      *
      *                           ***ADDWORD SUBROUTINE***
      *
      *      "ADDWORD" ADDS A WORD TO THE LIST OF NOUNS FROM THE CURRENT
      *      SENTENCE .
      *
 94            DEFINE('ADDWORD(X)N')                    : (ADDWORDEND)
 95 ADDWORD   IDENT(NLINK(AVAIL))                       :F(POP)
 96           N = NODE(X)                               : (ADD)
 97 POP       N = NLINK(AVAIL)
 98           NLINK(AVAIL) = NLINK(N)
 99           AREAR = IDENT(NLINK(AVAIL)) AVAIL
100 ADD       NLINK(N) = NLINK(CURRENT)
101           NWORD(N) = X
102           NLINK(CURRENT) = N
103                                                     : (RETURN)
104 ADDWORDEND
      *
      *                           ***PCHECK SUBROUTINE***
      *
      *      "PCHECK" SEARCHES THE LISTS OF RECENTLY USED NOUNS FOR LEXNO .
      *
105            DEFINE('PCHECK(X)P')                     : (PCHECKEND)
106 PCHECK    P = NLINK(CURRENT)
107 LOOP1     P = DIFFER(P)        DIFFER(X,NWORD(P))  NLINK(P)
    +                                                   :S(LOOP1)
108           DIFFER(P) IDENT(X,NWORD(P))               :S(RETURN)
109           P = NLINK(LASTC)
110 LOOP2     P = DIFFER(P)        DIFFER(X,NWORD(P))  NLINK(P)
    +                                                   :S(LOOP2)
111           DIFFER(P) IDENT(X,NWORD(P))      :S(RETURN)F(FRETURN)
112 PCHECKEND
      *
      *                           ***SWITCH SUBROUTINE***
      *
      *      "SWITCH" PUTS THE LIST OF NOUNS FROM THE LAST SENTENCE INTO THE
      *      AVAILABLE SPACE LIST AND MOVES THE LIST FROM THE CURRENT SENTENCE
      *      INTO THE LAST SENTENCE LIST .
113            DEFINE('SWITCH()')                       : (SWITCHEND)
114 SWITCH    NLINK(AREAR) = NLINK(LASTC)
115           AREAR = DIFFER(LREAR,LASTC) LREAR
116           NLINK(LASTC) = NLINK(CURRENT)
117           LREAR = LASTC
118           LREAR = DIFFER(CREAR,CURRENT) CREAR
119           NLINK(CURRENT) =
120           CREAR = CURRENT                           : (RETURN)
121 SWITCHEND
      *
      *                           ***OLD FUNCTION***
      *
      *      "OLD" SELECTS A NOUN FROM THE LISTS OF RECENTLY USED NOUNS
      *      AT RANDOM .
      *
122            DEFINE('OLD()L')                         : (OLDEND)
123 OLD       L = NLINK(CURRENT)
124           L = IDENT NLINK(LASTC)
125           IDENT(L)                                  :S(FRETURN)
126 OLDLP     GE(RANDOM(10),6) DIFFER(NLINK(L))         :F(OLDLPEND)
127           L = NLINK(L)                              : (OLDLP)
128 OLDLPEND
129           OUTPUT = NWORD(L)
130           OLD = NWORD(L)                            : (RETURN)
131 OLDEND
      *
```

```
      *
      *
      *                       ***SELNOUN FUNCTION***
      *
      *       "SELNOUN" SELECTS THE SUBJECT FOR A NEW CLAUSE EITHER AT RANDOM OR
      *       BY FINDING A NOUN WHICH MATCHES ONE OF THE NOUNS IN THE LISTS OF
      *       RECENTLY USED NOUNS .
      *
132           DEFINE('SELNOUN()')                         : (SELNOUNEND)
133 SELNOUN   GE(8,RANDOM(10))                            :F(SNRND)
134           OUTPUT = 'SMN'
135           SELNOUN = FIND(NLEX<OLD(),8>,SREFS,DEPTH<NLEX>,SEGS)
    +                                                     :S(RETURN)F(SNRND)
136 SNRND     OUTPUT = 'RMN'
137           SELNOUN = RANDOM(DEPTH<NLEX>)               : (RETURN)
138 SELNOUNEND
      *
      *
      *                       ***NP SUBROUTINE***
      *
      *       "NP" BUILDS A NOUN PHRASE AROUND THE NOUN INDICATED BY LEXNO .
      *
139           DEFINE('NP()')                              : (NPEND)
140 NP        ADDWORD(LEXNO)
141           WORD = FIND(NLEX<LEXNO,7>,AREFS,DEPTH<ALEX>,SEGS)
    +                                                     :F(ERROR)
142           SENTENCE = SENTENCE ' ' ALEX<WORD,2>
143           IDENT(FLAG) DIFFER(VFLAG)                   :F(NP1)
144           GE(RANDOM(10),5)                            :S(MMAJ)F(MMPOSS)
145 NP1       GE(RANDOM(10),6)                            :S(N)
146         OUTPUT = 'NP1'
147           GE(RANDOM(10),5)                            :S(POSS)
148 AJ        IDENT(FLAG) GE(RANDOM(10),5)                :S(MMAJ)
149           OUTPUT = 'AJ'
150           WORD = FIND(NLEX<LEXNO,7>,AJREFS,DEPTH<AJLEX>,SEGS)
    +                                                     :S(AJOK)F(ERROR)
151 MMAJ      FLAG = 1
152           OUTPUT = 'MMAJ'
153           WORD = FIND(NLEX<LEXNO,4>,AJREFS,DEPTH<AJLEX>,SEGS)
    +                                                     :F(ERROR)
154 AJOK      SENTENCE = SENTENCE ' ' AJLEX<WORD,2>       : (N)
155 POSS      IDENT(FLAG)   GE(RANDOM(10),5)              :S(MMPOSS)
156         OUTPUT = 'POSS'
157 POSS1     WORD = FIND(NLEX<LEXNO,7>,POSSREFS,DEPTH<NLEX>,SEGS)
    +                                                     :S(POSSOK)F(AJ)
158 MMPOSS    FLAG = 1
159         OUTPUT = 'MMPOSS'
160           WORD = FIND(NLEX<LEXNO,7>,MMPOSSREFS,DEPTH<NLEX>,SEGS)
    +                                                     :F(MMAJ)
161 POSSOK    SENTENCE = SENTENCE ' ' NLEX<WORD,2> "'S"
162           ADDWORD(WORD)                               : (N)
163 N         WORD = LEXNO
164           SENTENCE = SENTENCE ' ' NLEX<WORD,2>   : (RETURN)
165 NPEND
      *
      *
      *       THESE STATEMENTS RECOVER FROM MATCH FAILURE AND START THE CLAUSE
      *       GENERATION OVER .
      *
166                                                       : (ERROREND)
167 ERROR     OUTPUT = '*** MATCH FAILURE IN: ' SENTENCE
168           NLINK(CURRENT) =
169           CREAR = CURRENT
170           SENTENCE =                                  : (GEN2)
171 ERROREND
      *
      *
```

```
          *      BFGINNING OF MAIN PROGRAM
          *
172 DATAIN      ARRAYNAME = INPUT
173             $ARRAYNAMF = DIFFER(ARRAYNAME,'EOF') READ() :S(DATAIN)
174             OUTPUT = RANVAR
          *
          *      THIS IS THE BFGINNING OF THE MAIN LOOP.  WITHIN ONE EXECUTION OF
          *      THIS LOOP, A SENTENCE IS GENERATED, PRINTED ALONG WITH A TRACE
          *      OF ITS CREATION, AND ADDED TO THE PARAGRAPH.
          *
          *
175 GENERATE    QS = LT(QS,QSQ)  QS + 1                     :F(OUT)
176             SWITCH()
177 GEN2        FLAG =
178             VFLAG =
179 LNP
180             GE(2,RANDOM(3))    SELPNP()                 :S(ES)
181             LEXNO = SELNCUN()
182             OUTPUT = LEXNO
183             PCHECK(LEXNO)                               :S(PRON)
184             NP()                                        :(ES)
185 PRON        PNP()
186 ES          GE(RANDOM(10),5)                            :S(VI)
187 VT          IDENT(FLAG)  GE(RANDOM(10),3)                :S(MMVT)
188             OUTPUT = 'VT'
189             VFLAG = 1
190 VT1         WORD = FIND(NLEX<LEXNO,7>,VTREFS,DEPTH<VTLEX>,SEGS)
      +                                                     :S(VTOK)F(ERROR)
191 MMVT        FLAG = 1
192             OUTPUT = 'MMVT'
193             WORD = FIND(NLEX<LEXNO,3>,VTREFS,DEPTH<VTLEX>,SEGS)
      +                                                     :S(VTOK)
194             FLAG =
195             OUTPUT = 'VT'                               :(VT1)
196 VTOK        SENTENCE = SENTENCE ' '  VTLEX<WORD,2>
197             LEXNO = FIND(VTLEX<WORD,4>,NREFS,DEPTH<NLEX>,SEGS)
      +                                                     :F(ERROR)
198 RNP
199             NP()                                        :(TERM)
200 VI          IDENT(FLAG)                                 :S(MMVI)
201             OUTPUT = 'VI'
202 VI1         WORD = FIND(NLEX<LEXNO,7>,VIREFS,DEPTH<VILEX>,SEGS)
      +                                                     :S(VIOK)F(VT)
203 MMVI        FLAG = 1
204             OUTPUT = 'MMVI'
205             WORD = FIND(NLEX<LEXNO,3>,VIREFS,DEPTH<VILEX>,SEGS)
      +                                                     :S(VIOK)
206             FLAG =
207             OUTPUT = 'VI'                               :(VI1)
208 VIOK        SENTENCE = SENTENCE ' ' VILEX<WORD,2>        :(TERM)
209 TERM        GT(RANDOM(3),2) IDENT(CFLAG)                :F(DONE)
210             OUTPUT = 'CONJ'
211             CFLAG = 1
212             GT(RANDOM(2),1)                             :S(BUT)
213 AND         SENTENCE = SENTENCE ', AND '                 :(GEN2)
214 BUT         SENTENCE = SENTENCE ', BUT '                 :(GEN2)
215 DONE        CFLAG =
216             PARAGRAPH = PARAGRAPH  SENTENCE '.  '
217             OUTPUT = SENTENCE '.'
218             SENTENCE =                                  :(GENERATE)
219 OUT         OUTPUT =
220             OUTPUT = PARAGRAPH
221 END
```

Notes

Introduction

1. I am using "Languages" here in the sense of Nelson Goodman's *Languages of Art: An Approach to a Theory of Symbols* (Indianapolis: Hackett Publ. Co., Inc., 1976).

2. Quoted by Hans Richter in *Dada: Art and Anti-Art* (1965; rpt. New York: Oxford Univ. Press, 1978), p. 25.

3. Richard Huelsenbeck, "Dada oder der Sinn im Chaos," in Richard Huelsenbeck, ed., *Dada: eine Literarische Dokumentation* (Hamburg: Rowolt, 1964), p. 9.

4. Richter, p. 19.

5. A number of books trace the history of the Dada movement, among them: Hugo Ball, *Flight out of Time: a Dada Diary*, ed. John Elderfield (New York: Viking Press, 1974); Richard Huelsenbeck, *Memoirs of a Dada Drummer*, ed. Hans J. Kleinschmidt (New York: St. Martin's Press, 1975); and Stephen Foster and Rudolf Kuenzli, eds., *Dada Spectrum: the Dialectics of Revolt* (Madison: Coda Press, 1979).

6. Morse Peckham, *Man's Rage for Chaos: Biology, Behavior and the Arts* (Philadelphia: Chilton, 1965), p. 314.

7. See Ruth Perlmutter, "Dada Sine-ma Dada," *Dada/Surrealism*, No. 3 (1973), 7; and Gianni Rondolino, *L'Occhio tagliato* (Turin: Ed. Martano, 1972), p. 271.

8. Richter, p. 125, quotes Raoul Hausmann on the Berlin dadaist Johannes Baader: "Johannes Baader believed all his life that he was 'Jesus Christ returned from the clouds of heaven.'" Baader called himself the "Oberdada." Hugo Ball was another "priest": in performing his sound poems or "poems without words," he adopted the "liturgical chanting that wails through all the Catholic churches of East and West" (Richter, p. 43). Ball later left the movement and became a devout Christian. For a fuller discussion on the mystical side of Dada, see Richard Shepard "Dada and Mysticism: Influences and Affinities," in Stephen Foster and Rudolf Kuenzli, eds., *Dada Spectrum: The Dialectics of Revolt*, (op. cit).

9. Tristan Tzara, "Dada Manifesto 1918" in Mary Ann Caws, trans. and ed., *Approximate Man and Other Writings* (Detroit: Wayne State Univ. Press, 1973), p. 149.

10. Ibid., p. 154.

11. See the analysis of Duchamp's work by Harriet and Sydney Janis, "Marcel Duchamp: Anti-Artist" in Robert Motherwell, ed., *The Dada Painters and Poets* (New York: Wittenborn, Schultz, Inc., 1951), pp. 306–308.

12. Tzara, "Dada Manifesto 1918," p. 155.

13. Ibid., p. 152.

14. Tristan Tzara, "Manifesto on Feeble Love and Bitter Love," in Motherwell, ed., *The Dada Painters and Poets*, p. 92.

15. Tristan Tzara, "Lecture on Dada," in Motherwell, ed., p. 250.

16. For accounts of the genesis of the word "dada" see Georges Hugnet, *Dictionnaire du dadaisme 1916–1922* (Paris: Jean-Claude Simoën, 1976), p. 73; Willy Verkauf, *Dada: Monograph of a Movement* (New York: St. Martin's Press, 1975), pp. 7, 24, 47, 86; Richter, *Dada: Art and Anti-Art*, pp. 31–32.

17. Tzara, "Dada Manifesto 1918," p. 156.

18. Tzara, "Lecture on Dada," p. 250.

19. Michel Sanouillet distinguishes between the Dada artist of the Zürich movement who practiced art for art's sake and the Dadaist of the Berlin movement, "a militant concerned with the activity of a movement and the efficiency of an ideological platform." In moving from Zürich to Berlin, he argues, Richard Huelsenbeck made the transition from Dada artist to Dadaist. See his "Dada: A Definition" in Foster and Kuenzli, eds., *Dada Spectrum*, p. 25.

20. Hans J. Kleinschmidt, "Berlin Dada," in Foster and Kuenzli, eds., *Dada Spectrum*, p. 156.

21. Richter, p. 127.
22. Tzara, "Dada Manifesto 1918," p. 154.
23. Richter, pp. 151–153.
24. Tzara, "Lecture on Dada," p. 247.
25. Tzara, "Dada Manifesto 1918," p. 149.
26. See the discussion by Hans J. Kleinschmidt of "Berlin Dada" (op. cit.), pp. 170–171, and especially Michel Sanouillet's "Dada: A Definition" (op. cit.), pp. 16–27.
27. Tzara, "Dada Manifesto 1918," p. 150.
28. Ibid., p. 151.
29. Richter, pp. 137–139.
30. Peter Schifferli's *Dada: Dichtung und Chronik der Gründer* (Zürich: Die Arche, 1957) contains the simultaneous poem "L'Amiral cherche une maison à louer" by Richard Huelsenbeck, Marcel Janco, and Tristan Tzara as well as several group compositions, pp. 94–102. For illustrations of dadaist poems by artists see: Richard Huelsenbeck, *Phantastische Gebete* (1920; rpt. Zürich: Die Arche, 1960), illustrated by Hans Arp and George Grosz; and Paul Eulard, *Répétitions* (Paris: Au Sans Pareil, 1921), illustrated by Max Ernst. For typographical experiments see Tristan Tzara, "Proclamation sans prétention" in *Sept manifestes dada* (1924; Paris: Jean-Jacques Pauvert, 1963), pp. 37–39. For poems imitating film: Emmy Ball Hennings, "Die vielleicht letzte Flucht" ("The Perhaps Last Escape") in Schifferli, ed. (op. cit.). A kinetic version of Man Ray's painting "Dancer/Danger" occurs in his film *Emak Bakia* (1926). For a fuller discussion of Dada and music, see Rudolf Klein and Kurt Blaukopf, "Dada and Music" in Willy Verkauf, *Dada: Monograph of a Movement* (op. cit.). A recitation of Ball's and Schwitters' major sound poems is available in the record set *Futura: Poesia Sonora* (Cramps Records, Milan).
31. Michel Sanouillet, *Dada à Paris* (Paris: Jean-Jacques Pauvert, 1965), pp. 152–156.
32. Sanouillet, pp. 173–178.
33. Ibid., pp. 380–387.
34. Tzara, "Note on Art," in Caws, ed., p. 135.
35. For an account of the birth of Surrealism see Maurice Nadeau, *Histoire du surréalisme* (Paris: Seuil, 1964). Sanouillet, in *Dada à Paris* (op. cit.) makes several important distinctions between Dada and Surrealism pp. 419–428, stating, for instance, that "The originality of Surrealism consisted in its putting the accent on the importance of ritual and initiation" (p. 424).
36. Gerald Mead, "Language and the Unconscious in Surrealism," *The Centennial Review*, 20 (1976), 278–289.
37. André Breton, *Manifestoes of Surrealism*, trans. Richard Seaver and Helen R. Lane (Ann Arbor: Univ. of Michigan Press, 1977), p. 26. I have slightly amended the English version in which "dictée" is mistranslated as "dictated."
38. For an account of this "heroic period" of Surrealism see Nadeau (op. cit.), pp. 49–93.
39. Surrealist "opinion polls" occur in *La Révolution surréaliste* No. 2 (Jan. 15, 1925), 8–15 ("Is Suicide a Solution?"); No. 11 (March 15, 1928), 32–40 ("Research on Sexuality"); and No. 12 (Dec. 15, 1929), 65–76 ("What Kind of Hope Do You Put in Love?").
40. Press notice reprinted in Nadeau (op. cit.), p. 221.
41. André Breton, "Surrealist Situation of the Object" in *Manifestoes of Surrealism* (op. cit.), p. 268.
42. Ibid., pp. 266–267.
43. André Breton, introduction to his *Anthologie de l'humour noir* (1939; rpt. Paris: Jean-Jacques Pauvert, 1966).
44. Marvin Minsky, "A Framework for Representing Knowledge," in Patrick H. Winston, ed., *The Psychology of Computer Vision* (New York: McGraw-Hill, 1975), pp. 211–277; and Terry Winograd, "A Framework for Understanding Discourse," in Marcel Adam Just and Patricia A. Carpenter, eds., *Cognitive Processes in Comprehension* (Hillsdale, N.J.: Lawrence Erlbaum Associates, 1977), pp. 63–88.
45. For an introduction to this subject, see Roger Schank and Bonnie L. Nash-Webber, eds., *Theoretical Issues in Natural Language Processing* (New Haven: Dept. of Computer Science, 1975).
46. André Breton, *Manifestoes of Surrealism*, p. 26.

47. Ibid., p. 32.

48. I am adopting Dorothea Tanning's solution to the problem of translating the title's double meaning as it appears in the new bilingual edition she has prepared (New York: W. W. Norton, 1981).

49. *Max Ernst* (Paris: Galeries nationales du Grand-Palais, exhibition catalogue, 1975), p. 14.

50. See Anna Balakian, *André Breton: Magus of Surrealism* (New York: Oxford Univ. Press, 1971) and Michel Carrouges, *André Breton and the Basic Concepts of Surrealism*, trans. Maurice Prendergast (University, Ala.: Univ. of Alabama Press, 1974).

one. Surrealism and the alchemy of the word

1. André Breton, *Manifestoes of Surrealism,* trans. Richard Seaver and Helen R. Lane (Ann Arbor: Univ. of Michigan Press, 1977), pp. 74–75. The last phrase comes from Arthur Rimbaud's letter to Paul Demeny in 1871; it was Rimbaud, also, who coined the phrase "alchemy of the word" which Breton urged artists to take literally in his *Second Manifesto.*

2. Fulcanelli, *Les Demeures philosophales*, 3rd ed. (Paris: Jean-Jacques Pauvert, 1964), II, 176–179.

3. Jacques van Lennep, *Art et alchimie* (Brussels: Editions Meddens, 1966), p. 15.

4. André Breton, *La Clé des champs* (Paris: Editions du Sagittaire, 1953), p. 117.

5. Anna Balakian, *André Breton: Magus of Surrealism* (New York: Oxford Univ. Press, 1971), p. 149.

6. Fulcanelli, *Les Demeures philosophales*, 3rd ed. (Paris: Jean-Jacques Pauvert, 1964), I, 110.

7. Breton, *Manifestoes*, p. 37.

8. André Breton, *Manifestes du surréalisme* (Paris: Jean-Jacques Pauvert, 1962), p. 360 (my translation).

9. Fulcanelli, *Le Mystère des cathédrales*, trans. Mary Sworder (London: Spearman, 1971), p. 42.

10. Breton, *Manifestes*, p. 358 (my translation).

11. Michel Leiris, "Glossaire j'y serre mes gloses" (1939) in *Mots sans mémoire* (Paris: Gallimard, 1969), pp. 73–116; Robert Desnos, *Domaine public* (Paris: Gallimard, 1953), p. 70. "Rose Sélavy" was the alter ego adopted by Marcel Duchamp.

12. In addition to the texts by Fulcanelli (cited above), Breton footnotes Eugène Canseliet's *Alchimie: études diverses de symbolisme hermétique et de pratique philosophale* (Paris: Jean-Jacques Pauvert, 1964). He was also acquainted with René Alleau, who wrote *Aspects de l'alchimie traditionelle* (Paris: Editions de Minuit, 1953).

13. Carl Gustav Jung, *The Integration of the Personality* (New York: Farrar & Rinehart, 1939), pp. 212–214.

14. Ibid., p. 212.

15. Ibid., p. 3.

16. Quoted in André Breton, *Perspective cavalière,* ed. Marguerite Bonnet (Paris: Gallimard, 1970), p. 141. Anna Balakian suggests that the similarity between many of Jung's ideas and those of the surrealists may come from the fact that Breton was influenced by Jung's teacher, Pierre Janet. See her *André Breton*, p. 28.

17. Fulcanelli, *Les Demeures philosophales*, I, 428 (note).

18. For a psychological theory of the Tarot, see Alfred Douglas, *The Tarot* (New York: Penguin, 1971).

19. Eugène Canseliet, *Deux logis alchimiques* (Paris: Jean Schemit, 1945), p. 56. Translation: "With the earth, the salt and the sun, be silent."

20. André Breton, "Pour Dada," *Nouvelle revue française*, VII, No. 82 (July 1, 1920), 211 (my translation).

21. Breton, *Manifestoes*, p. 32.

22. André Breton, "Le Message automatique," *Le Minotaure*, No. 3–4 (1933), 62 (my translation).

23. Sarane Alexandrian, *André Breton par lui-même* (Paris: Seuil, 1971), p. 176.

24. Jules Monnerot, *La Poésie moderne et le sacré* (Paris: Gallimard, 1945), p. 73.

25. André Breton, "Projet initial," in André Breton and Marcel Duchamp, eds., *Le Surréalisme en 1947: exposition internationale du surréalisme* (Paris: Pierre à Feu, 1947), p. 136.

26. Douglas, *The Tarot*, pp. 34–40.

27. André Breton, *Anthologie de l'humour noir* (1939; rpt. Paris: Jean-Jacques Pauvert, 1966), p. 176 (my translation).

28. Breton, *Anthologie*, pp. 332–334.

29. Charles Fourier, *Théorie des quatre mouvements et des destinées générales* (Leipzig, 1808).

30. Emmanuel Swedenborg, *Memorabilia* (1747–1765), trans. and ed. George Bush (New York: John Allen, 1846). For the system of correspondences, see pp. 120–128. Karl Jaspers has attributed Swedenborg's productions of this period to schizophrenia. See *Strindberg and Van Gogh; an attempt at a pathographic analysis with reference to parallel cases of Swedenborg and Hölderlin*, trans. Oskar Grunow and David Woloshin (Tuscon: Univ. of Arizona Press, 1977), pp. 115–126.

31. Hervey de Saint-Denys, *Les Rêves et les moyens de les diriger* (Paris: Amyot, 1967).

32. Jean-Jacques Rousseau, *Rêveries d'un promeneur solitaire* in *Oeuvres complètes*, Vol. I (Paris: Gallimard, 1959), pp. 1086–1097.

33. Breton, *Anthologie*, p. 39.

34. Ibid., p. 273.

35. Douglas, p. 36.

36. Breton comments on the work of Forneret in his *Anthologie*, pp. 123–127.

37. A work with a similar title can be found in the Bibliothèque Nationale in Paris: Richart-Joseph-Edouard-Charles, Commandant Lefebvre des Noëttes, *La Force motrice animale à travers les âges* (Nancy-Paris-Strasbourg: Berger-Levrault, 1924).

38. Guillaume Apollinaire, *L'Enchanteur pourrissant* (Paris: H. Kahnweiler, 1909).

39. Johann Valentin Andreae, *Chymische Hochzeit Christian Rosencreutz* (1459; Strasbur: L. Zetzners S. Erben, 1616).

40. Jaspers (op. cit., p. 134) notes that Hölderlin's work from 1780 to 1805 was "undoubtedly written at a time when Hölderlin had become a victim of schizophrenia." The *Pléiade* edition of Hölderlin comments that the period of the great poems (1800–1806) was one in which "signs of insanity begin to manifest themselves" (Friederich Hölderlin, *Oeuvres* [Paris: Gallimard, 1977], p. 1199). This period includes the *Odes*, the *Elegies* and the *Hymns*. Generally, however, the term "poèmes de la folie" which Breton uses is reserved for the period 1806–1843 (date of the poet's death), during and subsequent to his confinement to a clinic. A selection of these may be found in Michael Hamburger's translation, *Friederich Hölderlin: Poems and Fragments* (London: Routledge & Kegan Paul, 1966).

41. See André Breton, "La situation surréaliste de l'objet" in *Position politique du surréalisme* (1935; rpt. Paris: Denoël/Gonthier, 1972), p. 133.

42. Jean-Pierre Brisset, *La Grammaire logique, suivi de la science de dieu* (Paris: Tchou, 1977). A chapter of this work, "Révélations," offers fantastic etymologies that are in the spirit of Michel Leiris' *Mots sans mémoire*.

43. Douglas, p. 37. The system of Tarot symbolism used in this chapter derives exclusively from this work.

44. Brisset, *La Science de dieu*, p. 143.

45. Breton, "Projet initial," in *Le Surréalisme en 1947*, pp. 136–137; for an explanation of the "starred mole," p. 120.

46. Balakian, *André Breton*, p. 232.

47. Max Ernst, *Beyond Painting and Other Writings by the Artist and His Friends* (New York: Wittenborn, Schultz, Inc., 1948), p. 13.

48. Max Ernst, *La Femme 100 têtes* (Paris: Editions du Carrefour, 1929). Translations of picture captions are from *The Hundred Headless Woman*, trans. Dorothea Tanning (New York: George Braziller, 1981). A comparison between Ernst's collages and the original woodcuts may be seen in Uwe M. Schneede, *Max Ernst* (Stuttgart: Wörttenbergischer Kunstverein, 1970), pp. 12–15. For an analysis of another collage novel, *Une semaine de bonté*, see Renée Riese Hubert, "The Fabulous Fiction of Two Surrealist Artists: Giorgio de Chirico and Max Ernst," *New Literary History*, 4, no. 1 (Autumn 1972), 151–166.

49. Canseliet, *Alchimie*, pp. 59–68; and Fulcanelli, *Les Demeures philosophales*, I, p. 276.

50. André Breton, *Nadja*, trans. Richard Howard (New York: Grove Press, 1960), p. 11.

51. Ernst, *Beyond Painting*, p. 17.

52. Breton, *Manifestes*, p. 313.

53. Breton, *Perspective cavalière*, p. 128.

54. Pierre-Olivier Walzer, "Une bibliothèque idéale," in Marc Eigeldinger, ed., *André Breton* (Neuchâtel: Editions de la Baconnière, 1970), p. 85.

55. Anna Balakian, "André Breton et l'hermétisme des 'Champs magnétiques' à 'La clé des champs,'" *Cahiers de l'Association Nationale des Etudes Francaises*, No. 15 (1953), 129.

56. Fulcanelli, *Les Demeures philosophales*, II, 46 and 186–187.

57. Marie-Claire Bancquart, *Paris des surréalistes* (Paris: Seghers, 1973), p. 107.

58. André Breton, *L'Amour fou* (Paris: Gallimard, 1937), p. 68.

59. Bancquart, p. 101. Dolet was accused of atheism and burned at the stake on the place Maubert in 1546.

60. See Fulcanelli, *Les Demeures philosophales*, II, 264: the hermetic cabala is a precise key enabling its possessor to open the door of the sanctuaries, the works of traditional science or "closed books," in order to extract their spirit and to seize their meaning.

61. Antonin Artaud, *Le Théâtre et son double* in *Oeuvres complètes* (Paris: Gallimard, 1964), IV, 12 (my translation).

62. Artaud, *Oeuvres complètes*, I, No. 1, 40–41 (my translation).

63. Ibid, p. 40.

64. Artaud, "Le Théâtre alchimique," in *Le Théâtre et son double*, pp. 58–63.

65. Ibid, p. 62.

66. Artaud, *Oeuvres complètes*, IV, 295 (my translation).

67. Antonin Artaud, "Cinema and Reality," in *Selected Writings*, ed. Susan Sontag (New York: Farrar, Strauss & Giroux, 1976), pp. 15–52.

68. Fulcanelli, *Les Demeures philosophales*, I, 42 and 434–445. Fulcanelli breaks "Compostella" down cabalistically into the Latin *compos stella*, "he who has obtained the (hermetic) star."

69. For a discussion of the mythological figure of Mars in terms of alchemy, see Dom Antoine-Joseph Pernety, *Les Fables egyptiennes et grecques* (Paris: Delalain L'ainé, 1786), II, 118–123.

70. The alchemical interpretation of the Venus myth may be found in Pernety, II, 104–113.

71. Pernety, II, 163–180, discusses Mercury as an alchemical figure.

72. Artaud's original scenario is reprinted in *Oeuvres complètes*, III, 25–31; and in Alain and Odette Virmaux, *Les Surréalistes et le cinéma* (Paris: Seghers, 1976), pp. 162–166.

73. Bettina Knapp proposes a similar interpretation in "Artaud: a New Type of Magic," *Yale French Studies*, No. 31 (1964), 95–97.

74. William F. van Wert, "Germaine Dulac: First Feminist Filmmaker," in Karyn Kay and Gerald Peary, eds., *Women and the Cinema* (New York: Dutton, 1977), pp. 213–223.

75. Virmaux, pp. 42–49.

76. Accounts of the celebrated "Scandal of the Ursulines" (the Ursulines was the movie theater in Paris where Artaud's and Dulac's film was first shown, on February 9, 1928), differ. By some accounts it was Artaud who openly and loudly attacked Dulac just as the film was about to begin. Other accounts do not even mention Artaud's presence, stating that the attack was led by Breton and his disciples Louis Aragon, Robert Desnos, Georges Sadoul (the film critic) and a dozen or so others. Whoever the actual leaders of the attack were, it is an established fact that Dulac was accused of betraying Surrealism in her filmed version of Artaud's script. In a 1932 letter to Jean Paulhan, however, Artaud reclaimed the film, stating that it was the first authentic surrealist film. The different accounts of the "scandal" are collected in Alain and Odette Virmaux, pp. 171–177.

77. Florence de Meredieu, "Corps solaire/pierre de lune," *Obliques*, No. 10–11 (1971), 244.

78. Guillame Apollinaire, "L'Esprit nouveau et les poètes," *Mercure de France*, Dec. 1918, 394.

79. For an assessment of the effect of psychoanalytic, scientific, and mathematical theories on the surrealists and their relationship to the occult see the analysis by Anna Balakian in *André Breton* (op. cit.), pp. 27–44.

80. Michel Carrouges, "Le surréalisme," in Marc Eigeldinger, ed., *André Breton* (Neuchâtel: Editions de la Baconnière, 1950), p. 79.

two. *The revolt: breaking the frames*

1. Lucy Lippard, ed., *Dadas on Art* (Englewood Cliffs, N.J.: Prentice-Hall, 1971), p. 20.

2. André Breton, *Manifestoes of Surrealism* (Ann Arbor: Univ. of Michigan Press, 1977), p. 32.

3. Morse Peckham, *Man's Rage for Chaos: Biology, Behavior and the Arts* (Philadelphia: Chilton Books, 1965), pp. 217–222 and 314.

4. Jan Mukařovský, *Structure, Sign and Function*, trans. John Burbank and Peter Steiner (New Haven: Yale Univ. Press, 1978), p. 20. A good selection of essays of the Russian formalist school by Shklovskij and others may be found in Ladislav Matejka and Krystyna Pomorska, eds. *Readings in Russian Poetics* (Cambridge: MIT Press, 1971).

5. Hugo Ball, *Flight out of Time: a Dada Diary*, ed. John Elderfield (New York: Viking Press, 1974), p. 70.

6. Erving Goffman, *Frame Analysis* (Cambridge: Harvard Univ. Press, 1974).

7. Marvin Minsky, "A Framework for Representing Knowledge," in Patrick H. Winston, ed., *The Psychology of Computer Vision* (New York: McGraw Hill, 1975), p. 212.

8. Teun A. van Dijk, "Semantic Macro-Structures and Knowledge Frames in Discourse Comprehension," in Marcel Adam Just and Patricia A. Carpenter, eds., *Cognitive Processes in Comprehension* (Hillsdale, N.J.: Lawrence Erlbaum Associates, 1977), p. 21.

9. Minsky, p. 246.

10. Ibid., p. 246.

11. Thomas Kuhn, *The Structure of Scientific Revolutions* (Chicago: Univ. of Chicago Press, 1962).

12. A collection of articles applying frame theory to discourse analysis may be found in Dieter Metzing, ed., *Frame Conceptions and Text Understanding* (New York: Walter de Gruyter, 1980).

13. Walter Kintsch, "On Comprehending Stories," in Just and Carpenter, eds., *Cognitive Processes in Comprehension*, pp. 33–62.

14. Terry Winograd, "A Framework for Understanding Discourse," in Just and Carpenter, eds., op. cit., pp. 83–84.

15. Bertold Brecht, "Anmerkungen zur Oper 'Aufstieg und Fall der Stadt Mahagonny'" in *Aufstieg und Fall der Stadt Mahagonny* (Berlin: Edition Suhrkamp, 1966), pp. 83–96. The essay explains Brecht's famous distinction between the "epic" and the "dramatic" theatre.

16. E. D. Hirsch, *Validity in Interpretation* (New Haven: Yale Univ. Press, 1967), p. 264.

17. Hans Robert Jauss, *Literaturgeschichte als Provokation* (Frankfurt am Main: Suhrkamp, 1970), pp. 144–208.

18. Jauss, p. 175.

19. Melchior Vischer, *Sekunde durch Hirn* (1920; rpt. in Melchior Vischer, *Sekunde durch Hirn, Der Teemeister, Der Hase und andere Prosa*, ed. Hartmut Geerken (München: Text und Kritik, 1976), pp. 31–79. The few facts which are known about Vischer (1895–1975) are related by Hartmut Geerkin in his anthology.

20. Luis Buñuel, "Notes on the Making of *Un chien andalou*," in Joan Mellen, ed., *The World of Luis Buñuel* (New York: Oxford Univ. Press, 1978), p. 151.

21. Umbro Apollonio, ed., *Futurist Manifestoes* (New York: Viking Press, 1973), p. 208. Later references are from pp. 208–218 (passim).

22. Germaine Dulac, "Visual and Anti-Visual Films," in *The Avant-Garde Film*, ed. P. Adams Sitney (New York: New York Univ. Press, 1978), p. 33.

23. Jacques Brunius, "Experimental Film in France," in Roger Manvel, ed., *Experiment in the Film* (New York: Arno Press and the New York Times, 1970), pp. 84–85. Brunius also cites the technique of "crick-necked camera" or "the mania for photographing everything crooked."

24. Quotations are taken from the scenario Buñuel published in *La Révolution surréaliste*, No. 12 (1929), 34–37.

25. For an analysis of the diegetic space of this segment, see Philip Drummond, "Textual Space in *Un chien andalou*," *Screen*, 18, No. 3 (Autumn 1977), 91–106. The article is in part a

critique of Linda Williams, "The Prologue to *Un chien andalou*: a Surrealist Film Metaphor," *Screen*, 17, No. 4 (Winter, 1976/ 77), 24–33.

26. Luis Buñuel, "Notes on the Making of *Un chien andalou*," p. 153.

27. The terminology being used is adopted from Sigmund Freud, *The Interpretation of Dreams, Complete Psychological Works*, IV and V, trans. James Strachey (London: Hogarth Press, 1953).

28. André Breton, "Comme dans un bois," *L'Age du cinéma*, No. 4/5 (1951); rpt. in Alain and Odette Virmaux, *Les Surréalistes et le cinéma* (Paris: Seghers, 1976), pp. 277–282.

29. Breton, "Comme dans un bois," p. 281 (my translation).

30. Buñuel, "Un chien andalou," 34.

31. Jurij Tynianov, "On Literary Evolution," in Matjeka and Pomorska, eds., pp. 66–77.

32. See chapter 1.

33. Jean Goudal, "Surréalisme et cinéma," *Revue Hebdomadaire*, No. 2 (February, 1925), 344.

34. Hans Richter, "Avant-Garde Film in Germany," in Manvell, ed., p. 222.

35. See chapter 5.

36. Antonin Artaud, *Selected Writings*, ed. Susan Sontag (New York: Farrar, Strauss & Giroux, 1976), p. 85 and pp. 215–271 (passim).

37. Antonin Artaud, "L'Activité du bureau de recherches surréalistes," *La Révolution surréaliste*, No. 3 (April, 1925), 31.

38. Antonin Artaud, *Le Théâtre et son double* in *Oeuvres complètes* (Paris: Gallimard, 1964), IV, p. 112.

39. Ibid., pp. 101–124 (passim, my translation).

40. Ibid., p. 107 (my translation).

41. Ibid., p. 98 (my translation).

42. Antonin Artaud, *The Spurt of Blood* in Susan Sontag, trans. *Selected Writings of Antonin Artaud*, p. 73. See Bettina Knapp, *Antonin Artaud: Man of Vision* (New York: David Lewis, 1969), for an ingenious interpretation of this dramatic sketch, pp. 32–34.

43. Antonin Artaud, p. 132 (my translation).

44. Ibid., p. 149 (my translation).

three. **The language: frame-making**

1. Teun A. van Dijk, *Text and Context* (New York: Longman, 1977), pp. 144–146. Van Dijk argues that the processes of selection and integration will be different for different types of discourse, different language users, or may vary according to different pragmatic contexts or social situations (p. 147).

2. Hans-Georg Gadamer, *Truth and Method* (New York: Seabury Press, 1975), p. 337.

3. Gadamer, p. 337.

4. Hans Robert Jauss, "Der Leser als Instanz einer neuen Geschichte der Literatur," *Poetics*, 7, No. 3/4 (1975), 339.

5. A good review of conventional genre theory may be found in Gustavo Pérez, "The Novel as Genres," *Genre*, 12 (Fall 1979), 269–292.

6. All quotations are from the Richard Howard translation of *Nadja* (New York: Grove Press, 1960).

7. Sigmund Freud, *The Complete Psychological Works*, trans. James Strachey (London: Hogarth Press, 1953–63), IV, V, VIII, and XV.

8. Freud, *Introductory Lectures to Psychoanalysis*, XV, 173–175.

9. Freud, *The Interpretation of Dreams*, IV, 279–304.

10. Freud, *Introductory Lectures*, XV, 175–181.

11. Ibid., pp. 154–157.

12. Marie-Claire Bancquart, "Surréalisme et 'Génie du lieu,'" *Cahiers du 20ème siècle*, No. 4 (1975), 79–95.

13. Freud, *Introductory Lectures*, XV, 173–175.

14. Jean Starobinski, "Freud, Breton, Myers," *L'Arc*, 34 (1968), 87–89.

15. André Breton, "Comme dans un bois," in Alain and Odette Virmaux, eds., *Les Surréalistes et le cinéma* (Paris: Seghers, 1976), pp. 277–282.

16. Walter Kintsch, *The Representation of Meaning in Memory* (New York: John Wiley, 1974), pp. 77–81.

17. Teun A. van Dijk, "Cognitive Processing of Literary Discourse," *Poetics Today*, No. 1/2 (Autumn 1979), 143–159.

18. Walter Benjamin, "Der Surrealismus," in *Angelus Novus: Ausgewählte Schriften* (Frankfurt am Main: Suhrkamp, 1966), II, 203.

19. Topicalization in language is discussed in Teun A. van Dijk, *Text and Context*, p. 6 and pp. 138–142 and in A. J. Grimes, *The Thread of Discourse* (The Hague: Mouton, 1975), pp. 337–344. See also S. T. Rosenberg, "Frame-based Text Processing" in Dieter Metzing, ed., *Frame Conceptions and Text Understanding* (New York: Walter de Gruyter, 1980), pp. 96–119.

20. André Breton and Philippe Soupault, *Les Champs magnétiques* (1920; rpt. Paris: Gallimard, 1976).

21. Breton and Soupault, "Eclipses" in *Les Champs magnétiques*, pp. 41–49.

22. Van Dijk, *Text and Context*, pp. 133–134.

23. George A. Miller and Philip N. Johnson-Laird, *Language and Perception* (Cambridge: Harvard Univ. Press, 1976), p. 291.

24. Topicalization in film is covered somewhat indirectly by theories of segmentation as presented by Christian Metz, *Film Language* (New York: Oxford Univ. Press, 1974), pp. 108–146; Brian Henderson, *A Critique of Film Theory* (New York: E. P. Dutton, 1980), pp. 144–159; and Raymond Bellour, *L'Analyse du film* (Paris: Albatross, 1979), pp. 247–270.

25. The term "arranger" is borrowed from David Hayman, *Ulysses: the Mechanics of Meaning* (Englewood Cliffs, N.J.: Prentice-Hall, 1970). For an extended discussion of film narrators, see my "Form and Meaning in the French Film, II: Narration and Point of View," *The French Review*, 54, No. 2 (Dec. 1980), 288–298.

26. For discussions of *Un chien andalou*, see "Jean Vigo on *Un chien andalou*," in Luis Buñuel, *L'Age d'or and Un chien andalou*, trans. Marianne Alexandre (New York: Simon & Schuster, 1968), pp. 75–81; Peter Harcourt, "Luis Buñuel: Spaniard and Surrealist," *Film Quarterly*, No. 45 (April, 1960), 2–18; Elizabeth Lyon, "Luis Buñuel: the Process of Dissociation in Three Films," *Cinema Journal*, 13, No. 1 (1973), 45–48; Pierre Renaud, "Symbolisme au second degré: *Un chien andalou*," *Etudes cinématographiques*, No. 20/23 (1963), 147–157; Raymond Durgnat, *Luis Buñuel* (Berkeley: Univ. of California Press, 1968), pp. 22–37 and 46–55; Freddy Buache, *Luis Buñuel* (Lausanne: La Cité, 1970), pp. 12–17; Adou Kyrou, *Luis Buñuel* (Paris: Seghers, 1970), pp. 14–21; Alice Goetz and Helmut W. Banz, eds., *Luis Buñuel, eine Dokumentation* (Verband des deutschen Filmclubs, e. V., anlässlich der Retrospektive Bad Ems, 1975), pp. A31–50 and 188–191; Alberto Cattini, "Luis Buñuel," *La Nova Italia*, No. 59 (Nov. 1978), 16–20.

27. For a psychoanalytic approach to the film (which, in my view, goes too far in trying to impose an external grid on the work), see Fernando Cesarman, *El Ojo de Buñuel; psicoanalysis desde una butaca* (Barcelona: Editorial Anagrama, 1976), pp. 69–86. Another intriguing observation was made by my student Janis Applewhite, who noted that the pianos may actually be an androgynous symbol (a female, curved form surmounted by phallic animals).

28. Christian Metz, *Le Signifiant imaginaire: psychanalyse et cinéma* (Paris: Union Générale d'éditions, 1977), p. 69.

29. Metz, *Le Signifiant imaginaire*, pp. 89–90.

30. Van Dijk, *Text and Context*, p. 147.

31. Marcel Duchamp, alias Louise Norton, "The Richard Mutt Case," *The Blind Man*, No. 2 (May 1917), rpt. *Dada americano* (Milano: Mazzotta, 1970).

32. I would like to thank Mr. François Chapon, Conservator of the Bibliothèque Littéraire Jacques Doucet, for bringing this fact to my attention.

33. Francis Picabia, "A Propos d'Entr'acte," *Films*, No. 28 (Nov. 1, 1924).

34. René Clair, "En guise d'epigraphe," in *Cinéma d'hier, cinéma d'aujourd'hui* (Paris: Gallimard, 1970), p. 26.

35. *Spectator*, Alger, Dec. 27, 1924 (quoting Jules Mazelhin in *La France Théâtrale*); Georges Pioch, *Partisan*, Dec. 1924; Louis Schneider, *Revue de France*, Jan. 15, 1925.

36. Albert Flament, "Tableaux de Paris," *La Revue de Paris*, 32, No. 1 (Jan.–Feb. 1925), 199–200.

37. André Breton and Philippe Soupault, *S'il vous plaît*, in Michael Benedikt and George W. Wellwarth, eds., *Modern French Theatre* (New York: Dutton, 1966), p. 173.

38. Louis Aragon, "L'Homme coupé en deux," *Les Lettres françaises*, May 8, 1968, p. 8.

39. Morse Peckham, *Man's Rage for Chaos: Biology, Behavior and the Arts* (New York: Schocken Books, 1967), p. 314.

four. Surrealist metaphor and thought

1. André Breton, *Manifestoes of Surrealism*, trans. Richard Seaver and Helen R. Lane (Ann Arbor: Univ. of Michigan Press, 1977), pp. 173–175.

2. André Breton, *L'Amour fou* (Paris: Gallimard, 1937), pp. 38–41.

3. Arthur Rimbaud, *Oeuvres complètes* (Paris: Gallimard, Editions de la Pléiade, 1972), p. 108.

4. André Breton, *Perspective cavalière*, ed. Marguerite Bonnet (Paris: Gallimard, 1970), p. 58.

5. Anna Balakian, "Metaphor and Metamorphosis in André Breton's Poetics," *French Studies*, 19, No. 1 (Jan. 1965), 36.

6. Breton, *Manifestoes*, p. 32.

7. André Breton, "Du surréalisme en ses oeuvres vives," in *Manifestes du surréalisme* (Paris: Jean-Jacques Pauvert, 1962), p. 361.

8. Breton, *Manifestes*, pp. 361–363.

9. Octavio Paz, "André Breton ou la recherche du commencement," *Nouvelle revue francaise*, No. 172 (April 1, 1967), 615.

10. André Breton, *Arcane 17, enté d'ajours* (1947; rpt. Paris: Union Générale d'Editions, 1965), p. 106 (my translation).

11. André Breton, *La Clé des champs* (Paris: Editions du Sagittaire, 1953), p. 113.

12. Breton, *Arcane 17*, p. 105.

13. Benjamin Lee Whorf, *Language, Thought and Reality* (Cambridge: MIT Press, 1956).

14. Breton, *Manifestes*, p. 358.

15. Antonin Artaud, *Le Théâtre et son double, Oeuvres complètes* (Paris: Gallimard, 1964), IV, 12 (my translation).

16. Breton, *Manifestes*, p. 358.

17. Breton, *Manifestes*, pp. 39–40.

18. David E. Rumelhart, "Some Problems with the Notion of Literal Meaning," in Andrew Ortony, ed., *Metaphor and Thought* (New York: Cambridge Univ. Press, 1979), pp. 78–90.

19. Barbara Leondar, "Metaphor and Infant Cognition," *Poetics*, 4 (1975), 273–287.

20. Rumelhart, in Ortony, ed., *Metaphor and Thought*, p. 90.

21. Max Black, "More about Metaphor," in Ortony, ed., pp. 19–43.

22. Breton, *Manifestoes*, p. 37.

23. Walter Benjamin, "Der Surrealismus," in *Angelus Novus: Ausgewählte Schriften* (Frankfurt am Main: Suhrkamp, 1966), II, 101.

24. Susumu Kuno, *The Structure of the Japanese Language* (Cambridge: MIT Press, 1973), p. 127.

25. Kuno, p. 130.

26. The relation between "fictional worlds" and metaphors is explored by Samuel R. Levin in *The Semantics of Metaphor* (Baltimore: The Johns Hopkins Univ. Press, 1977): "A poet in writing what we would consider a (fresh) metaphor can intend it quite literally. For him the historical process of aggrammatization is seized and implemented in the single instant of conception. To be in sympathy with the poet, to read in a condition of poetic faith, we should have to take the poet at his word. This means that instead of construing the expression, we must construe the world" (p. 115).

27. The underlying model here is Saussurian; see Ferdinand de Saussure, *Course in General Linguistics*, trans. Wade Baskin (New York: McGraw-Hill, 1966). Jacques Derrida puts the case strongly for the underlying metaphoricity of language in "White Mythology: Metaphor in the Text of Philosophy," *New Literary History*, IV, No. 1 (Autumn, 1974), 5–74. The historical background to this notion is discussed in Derrida's *Of Grammatology*, trans. Gayatri Chakravorty Spivak (Baltimore: Johns Hopkins Univ. Press, 1976), p. 335, n.5.

28. Samuel R. Levin, "Standard Approaches to Metaphor and a Proposal for Literary Metaphor," in Ortony, ed., op. cit. p. 131.

29. H. Paul Grice, "Logic and conversation," in *Syntax and Semantics: Speech Acts*, III, ed. Peter Cole and J. L. Morgan (New York: Academic Press, 1975).

30. Teun A. van Dijk, "Pragmatics and Poetics," in van Dijk, ed., *Pragmatics of Language and Literature* (Amsterdam: North Holland, 1976).

31. For theories of deviance, see Tzvetan Todorov, *Théories du symbole* (Paris: Seuil, 1977) and J. Dubois et al, *Rhétorique générale* (Paris: Librairie Larousse, 1970); for a contextual approach to metaphor, see works already cited above and Paul Ricoeur, *La Métaphore vive* (Paris: Seuil, 1975).

32. Breton, *Manifestoes*, p. 37.

33. Laurent Jenny, "La Surréalité et ses signes narratifs," *Poétique*, 16 (1973), 499–520.

34. J. M. Adam, "La Métaphore productrice," in *Linguistique et discours littéraire* (Paris: Larousse, 1974), pp. 175–184.

35. Breton, *Soluble Fish*, in *Manifestoes*, p. 93.

36. Jenny, p. 506.

37. Ibid., p. 504.

38. Ibid., p. 510.

39. Ibid., p. 511.

40. Adam, p. 182.

41. Jenny, p. 512.

42. Adam, p. 178.

43. Robert Ariew, "André Breton's *Poisson soluble*," *Association for Literary and Linguistic Computing Bulletin*, 6, No. 1 (1978), 34–41.

44. Ariew, pp. 37–38.

45. Jenny, p. 511.

46. Michael Riffaterre, "Semantic Incompatibilities in Automatic Writing," in Mary Ann Caws, ed., *About French Poetry from Dada to 'Tel Quel'* (Detroit: Wayne State Univ. Press, 1974), pp. 223–241.

47. Riffaterre, p. 238.

48. Werner Abraham, *A Linguistic Approach to Metaphor* (Lisse, Netherlands: Peter de Ridder Press, 1975), p. 28.

49. A complete list of semantic features may be found in the Appendix.

50. The componential feature system and computer program were first developed at the University of Wisconsin-Madison by Arthur E. Kunst and the Black Earth Research Team that started work in 1974. See Arthur Kunst, "Semantic Codes," *SMIL Journal of Linguistic Calculus* (1978), 5–20; Arthur Kunst, "Text Generation," *Sub-Stance*, No. 16 (1977), 159–171; Brent L. Harvey and Karl S.Y. Kao, "Text Generative Modelling of Chinese Regulated Verse," *Poetics*, 8 (1979), 459–479.

51. Jenny, p. 51, and Michael Riffaterre, "La Métaphore filée dans la poésie surréaliste," *Langue française*, No. 3 (Sept. 1969), 46–60.

52. For an analysis of the effect of motion on human perception, see Gunnar Johansson, "Visual Motion Perception," *Scientific American*, 232, No. 6 (June 1975), 76–88. There is evidence that sophisticated film audiences learn to foreground other visual stimuli even when motion is present. Films made for European audiences and shown to Africans unfamiliar with the medium in the 1940's were often not able to convey the intended message because the inexperienced viewers paid too much attention to minor details on the screen (chickens, geese) that were in motion. See John Maddison, "Le Cinéma et l'information mentale des peuples primitifs," *Revue internationale de filmologie*, No. 3/4 (1948), 305–310.

53. Rudolf Arnheim, *Art and Visual Perception* (Berkeley: Univ. of California Press, 1960), p. 178.

54. Arnheim, p. 235.

55. Christian Metz, "Métaphore/métonymie, ou le référent imaginaire," in *Le Signifiant imaginaire: psychanalyse et cinéma* (Paris: Union Générale d'Editions, 1977), calls this a "paradigmatic metonymy" (one diegetic element suggests another, absent one). Example: In Fritz Lang's *M*, the little girl's murder is suggested metaphorically when her balloon floats up out of the bushes (pp. 227–228).

56. Metz (ibid., pp. 227–228) calls this a "syntagmatic metaphor" (the diegetic element is juxtaposed to the nondiegetic one). Another type of non-diegetic mataphor is the "paradigmatic metaphor" in which the non-diegetic element *replaces* the diegetic shot. Example: in the absence of a shot of two people making love, a shot of roaring flames (a waterfall, a train, etc.)

57. Luis Buñuel, "A Giraffe," in Francisco Aranda, *Luis Buñuel: a Critical Biography* (New York: Da Capo Press, 1976), pp. 262–264.

58. Antonin Artaud, *Selected Writings*, ed. Susan Sontag (New York: Farrar, Strauss & Giroux, 1976), pp. 240–241.

59. Henri Bergson, *Le Rire: essai sur la signification du comique* (Paris: Felix Alcan, 1929), p. 122.

60. Max Black, in Ortony, p. 36.

61. André Breton and Philippe Soupault, *Les Champs magnétiques* (1920; rpt. Paris: Gallimard 1976), pp. 48–49 (my translation).

62. André Breton, *Anthologie de l'humour noir* (Paris: Jean-Jacques Pauvert, 1966), p. 17.

63. Max Ernst, *Beyond Painting and Other Writings of the Artist and his Friends* (New York: Wittenborn & Schultz, 1948), pp. 16–17.

64. Artaud, in Sontag, ed., *Selected Writings*, pp. 241–42.

65. For a discussion of the limits of human information processing capacity, see George A. Miller, "The Magical Number Seven, Plus or Minus Two: Some Limits on our Capacity for Processing Information," in Ralph N. Haber, ed., *Contemporary Theory and Research in Visual Perception* (New York: Holt, Rinehart & Winston, 1968).

66. All quotations are from Luis Buñuel, *L'Age d'or and Un Chien Andalou*, trans. Marianne Alexandre (New York: Simon & Schuster, 1968).

67. John Russel Taylor, *Cinema Eye, Cinema Ear* (London: Methuen & Company, 1964), p. 86.

68. Information about the music accompanying *L'Age d'or* comes from private screenings at the Museum of Modern Art, New York; the Cinémathèque Française, Paris; and the Cinémathèque Royale de Belgique, Brussels; and also from the Studio 28 program published on the occasion of the film's premiere.

69. For an explanation of "off-screen" and "off-track" sound, see Claudia Gorbman, "Teaching the Soundtrack," *Quarterly Review of Film Studies*, 1, No. 4 (Nov. 1976), 446–452.

70. Maurice Nadeau, ed., *Documents surréalistes* (Paris: Seuil, 1948), p. 174.

71. Sigmund Freud, *Jokes and their Relation to the Unconscious, The Complete Psychological Works*, trans. James Strachey (London: Hogarth Press, 1953–63), VI.

72. Todorov, *Théories du symbole*, pp. 285–321.

73. Breton, *Manifestoes*, p. 90.

five. Image and ideology: the dynamics of artistic exchange

1. Walter Benjamin, *Das Kunstwerk im Zeitalter seiner technischen Reproduzierbarkeit* (Frankfurt am Main: Suhrkamp, 1968), pp. 13–16.

2. Harriet and Sidney Janis, "Marcel Duchamp: Anti-Artist," in Robert Motherwell, ed., *The Dada Painters and Poets: An Anthology* (New York: Wittenborn, Schultz, 1951), p. 307.

3. Marcel Duchamp (alias Louise Norton), "The Richard Mutt Case," *The Blind man*, No. 2 (May 1917), rpt. *Dada americano* (Milano: Mazzotta, 1970). See also Calvin Tomkins, *The World of Marcel Duchamp* (New York: Time-Life Books, 1966), p. 39.

4. Francis Picabia, "L'oeil cacodylate," *Ecrits* (Paris: Pierre Belfond, 1978), II, 37–38.

5. Louis Aragon, "L'Ombre de l'invention," *La Révolution surréaliste*, No. 1 (Dec. 1924), 24–25.

6. Noted by William Camfield, *Francis Picabia* (Princeton: Princeton Univ. Press, 1979), who links the eye to voyeurism (p. 194).

7. Louis Aragon, *Anicet ou le panorama* (Paris: Gallimard, 1921), p. 32.

8. For descriptions of Duchamp's construction of the "Large Glass," see Hans Richter, *Dada: Art and Anti-Art* (New York: Oxford Univ. Press, 1978), pp. 93–95 and Richard Hamilton, "The Large Glass," in Anne d'Harnoncourt and Kynaston McShine, eds., *Marcel Duchamp* (New York: Museum of Modern Art, 1973), pp. 57–67.

9. Marcel Duchamp, *Notes and Projects for the Large Glass*, ed. Arturo Schwartz (New York: Abrams, 1969).

10. Marcel Duchamp, "The Bride Stripped Bare by Her Bachelors, Even," in Lucy Lippard, ed., *Dadas on Art* (Englewood Cliffs, N.J.: Prentice-Hall, 1971), p. 147. See also the commentary by Humphrey Jennings, "The Iron Horse," *London Bulletin*, No. 3 (June 1938), 27–28.

11. Michel Carrouges, *Les Machines célibataires* (Paris: Chêne, 1976), pp. 26–53; *Les Machines célibataires* (catalogue of the exposition May-July 1976, Musée des Arts Decoratifs, Paris).

12. Benjamin, p. 42.

13. For an analysis of *Anemic Cinema*, see Annette Michelson, "Anemic Cinema: Reflections on an Emblematic Work," *Artforum*, 12, No. 2 (1973), 64–69.

14. Louis Aragon, *Le Libertinage* (Paris: Gallimard, 1924), p. 22. This passage is noted by Armand Hoog, who has written on the subject of Surrealism and the machine in "The Surrealist Novel," *Yale French Studies*, No. 8 (1951), 17–25. See also K. G. Pontus Hultén, *The Machine (as Seen at the End of the Mechanical Age)* (New York: Museum of Modern Art exhibition catalogue, 1968), pp. 6–13.

15. Maurice Blanchot, "Reflexions sur le surréalisme," *La Part du feu* (Paris: Gallimard, 1949), p. 93.

16. Antonin Artaud, "Manifeste en langage clair," *Nouvelle revue française*, XXV, No. 147 (Dec. 1925), 683.

17. Georges Bataille, "Friandise cannibale," *Documents*, No. 4 (1929–30), p. 216.

18. André Breton, "Arshile Gorky," *Surrealism and Painting*, trans. Simon W. Taylor (New York: Harper and Row, 1972), p. 199.

19. Breton, *Surrealism and Painting*, p. 199. For a discussion of the role of the eye in this work, see Anna Balakian, *André Breton: Magus of Surrealism* (New York: Oxford Univ. Press), pp. 152–154.

20. The two birds in the painting represent, perhaps, Jocasta and Laius. Laius is cuckolded (he wears horns) and is led by fate (the string that hangs from the sky).

21. André Breton, *Position politique du surréalisme* (1935; rpt. Paris: Denoël/Gonthier, 1972), pp. 167–168.

22. Paul Eluard, *Donner à voir* (Paris: Gallimard, 1939), p. 95.

23. André Breton, "Vigilance," from *Le Revolver à cheveux blancs*, in *Clair de terre* (Paris: Gallimard, 1966), p. 136.

24. Max Ernst, quoted in Wieland Schmied, "Apprendre à ne plus être aveugle," *Max Ernst: à l'intérieur de la vue* (Paris: Gallimard, 1964), pp. 13–14.

25. In chapter five of *La Femme 100 têtes* the text equates blindness with inner vision: "One will discover the germ of very precious visions in the blindness of wheelrights," Max Ernst, *The Hundred Headless Woman*, trans. Dorothea Tanning (New York: George Braziller, 1981), p. 187.

26. Alain Jouffroy, *Une révolution du regard* (Paris: Gallimard, 1964), pp. 13–14.

27. The "starred mole" was discussed in Chapter 1; see also note 45 from that chapter.

28. Hans Robert Jauss, "Literaturgeschichte als Provokation der Literaturwissenschaft," in *Literaturgeschichte als Provokation* (Frankfurt am Main: Suhrkamp, 1974), p. 172.

29. Franz Mon, *Herzzero* (Berlin: Luchterhand, 1968).

30. This translation, prepared with the assistance of the author, is a phonetic permutation of the first text. The permutations in English follow as closely as possible the principles of permutation used in the original. In general this meant locating a word that diverged from the original after the first syllable (in some cases the first syllable could begin with a related consonant, e.g., d instead of t). In order to insure randomness, I used the *American Heritage Dictionary* (Boston: Houghton Mifflin, 1973), choosing the first word appearing after the original word entry that diverged from it after the first syllable. If the list was exhausted before a word was found, then the word list was searched in the other direction. Exception was made in cases where the word selected would have been overly technical, thus distorting the register of the original (for instance "seil/segel" which would have been "rope/roquelaure" was changed to "rope/rosary").

31. Franz Mon, *Texte über Texte* (Berlin: Luchterhand, 1970), p.9.

32. Mon, *Texte über Texte*, p. 9.

33. Ibid., p. 10.
34. Translated with the assistance of the author.
35. Mon, *Texte über Texte*, p. 98.
36. For a definition of "constellations," see the essay "Text als Prozess," in Mon's *Texte über Texte*, pp. 86–101.
37. From the preface to *Herzzero*.
38. Mon, *Herzzero*, p. 85.
39. Julio Cortázar, *Rayuela* (Buenos Aires: Editorial Sudamerica, 1972). Except where indicated, translated passages refer to *Hopscotch*, trans. Gregory Rabassa (New York: Random House, 1966).
40. Maurice Roche, *Codex* (Paris: Seuil, 1974).
41. Maurice Roche, *Mémoire* (Paris: Pierre Belfond, 1976), p. 143.
42. The play on words here is between "dear" (chéri) and "defecate" (chier).
43. Translation:
 family
The loss of a member
 masculine
44. "Confondu" (confused) is a combination of "con" (idiot) and "fondu" (melted). "Contenu" (contained) is a combination of "con" and "tenu" (held). "Sénescence c'est naissance" translates as "senescence is birth."
45. "Commentaire" (commentary) is a combination of "comment" (how) and "taire" (be silent).
46. Sigmund Freud, *The Complete Introductory Lectures on Psychoanalysis* (New York: Norton, 1965), pp. 230–231. I am grateful to Stephen Heath for pointing out this passage to me.
47. Sergei Eisenstein, "The Cinematographic Principle and the Ideogram," *Film Form* (New York: Harcourt, Brace & World, 1949), pp. 28–44.
48. Eisenstein, p. 30.
49. An excellent discussion of meaning in film is Calvin Pryluck's *Sources of Meaning in Motion Pictures and Television* (New York: Arno Press, 1976).
50. Maurice Roche, *Compact* (Paris: Seuil, 1966).
51. Roche, *Mémoire*, p. 56.
52. A free translation of the right-hand figure: "The eagle, miss," even wounded in its L [French "aile" means wing"]—and having lost its g—suffering great pain [ea e!] is always, although ill, the sign of the predator with all claws drawn!"
53. Julia Kristeva, *La Révolution du langage poétique* (Paris: Seuil, 1974); Helmut Heissenbüttel, *Zur Tradition der Moderne* (Berlin: Luchterhand, 1972).
54. Roche, *Compact*, p. 164.
55. See Ladislav Matejka and Krystyna Pomorska, eds. *Readings in Russian Poetics* (Cambridge: MIT Press, 1971).

Conclusion

1. Jacques Lacan, *The Language of the Self: the Function of Language in Psychoanalysis*, trans. Anthony Wilden (New York: Dell, 1968).
2. Benjamin Lee Whorf, *Language, Thought and Reality* (Cambridge: Technology Press of MIT, 1956). See also chapter four.
3. See Meankhem Perry, "Alternative Patterning: Mutually Exclusive Signs-Sets in Literary Texts," *Versus*, 24 (1979), 84; and B. Elan Dresher and Norbert Hornstein, "On Some Supposed Contributions of Artificial Intelligence to the Scientific Study of Language," *Cognition*, 4 (1976), 321–328. The above critique was answered in 1977 by Roger C. Schank and Robert Wilensky, "Response to Dresher and Hornstein," *Cognition*, 5 (1977), 133–146; and Terry Winograd, "On Some Contested Suppositions of Generative Linguistics About the Scientific Study of Language," *Cognition*, 5 (1977), pp. 151–179.
4. Perry, p. 84.
5. Bonnie J. F. Meyer, *The Organization of Prose and Its Effects On Memory* (New York: American Elsevier, 1975), p. 166.

6. Walter Kintsch, *The Representation of Meaning in Memory* (New York: John Wiley, 1974). See in particular the discussion of "verb frames" pp. 34–36.

7. Winograd, pp. 173–174.

8. Ibid., p. 178, quoting from Donna J. Haraway, *Crystals, Fabrics and Fields* (New Haven: Yale University Press, 1976), p. 17.

9. André Breton, "On Surrealism in its Living Works," in *Manifestoes of Surrealism*, trans. Richard Seaver and Helen R. Lane (Ann Arbor: Univ. of Michigan Press, 1977), p. 299.

Acknowledgments of illustrations and permissions

Altus, *Mutus Liber (in quo tamen tota Philosophica hermetica figuris hieroglyphicis depingitur)* Rupellae, 1677. Collection of the Library of Congress; photo courtesy of Library of Congress Photoduplication Service.

Artaud, Antonin and Germaine Dulac. *La Coquille et le clergyman*, 1928. Stills courtesy of Anthony Benson, Department of Audio-Visual Education, Duke University Medical Center.

Basilius Valentinus. *Les Douze clefs de la philosophie* (Frankfurt: Herman von Sand, 1688; engravings developed from the original woodcuts of 1602). Jantz Collection, Duke University. Photo courtesy of Anthony Benson, Dept. of Audio-Visual Education, Duke University Medical Center.

Buñuel, Luis and Salvdor Dali. *Un chien andalou*, 1928. Stills courtesy of Museum of Modern Art Film Stills Archive, The British Film Institute, and Anthony Benson, Department of Audio-Visual Education, Duke University Medical Center.

Buñuel, Luis. *L'Age d'or*, 1930. Stills courtesy of Museum of Modern Art Film Stills Archive and Cinémathèque Française.

Duchamp, Marcel. *La Mariée mise à nu par ses célibataires, même*, 1915–23. Collection of the Philadelphia Museum of Art, bequest of Katherine S. Dreier. Photo courtesy of the Philadelphia Museum of Art.

Ernst, Max. *Le Chapeau ça fait l'homme*, 1920. Collection of the Museum of Modern Art, New York. Photo courtesy of the Museum of Modern Art.

—*Oedipus Rex*, 1921. Private collection. Photo courtesy of Günter Metken, Paris.

—Illustrations of Paul Eluard's *Répétitions*. Paris, Au Sans Pareil, 1922. Photos courtesy of Houghton Library, Harvard University.

—*Histoire naturelle*, 1925. By permission of Gerd Hatje Verlag, Stuttgart. Photo courtesy of Anthony Benson, Department of Audio-Visual Education, Duke University Medical Center.

—*La Femme 100 têtes*. Paris: Editions du Carrefour, 1929. Photo courtesy of Beinecke Rare Book and Manuscript Library, Yale University. Translations of captions courtesy of Dorothea Tanning, trans., *The Hundred Headless Woman* (New York: George Braziller, 1981).

All illustrations by Max Ernst by permission of: Estate of Max Ernst. © SPADEM, Paris/VAGA, New York, 1981.

Magritte, René. *Faux miroir* (The False Mirror), 1928. Collection of the Museum of Modern Art, New York. Photo courtesy of the Museum of Modern Art. © by ADAGP, Paris, 1982.

Maier, Michael. *Atalanta fugiens (hoc est Emblemata nova de Secretis naturae chymicae)*, 1618; engravings by T. de Bry, Oppenheim, reproduced in *Secretoris naturae secretorium scrutinium chymicum* (Frankfurt: G. H. Oehrlingius, 1687). Collection of the Library of Congress; photo courtesy of Library of Congress Photoduplication Service.

Mylius, *Philosophia Reformata*. Frankfurt: apud L. Iennis, 1622. Photo courtesy of Bibliothèque Nationale, Paris.

Picabia, Francis. *L'Oeil cacodylate*, 1921. Collection of the Centre National d'Art et de Culture Georges Pompidou. Photo courtesy of the Centre National d'Art et de Culture Georges Pompidou. © by ADAGP, Paris, and VAGA, New York, 1982.

—*Optophone II*, 1923. Collection of the Musée d'Art Moderne de la Ville de Paris. Photo courtesy of Bulloz, Paris. © by ADAGP, Paris, 1982, and VAGA, New York, 1982.

Ray, Man. *Emak Bakia*, 1926. Still courtesy of Museum of Modern Art Film Stills Archive.

Roche, Maurice. *Codex*. Paris: Editions du Seuil, 1974. Quotations courtesy of Editions du Seuil.

Index

Adam, J. M., 88–91 passim
L'Age d'or, xx, 32; black humor in, 101,
 103–5; eye images in, 117; metaphor in,
 101–7; soundtrack, 105–7
L'Age d'or Manifesto, 107
Alchemy: and classical myth, 7, 16, 28,
 79, 107; color symbolism in, 7; and ico-
 nography, 7, 26, 28, 30; myths, 3–6;
 as self-knowledge, 7; stages of, 7; and sur-
 realist poetics, xx, 15
Alexandrian, Sarane, 10
Andalusian Dog. See Un Chien andalou
Androgyne: in alchemy, 5, 7; in Surrealism,
 5
Antheil, Georges, 45
Anthologie de l'humour noir (Anthology
 of Black Humour), 12
The Apocalypse According to St. John,
 11, 14
Apollinaire, Guillaume, 11, 13, 33
Aragon, Louis, 78; Anicet, 110–11; Le
 Libertinage, 113
Ariew, Robert, 90–91 passim
Arnheim, Rudolf, 96
Arp, Hans, xi
Art: abstraction in, xii, xv; as adaptive
 mechanism, 78; anti-forms in, xii; cogni-
 tive dimension, 135; disorientative
 function of, xii
Artaud, Antonin, 54–57, 99–101 passim,
 114; and theatre of alchemy, 27, 55;
 and theatre of cruelty, 55. See also
 "Scandal of the Ursulines"
—Works: The Cenci, xx, 32; Le Jet de sang
 (The Spurt of Blood), 56; L'Ombilic
 des limbes, 56; The Philosopher's Stone,
 56; Le Theatre et son double (The
 Theater and Its Double), 27, 56, 57.
 See also The Sea Shell and the Clergyman
Automatic writing, xviii, xix, 26, 69;
 and componential theory, 92; discourse
 organization of, 91; and metaphor, 91;
 and readers, 91; and the unconscious,
 107. See also Les Champs magnétiques

Baader, Johannes, xiv
Bakhtin, Mikhail, xxi
Balakian, Anna, 4, 14–15, 23
Ball, Hugo, xi, 35–36
Bancquart, Marie-Louise, 26

Bataille, Georges, 115
Baudelaire, Charles, 11, 12
Benjamin, Walter, 65, 83, 108, 113
Bergson, Henri, 100
Black, Max, 82, 100
Blanchot, Maurice, 108, 114
Brecht, Bertold, 39
Breton, André, xvii, 3, 4, 23–27, 39, 117;
 on cinema, 52; on Max Ernst, 19
—Works: L'Amour fou, 79, 80; Anthol-
 ogie de l'humour noir (Anthology of
 Black Humour), 11; Poisson soluble (Sol-
 uble Fish), 88–91; Surrealism and
 Painting, 115. See also Les Champs
 magnétiques; First Manifesto of Surreal-
 ism; Nadja; S'il vous plaît
Brisset, Jean-Paul, 11, 14
Bruitist music, xv
Bruitist poems, xii
Brunius, Jacques, 45
Büchner, Georg: Woyzeck, 44
Buñuel, Luis: cet obscur objet du désir
 (This Obscure Object of Desire), 52;
 Los Olvidados, 97–99. See also L'Age
 d'or; Un Chien andalou
Bureau of Surrealist Research, xvii

Cabaret Voltaire, xi, xii, xv
Canseliet, Eugène, 23
Carrouges, Michel, 33
Celibate machine, 110
Les Champs magnétiques (Magnetic
 Fields), xix, 114; "Eclipses," 66–69, 93–
 96, 101
The Chemical Wedding of Simon Rosy-
 Cross, 11, 13
Cheval, Maurice (the Mailman Cheval), 11,
 14
Un Chien Andalou (Andalusian Dog), xx,
 44–52, 134; and dream work, 52, 61;
 eye images in, 114; metaphor in, 102; and
 Oedipus myth, 72–73; readings of, 154
 n.26; scenario, 70–72; and spectator
 identification, 73; and structural disloca-
 tion, 45–52; and topicalization, 69–73
Clair, René: Entr'acte, 45, 74–77, 113
Cocteau, Jean: Le Sang d'un poète (The
 Blood of a Poet), 32
Codex, 127–34; and dream work, 129; and
 film montage, 131–32

Inez Hedges is Assistant Professor of Romance Languages, Duke University. She has published articles in several scholarly journals, among them *The French Review, Poetics Today, Dada/Surrealism,* and *Science, Technology, and the Humanities.*